THE LEGACY OF
NORMAN ROCKWELL

BEN SONDER

NEW LINE BOOKS

Fax: (888) 719-7723
e-mail: info@newlinebooks.com

Printed and bound in Korea

ISBN 1-59764-078-6

Visit us on the web!
www.newlinebooks.com

Author: Ben Sonder

Publisher: Robert M. Tod
Editorial Director: Elizabeth Loonan
Book Designer: Mark Weinberg
Senior Editor: Cynthia Sternau
Project Editor: Ann Kirby
Photo Editor: Edward Douglas
Production Coordinator: Jay Weiser
Desktop Associate: Paul Kachur
Typesetting: Command-O Design

Picture Credits

CONTENTS

"I PAINT LIFE AS I WOULD LIKE IT TO BE."

On a warm July day in 1944 a train station in Chicago was the site of a great deal of commotion. Despite the evening rush, the managers of the Chicago and North Western Railroad Station had closed all doors except one set, so that thousands of commuters had to funnel into a single entry. As they passed through, the inconvenienced travelers may have noticed a newly constructed platform directly facing them. On this platform was a skinny fifty-year-old man and a photographer, and they were taking dozens of photos of the mad rush in front of them. The skinny man was none other than Norman Rockwell, the most famous American illustrator of the twentieth century.

Rockwell had traveled from his Vermont home to Chicago that summer on a particular mission: To create a Christmas cover painting for *The Saturday Evening Post*. Although Christmas was months away, magazine covers had to be conceived and developed well ahead of their appearance. Rockwell had already come up with a satisfactory idea for his annual holiday cover: A crowded railroad station in the middle of the United States, with people rushing to get home for Christmas. The idea was typical of his sensibility. Never would he have chosen a pointedly religious theme. Nor would he have depicted anything that could not be associated immediately with the average person's feelings and associations about Christmas. There would be no statement except that of the

slightly annoyed, yet often relieved and excited feeling of fighting crowds to get home for the holidays.

To capture every detail, Rockwell wanted to see for himself the real thing, or at least, given the calendar, get as good an idea as possible. The use of a camera was a fairly new innovation for him at that point. Up until the mid-1930s, he had sketched everything from life. But the camera did not really change Rockwell's vision, for as an artist he had the meticulous, perceptive gaze of a camera. After rolls of film of the crowded train station in Chicago were shot, he headed back to Vermont, where he would then use parts of his photos to craft the impetus of hurling bodies: an elbow squeezing past the shoulder of a shorter person, or arms laden with packages. He'd add the winter clothes over the summer-clad bodies and then slowly bring his image of the Christmas rush, born in July, to fruition.

The sight of the well-known artist in action might have reassured many of Rockwell's fans, who invariably knew him as a realist, albeit one with an eye for the lighter and friendlier side of life. Throughout his career, however, Rockwell never approached his work as a documentarist. His whimsical scenes of everyday American life did not come strictly from the streets, barbershops, doctor's offices, or boy scout outings we all know, but developed rather as counterparts of those scenes constructed in his own mind. They may have been inspired by memories or

TRAIN STATION AT CHRISTMAS

Oil on canvas, first printed on the cover of The Saturday Evening Post, *December 23, 1944.*
Rockwell began planning his seasonal covers months in advance,
working on Christmas scenes like this one in the heat of summer.

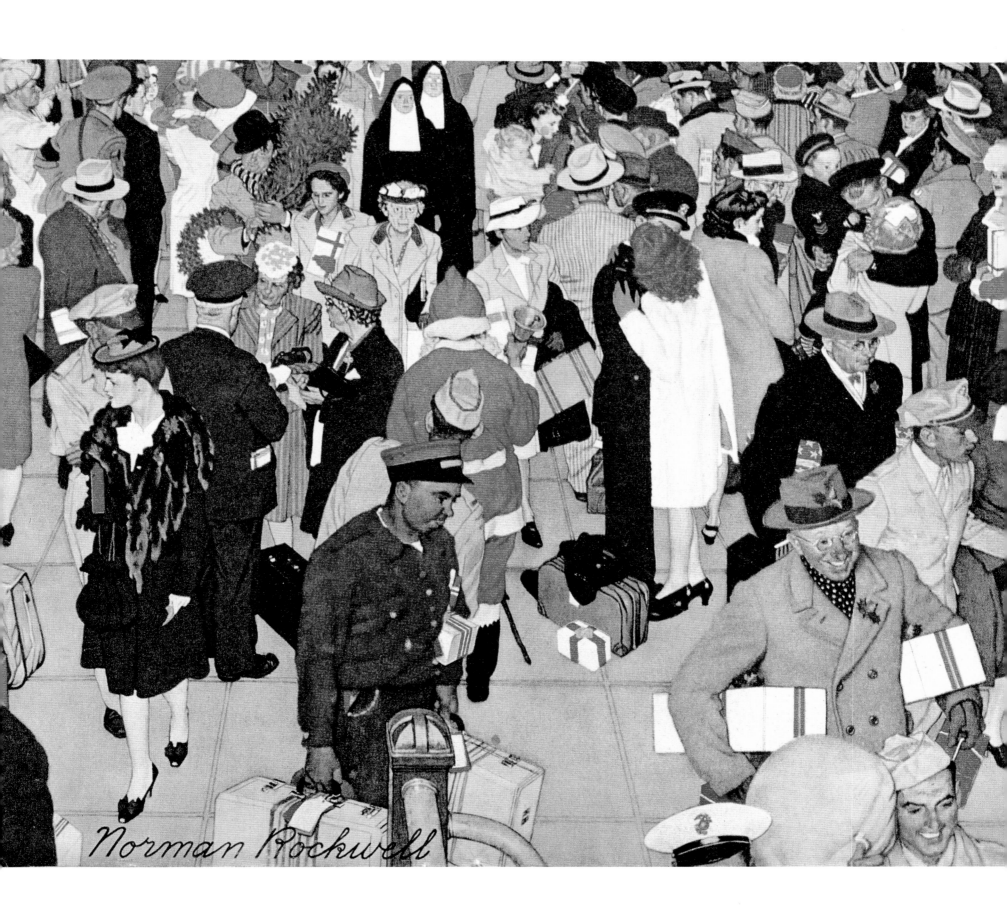

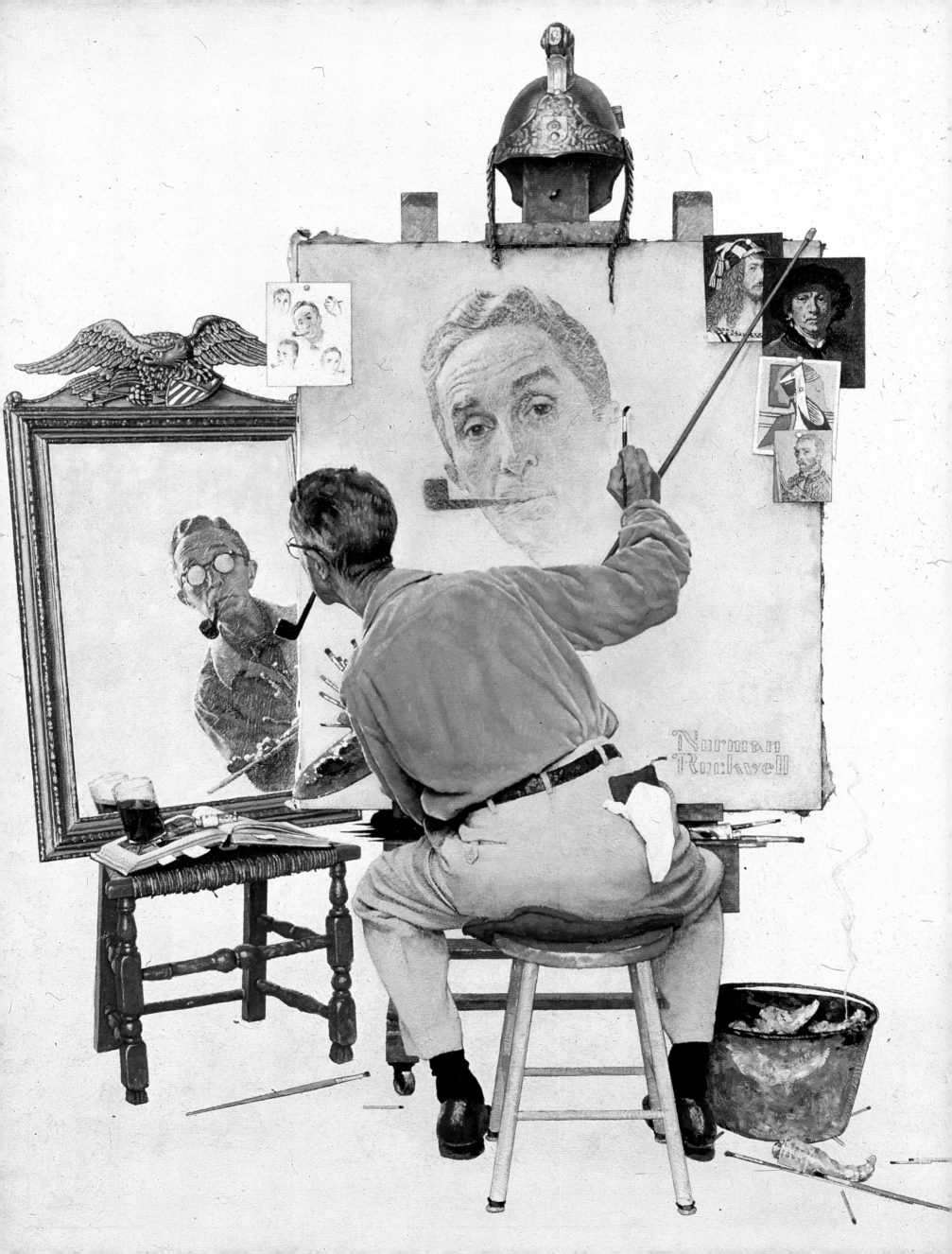

anecdotes but they were always transformed by Rockwell's own particular fantasy of a gentler, more lighthearted America. They grew out of a vision of boyhood that survives in some men for their whole lives, but they were also a reaction to some bitter urban experiences of the artist's youth. He had seen the sordid and wanted nothing of it. His vision was molded by a poignant yearning for an ideal middle-class life that included a comfortable, safe place for generations to come.

Each of Rockwell's canvases is a narrative, a mini-movie. He conceived of the idea; won commercial approval for it; and cast it with models from his home, neighborhood, or town. He often designed and constructed his sets and dressed his models in costumes that he kept in his studio. This approach seldom varied during the course of his long career—from his first work prior to World War I to his last illustrations in the early 1970s. Most of his paintings have a hospitable relationship to the viewer. One can see his most effective visual device, the foreground invitation, as early as 1916 in a painting called *The Letter*. It portrays a man with three days growth of beard, sitting with his feet on a checker-clothed table near a sink full of unwashed dishes. The man is wearing a pink apron. But it is the letter he is holding in the foreground of the picture that draws us in and decodes the cluttered scene. It is signed "Nora" and clearly informs the viewer that the whole setup is the outcome of a missing wife.

Rockwell's work remains far from the gritty realism of any "ash-can" school of American art. He told stories in his pictures that he wanted to tell and that would be appreciated by the mainstream middle-class audience who bought *The Saturday Evening Post*, which published hundreds of covers by Rockwell over a period of forty-eight years. He had a remarkable eye for detail, was rigorous in his authenticity in rendering people and things, and possessed the academic training and technical skills of a fine artist.

TRIPLE SELF-PORTRAIT

Oil on canvas, first printed on the cover of The Saturday Evening Post, *February 13, 1960.* Rockwell is the post-modernist here, with a triple self-portrait cover. By the 1960s, Rockwell's name was synonymous with the *Post,* and the artist himself had become as much of an American icon as those he depicted in his paintings.

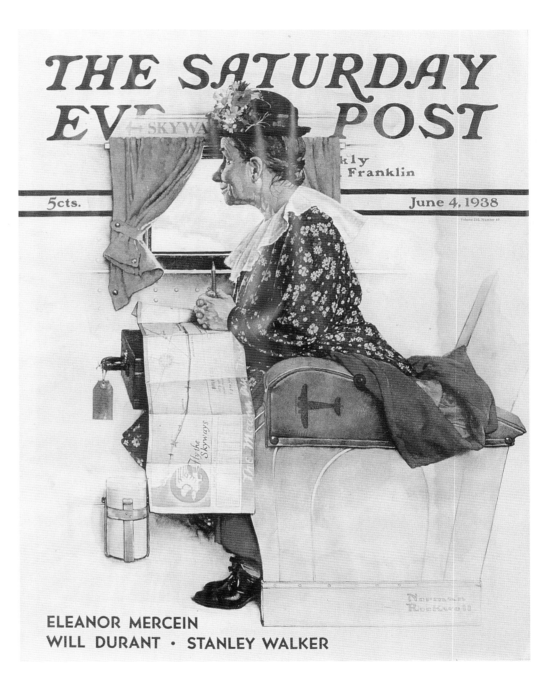

He told anecdotes that happened, or could have happened, in the family circle and in small towns, and they were stories that many people wanted to hear. Because he left out the negative, his work was a mainstay to the public during times of national crisis. In the twenties, when industry and technology were changing the work place and home and the jazz age was changing American morals, Rockwell's work reminded people of simpler times. During the Depression, when economic pressures darkened every community, Rockwell's familiar scenes of cozy security heartened millions of magazine readers who had lost their jobs. And during the war, his series of

AIRPLANE TRIP

Oil on canvas, first printed on the cover of The Saturday Evening Post, *June 4, 1938.* Here Rockwell captures the excitement and anxiety of a first airplane trip in the early days of commercial flight. With a map on her lap, the passenger sits with her eyes shut, hands clasped in prayer.

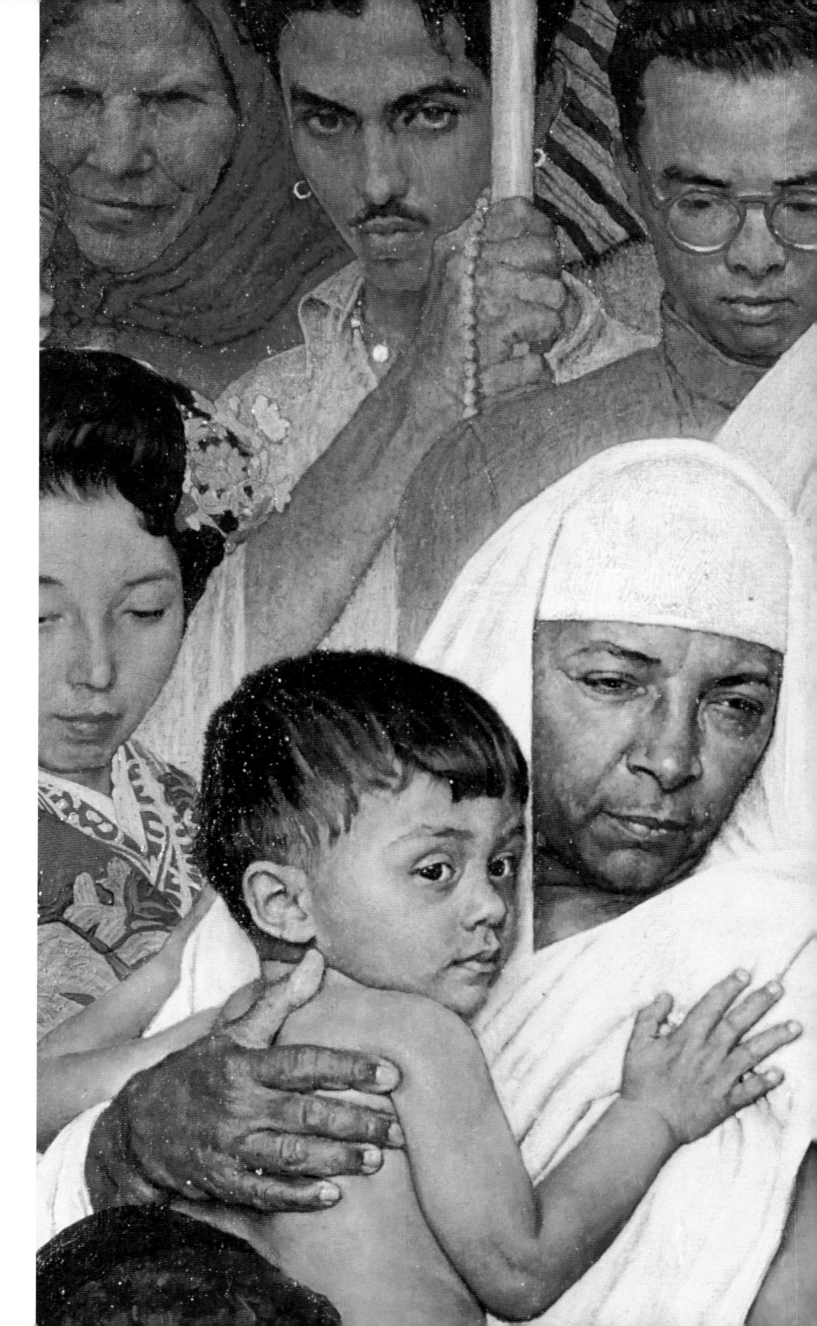

**THE
GOLDEN RULE**

*detail; oil on canvas,
first printed on the cover
of* The Saturday Evening
Post, *April 1, 1961.*
Later in his life,
Rockwell chose
more politically
motivated subject
matter, while still
appealing to the
mainstream values
of middle America.

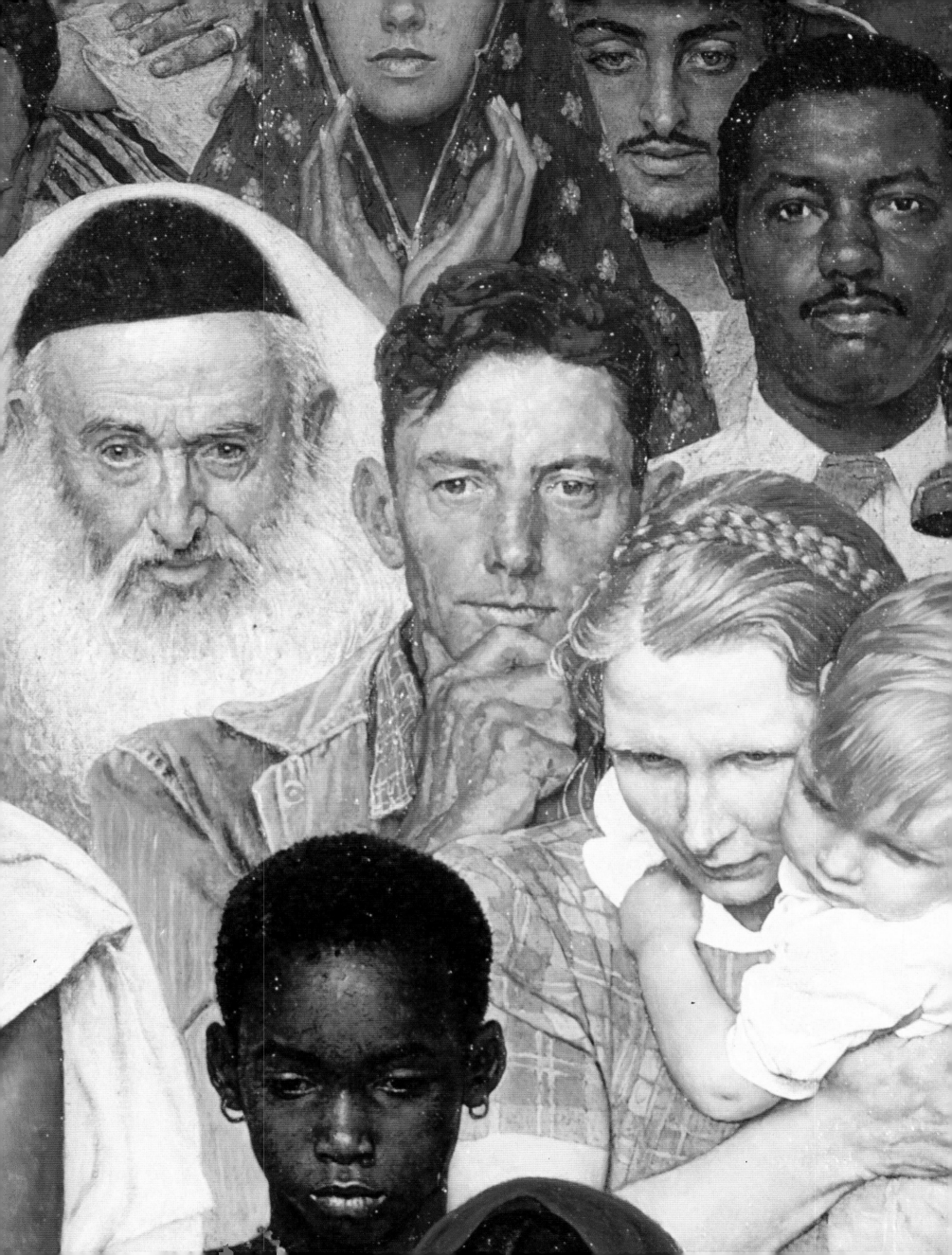

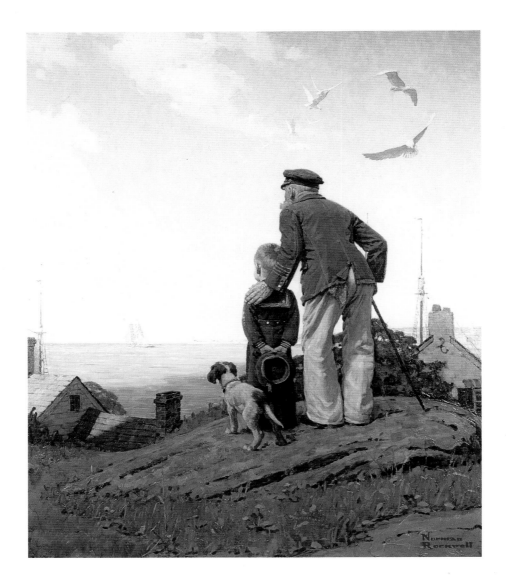

LOOKING OUT TO SEA

Oil on canvas, 1919.
Although the old man and
the boy are looking out at
the coast, it appears as though
it is the potential for adven-
ture, and not the beauty of the
scene, that has captured their
attention. Rockwell largely
ignored natural scenery in his
early work, concentrating
instead on characterization
and action.

TRAFFIC CONDITIONS

*Oil on canvas, first printed on the cover of
The Saturday Evening Post, July 9, 1949.*
Rockwell's scenes are typi-
cally centered around move-
ment and life, his figures
seemingly caught mid-stride
as they deal with some
adventure of daily life. He used
real models to ensure authen-
ticity in the faces and body
language of his characters.
This scene is far busier than a
typical Rockwell painting, and
offers countless mini-scenes
within the larger picture.

illustrations known as "The Four Freedoms" reinter-
preted the global struggle as a struggle for familiar
American ideals.

As consistent as Rockwell's work is, one might ex-
pect him to have lived and worked without serious
conflict. Yet like many prolific artists he constantly
struggled with anxiety about the creative process. To
arrive at an idea, he sometimes drew and destroyed a
dozen sketches, then went to bed in anguish and
began the next day in doubt. One of the reasons that
coming up with a workable idea was so difficult was
that each idea for him had to be in itself a complete
vignette—a one-panel story with characterization,
setting, mood, and a one-line joke or piece of irony
about the human condition.

Once he had an idea, it was not unusual for him to
be crippled by the feeling that a canvas he was work-
ing on had suddenly turned "all wrong." He would

become obsessive about a
painting he was working on,
rushing back into his studio
after hours of work to see if it
resembled the way he had
thought it looked a few hours
before. The antidote to such
a crisis was to appeal to the
opinions of his wife, his friends,
and his colleagues, whose sup-
port and suggestions eventu-
ally helped him finish a work.
When even their support was
not enough to overcome his
doubts, he went for long, brooding walks until he
was able again to face the interior battle that only he
could see being played out on the canvas.

Rockwell went through periods when he bemoaned
the fact that he had "sold out." On a couple of occa-
sions he confessed to journalists that he was still wait-
ing for the opportunity to produce a great work of art.
At various points in his life, he tried to participate in
the Modernist revolution in painting that had taken
over high culture, but in most cases the results were
unsatisfactory. He was an admirer of the works of
Picasso and Matisse but he never achieved a parallel
vision, and eventually he admitted to himself that this
was due more to predilection than to lack of skills,
originality, or talent.

In 1960 Rockwell said, "Maybe I grew up and found
the world wasn't the perfectly pleasant place I had
thought it to be. I unconsciously decided that if it

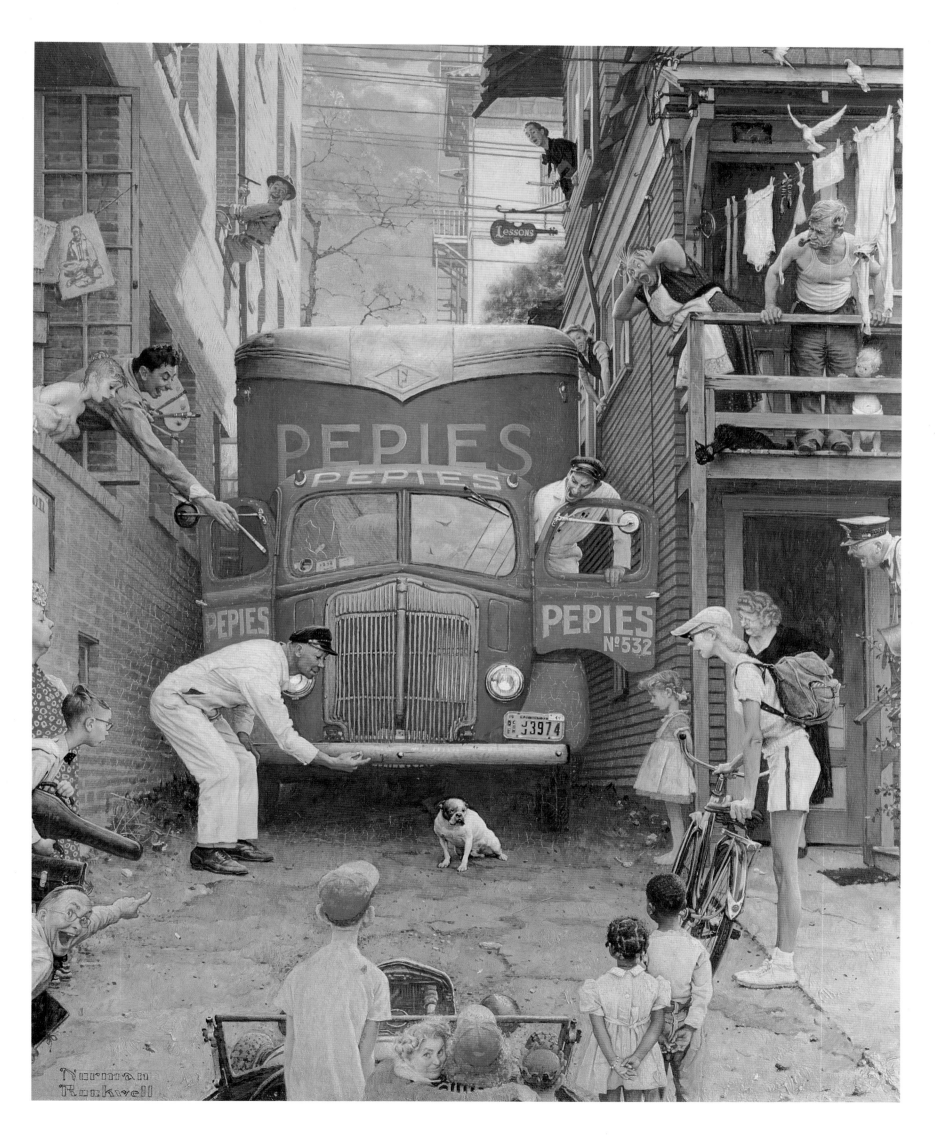

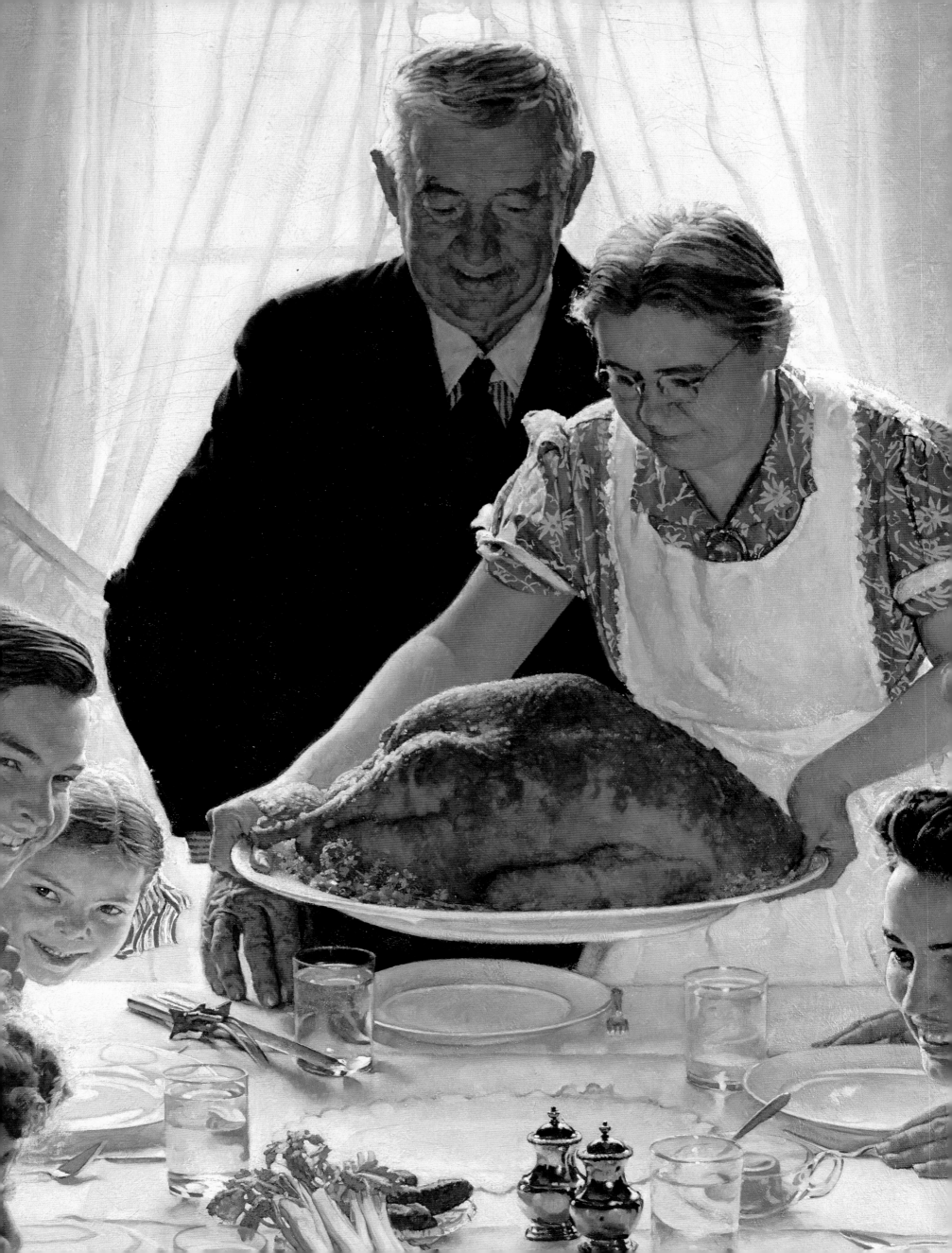

wasn't an ideal world, it should be, and so painted only the ideal aspects of it, pictures in which there were no drunken fathers, or self-centered mothers, in which, on the contrary, there were only foxy Grandpas who played baseball with the kids, and boys fished from logs and got up circuses in the backyard. If there were problems, they were humorous problems."

His attempts at deeper political relevance were, on the whole, equally unsuccessful. It is true that he produced the much admired "Four Freedoms," but none of these four works created any controversy for American audiences. *Freedom from Want* depicts a Thanksgiving dinner at the moment an aproned and bespectacled elder is placing a plump turkey on the table to the delighted grins of a multigenerational family—all of whose beverage preferences seem to be water in simple glasses. And although *Freedom from Fear* portrays a man holding a newspaper with a banner headline about bombing, he is peacefully gazing upon two children, snuggled in bed under clean linen and being tucked in by a doting mother.

Virtually none of Rockwell's work is multicultural in today's sense of the term. In almost every case, his subjects and their customs are Caucasian, Christian, and Anglo-Saxon. On the other hand, as adamant as Rockwell was about maintaining his vision of middle-class life, he was not inured to crises in American culture. To keep abreast of the turmoil that swept the nation in the sixties, he produced a magazine cover showing unsmiling U.S. marshals escorting a black child to school in Little Rock, Arkansas. Another canvas from the same period depicted the murder of three civil rights workers in Mississippi. However, these never became his best received works, and when it came to the realm of politics the artist seemed more comfortable doing portraits of established political officials.

FREEDOM FROM WANT

detail; oil on canvas, from The Four Freedoms *series; first printed as an illustration in* The Saturday Evening Post, *March 6, 1943.*
Rockwell's Four Freedoms poster series was immensely powerful and highly popular. *Freedom from Want* captured the American dream on a number of levels, with its emphasis on home and family.

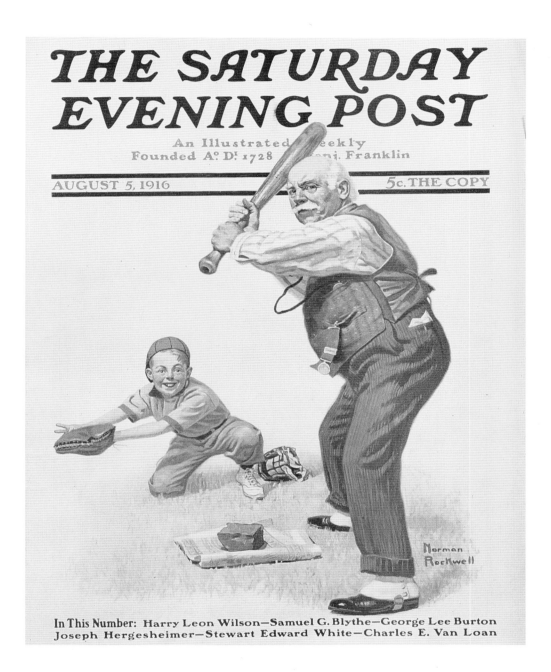

THE SATURDAY EVENING POST

An Illustrated Weekly
Founded A°. D! 1728 ...nj. Franklin

AUGUST 5, 1916 5c. THE COPY

In This Number: Harry Leon Wilson—Samuel G. Blythe—George Lee Burton
Joseph Hergesheimer—Stewart Edward White—Charles E. Van Loan

Despite what some see as his cultural limitations, by the later 1960s Rockwell—who for millions of Americans had never gone out of fashion—won greater acceptance among critics, and a late Rockwell boom began to flower. Books on his art appeared, a major exhibition of his works was held at a New York City gallery, and a documentary film celebrating his life was made. Even in an age of assassinations, ghetto riots, war, a generation gap, and political corruption, Rockwell's simple but elegant style of illustration, his humane optimism, and his personal integrity won him new admirers. By the time he died in 1978 at the age of eighty-four, Norman Rockwell was a national institution.

LOW AND OUTSIDE

Oil on canvas, first printed on the cover of The Saturday Evening Post, *August 5, 1916.*
Although he was never an athlete himself, Rockwell would incorporate the national pastime into many works over the years, including this, his third cover for the *Post*.

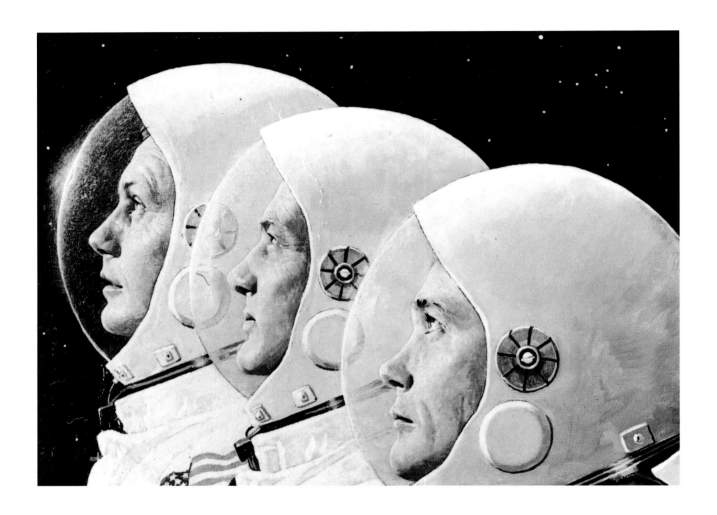

APOLLO 11 SPACE TEAM

detail; oil on canvas; first printed in Look *magazine, July 15, 1969.*

Throughout his life, Rockwell remained the
chronicler of American events, although he chose
for the most part to stick to the happier side of life.

SELF PORTRAIT: THE ARTIST WAS FACED WITH A DILEMMA

Oil on canvas, first printed on the cover of The Saturday Evening Post, *October 8, 1938.*

Over the course of his career, Rockwell would paint 322 covers for *The
Saturday Evening Post,* and many more for other publications. Generating new
ideas was often quite a dilemma indeed, as this self-parodying painting attests.

"I PAINT LIFE
AS I WOULD LIKE IT TO BE."

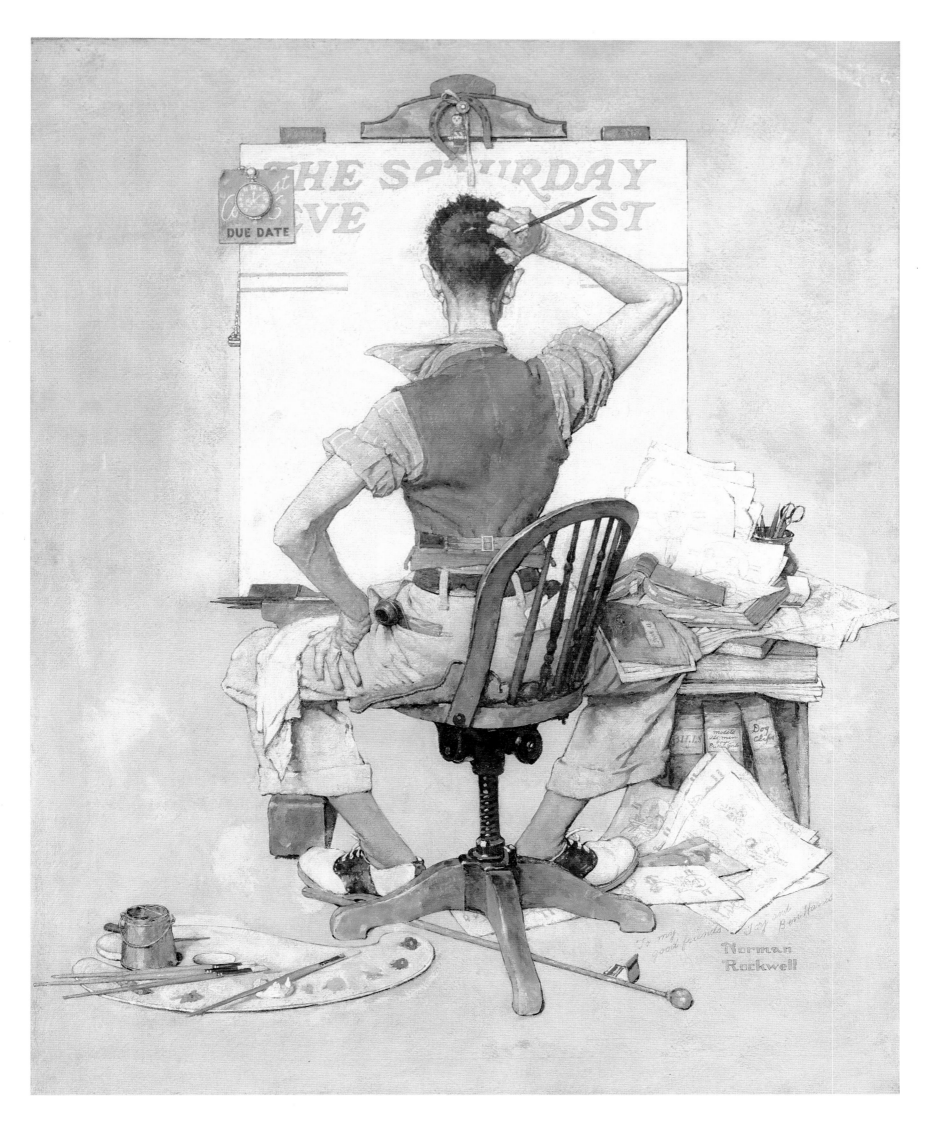

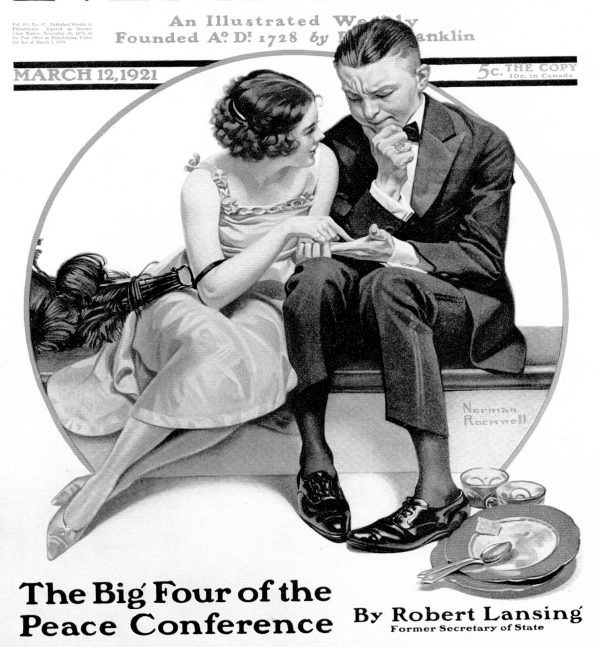

FORTUNE TELLER

Oil on canvas, first printed on the cover of The Saturday Evening Post, *March 12, 1921.*

The young woman, with her cropped hair, shapeless dress, and black ostrich-feather

fan, is as close as Rockwell ever came to chronicling the flapper look of the 1920s.

His female characters were more typically small-town women and girls, and many of

his scenes depict an apprehensive astonishment at the advancements of the jazz age.

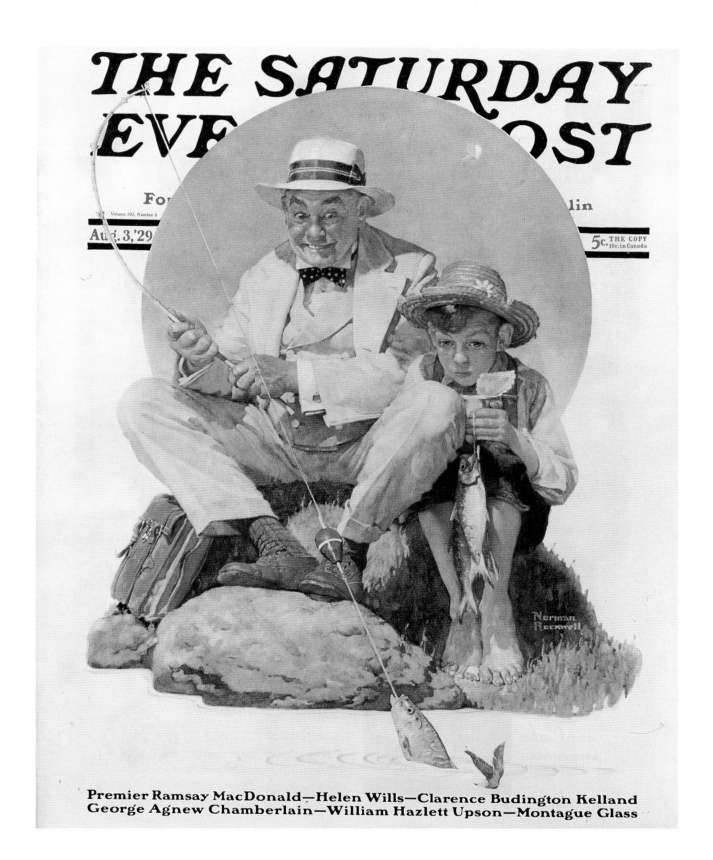

THE SATURDAY
EVE POST

Volume 202, Number 5
Aug. 3, '29

5c. THE COPY
10c. in Canada

Premier Ramsay MacDonald—Helen Wills—Clarence Budington Kelland
George Agnew Chamberlain—William Hazlett Upson—Montague Glass

SNAGGING THE BIG ONE

Oil on canvas, first printed on the cover of

The Saturday Evening Post, *August 3, 1929.*

Rockwell painted scenes not from his memory,

but from his nostalgic imagination. His world offered

a safe and comfortable existence for all generations.

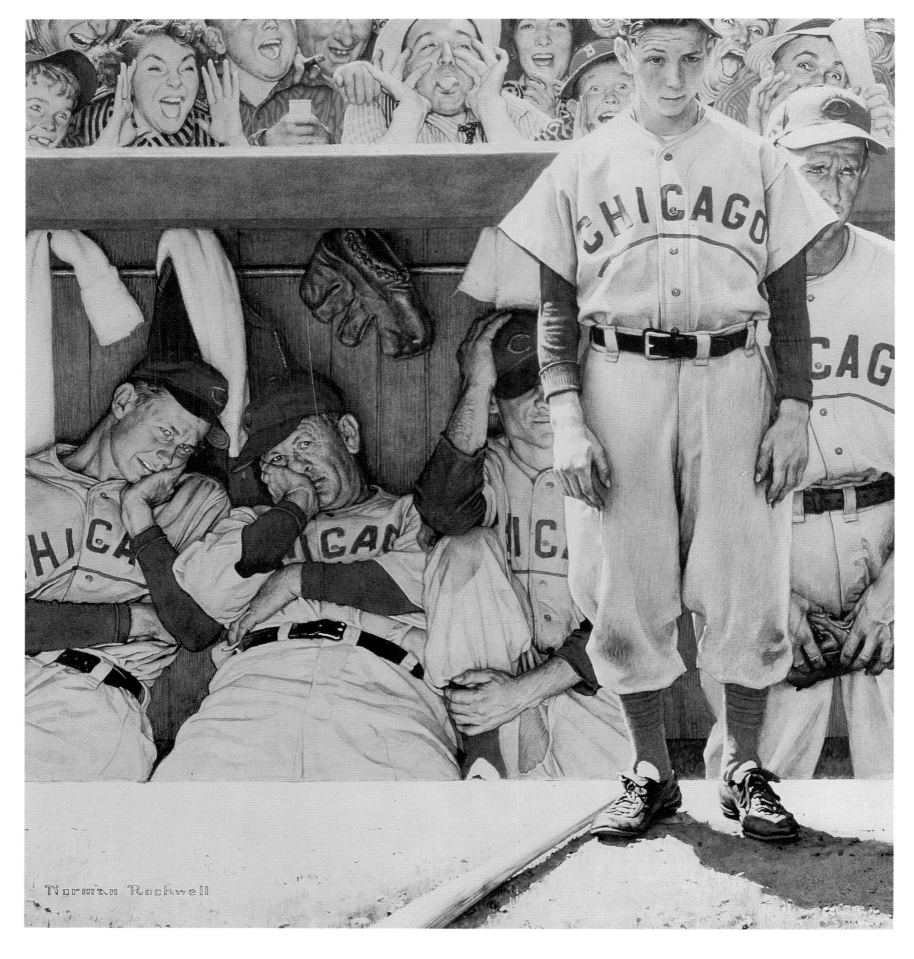

Norman Rockwell

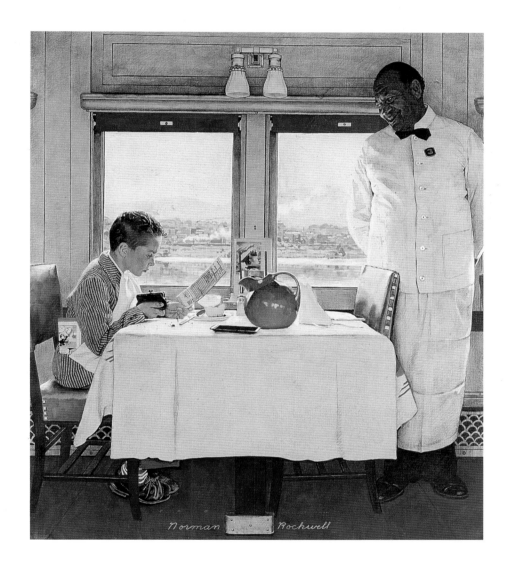

NEW YORK
CENTRAL DINER

Oil on canvas, first printed

on the cover of The Saturday

Evening Post, *December 12, 1946.*

Much like *Airplane Trip*,
the young boy in this
painting appears to be
on his first long journey
alone. Finished eating,
he is now dealing with
the very adult task of
figuring out the pay-
ment, while the sea-
soned waiter looks on.

THE DUGOUT

Oil on canvas, first printed on the cover of The Saturday Evening Post, *September 4, 1948.*

Rockwell's characters were rendered with painstaking detail, giving
each one a unique and believable personality. Here, the contrast
between the frightened young rookie, the seasoned veteran players in
the dugout below, and the jeering crowd creates a powerful effect, and
captures the still ongoing frustrations of the Chicago Cubs and their fans.

NORMAN ROCKWELL IN HIS STUDIO

Undated photograph.

Rockwell was a meticulous artist, and his paintings
typically went through several drafts. He was
known to become obsessive with his work, and
frequently called upon the opinions of his wife,
family, and friends to help him finish his scenes.

FREEDOM OF SPEECH

detail; oil on canvas, from The Four Freedoms *series; first printed
as an illustration in* The Saturday Evening Post, *February 20, 1943.*

Rockwell was inspired by a farmer he witnessed speaking up
against the majority at a New England town meeting.
His speaker is unrehearsed but assertive, and repre-
sents the voice of the people in this quietly elegant work.

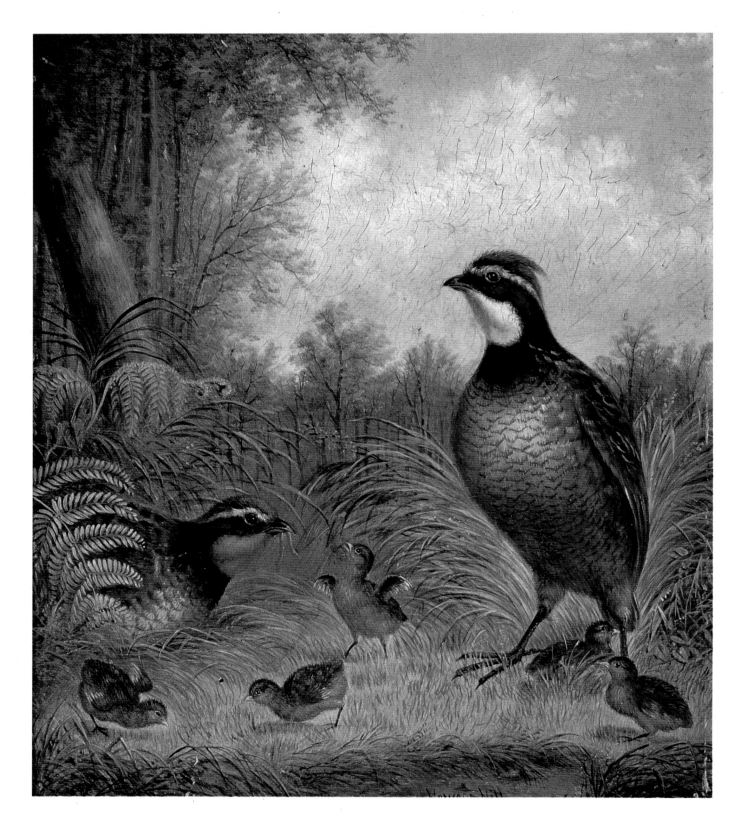

BIRDS

Oil painting by Howard Hill, Norman Rockwell's grandfather, undated.

Rockwell's maternal grandfather came to the United States

from England with dreams of becoming an artist. While he

was never financially successful, his work shows the meticulous

attention to detail, color, and form that Norman would master.

CHAPTER ONE

LAYING THE FOUNDATIONS FOR AN ILLUSTRIOUS CAREER

Norman Rockwell was an illustrator of tremendous ingenuity and energy. From his early beginnings as an artist until his death he turned out a breathtaking array of paintings, magazine covers, book illustrations, and advertisements. He was, by his own definition, an obsessive draftsman, who never took a vacation without a sketch pad and could not separate his work from his pleasure. What impelled him to such extraordinary challenges? What kept him at his art work through every crisis and every triumph of his life?

Family and Childhood

One gets the sense in reading Rockwell's autobiography that, from the start, illustration was for him a source of identity and a means of emotional survival. We first catch sight of him as a gawky pre-adolescent living in New York City—where he was born, in upper Manhattan, on February 3, 1894—drawing pictures of the Dickensian character Mr. Micawber, while his father read out loud to the family from *David Copperfield*. Norman's father was descended from a family whom he described as being "distinguished by their lack of distinction." "I really remember very little about my parents," Rockwell tells us in his autobiography. However, the details he does furnish us give us some idea of how he felt about his family. He was well aware that his background made him, as he says, "a queer mixture."

Rockwell's paternal grandmother was from a well-to-do family in Yonkers, New York, and his paternal grandfather was in the coal business. Rockwell's mother was the daughter of a poor artist who had come to the United States from England after the Civil War. When this artist's dreams of opening a portrait and landscape studio were smashed, he set his family

to work making "potboilers"—sentimental paintings of poetic subjects. These paintings were made using an assembly-line method, passed from family member to family member, each putting in a detail.

Rockwell's maternal grandfather also made paintings of animals for money, trudging from house to house and offering to paint the pet dog or favorite cow. These paintings were meticulously executed down to the last detail. However, none of this work brought in much money, and Rockwell's mother grew

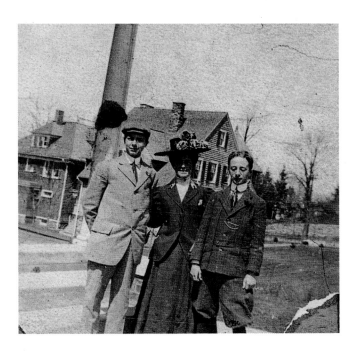

JARVIS, NANCY, AND NORMAN ROCKWELL

Photograph, c. 1910.

Rockwell's mother was very proud of her English heritage, and resentful of her lower-middle class status. She named her younger son after Sir Norman Percevel, a legendary British noble and a family ancestor, and reminded him constantly of his lineage.

23

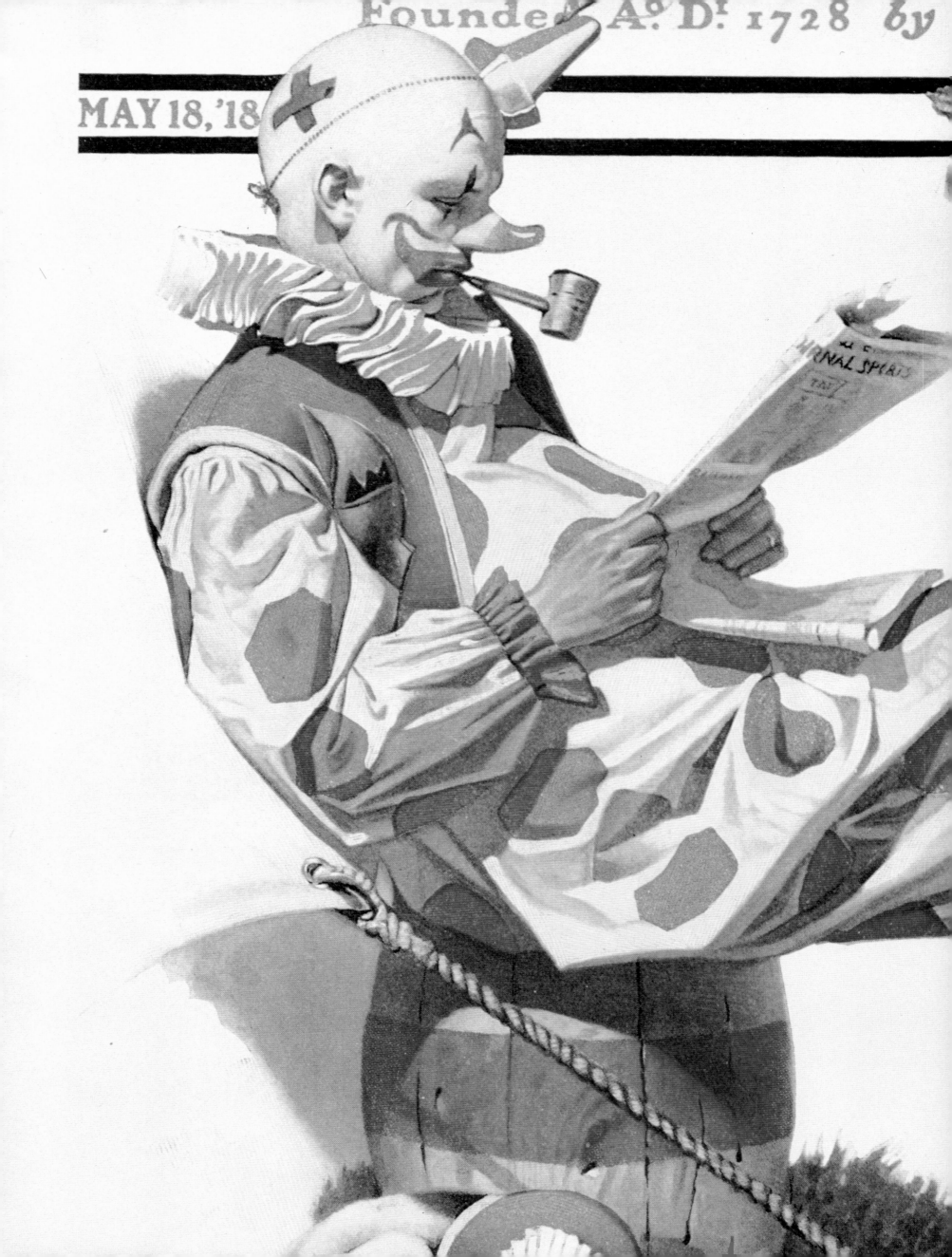

Franklin

5c. THE COPY

**MEETING THE
CLOWN**

*detail; oil on canvas, first
printed on the cover of
The Saturday Evening Post,
May 18, 1918.*

By taking the clown
out of his circus con-
text, Rockwell man-
ages to add both a new
kind of mystery, and
yet a vague familiarity,
to the character.

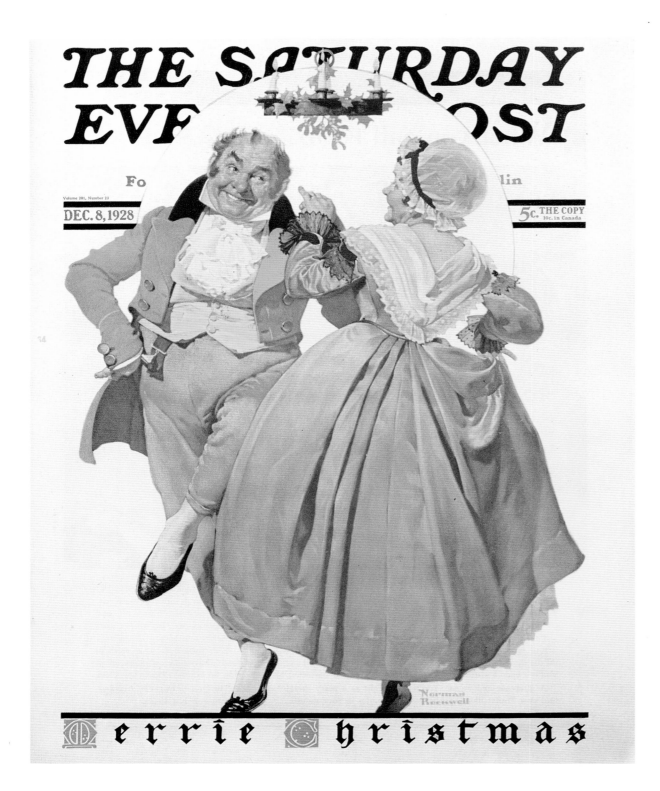

THE SATURDAY EVENING POST

DEC. 8, 1928

5c. THE COPY
10c. in Canada

Merrie Christmas

MERRIE CHRISTMAS

Oil on canvas, first printed on

the cover of The Saturday

Evening Post, *December 8, 1928.*

Rockwell's Christmas illustra-

tions were often infused with a

Dickensian spirit, such as this

image of a Victorian couple en-

gaged in a holiday dance. As

a child, Rockwell's father often

read from Dickens' novels,

while young Norman sketched

the scenes as he listened.

City, slowly rising from office boy to manager, worshipful of his boss and intensely loyal to the firm. Rockwell tells us that there was never a lack of food or decent clothes at home, but that the whole family had to labor under the constant necessity of penny-pinching. Unlike many of his boyhood friends, Norman never had pocket money. "I won't say I was obsessed with money, because I wasn't," he reports in his autobiography. "But I was painfully conscious of the differences—in manners, clothes, speech, position—which (or so I believed) money wrought." Meanwhile, the specter of the other side of the family and its impressive economic accomplishments loomed in Rockwell's young mind, despite the fact that his family had relatively little contact with these relatives.

Once or twice a year Rockwell and his family would make a visit to a certain relative on his father's side called Auntie Paddock, whose lifestyle and foibles impressed the young boy deeply. With an eye for form, color, and detail that would later serve him so well as a visual artist, he took in the handsome architecture and dazzling gardens of her home, as well as the rich glow of the mahogany panel which covered part of the walls in her parlor. Auntie Paddock's carefully done hair, silver-topped cane, and pince-nez also seemed to fascinate him.

Perhaps the most striking aspect of Auntie Paddock's lifestyle was also the most neurotic. A floor above the parlor was the bedroom of a son who had died. She kept the room looking as if the boy were about to return to it at any moment. Tin soldiers, a toy wagon, and a dump cart loaded with sand still lay on the floor. So lifelike was the setting that Rockwell said he felt as if "the wheels of the overturned toy wagon

up deeply resenting her father for her life of poverty and his odd ways, for he became a heavy drinker. As a result, she identified strongly with her mother's pedigree, which was that of a distinguished old English family. She communicated this preference for high British culture to her son by making her mother's maiden name—Percevel—Norman's middle name.

Rockwell's parents too lived with financial constraints through most of his childhood, which means that his mother never completely escaped the associations with poverty that she had so resented growing up. They lived mostly in lower-middle-class neighborhoods in the New York area. His father worked his entire life for a textile firm in New York

had just stopped spinning." The scene reminds us of a Rockwell painting with the figures missing because of the "frozen-in-time" details that economically convey an atmosphere—perhaps a whole life. This may have been the first time that Rockwell realized it was possible to capture a fleeting scene in all its shimmering realness, to use synthetic means to preserve and memorialize a precious moment in time.

Rockwell's father seems to have been a patient and caring family man. He was willing to reread—"in a colorless voice"—descriptions of Dickens characters as the young Norman tried to draw them, smudging them out and redrawing them over and over again until his picture matched the verbal description. However, there is so little in Rockwell's autobiography about his parents that one feels a sense of emotional absence, or at least a great deal of reserve, among all the members. Perhaps that is one reason why, at an early age, Rockwell seized upon the work of Charles Dickens as an escape. Sometimes, as he listened to Dickens being read, he was able to conjure up the streets of London and pretend that rude noises coming from the New York streets were really just a part of that fictional world. When someone called a mildly mentally disturbed uncle of his an "idiot" and said that he ought to be locked up, Rockwell transformed his distress about the statement into the idea that his uncle, of whom he was intensely fond, was just another version of Mr. Dick, the dotty but likable character in *David Copperfield*.

From the very beginning, boyhood adventure served as a conduit to the outside world for Rockwell. As many boys will, he and his friends turned the tensions, dangers, and hubbub of city life into a source of entertainment. They'd all gather on the sidewalk and wave their hats when a fire engine rushed by, its bells clanging out an alarm. They climbed telephone poles and chased stray dogs and cats. When one friend's drunken uncle dropped dead in the street, Rockwell's group relished a ride in the patrol wagon to identify the body. On the way they saw "cutthroats" and "painted women." Another juvenile thrill was going in a group to Amsterdam Avenue to peek under saloon

doors to see the feet of men standing at the bar. No one can claim that the tableau of urban life ever became Rockwell's primary material as an artist. However, most would agree that his work has a heightened energy, a dizzy immediacy, a high sensory output, and a lusty enjoyment of human foibles characteristic of urban living.

Despite all the vitality that Rockwell encountered as an urban child, certain traumatic experiences made him associate the city with the sordid and the unpleasant. He describes a littered and parched vacant lot of the type that can only be found in the city, which happened to contain a cursing, drunken woman in filthy rags who was hitting a man over the head with an umbrella. This was a memory he could not forget, and years afterward it became for him emblematic of the harshness of survival in the city. It stood in stark contrast to some idyllic summers

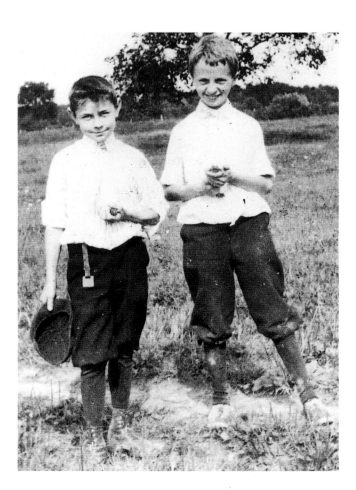

**NORMAN ROCKWELL
AND A FRIEND,
AS YOUNG BOYS.**

Photograph, c. 1905.
Rockwell, on the right,
grew up in the lower-
middle class neighborhoods
of Manhattan. Although
the city offered the kinds
of adventures young boys
often craved, Rockwell
longed for the simplicity
and peace of country life.

On the other hand, boyhood for Rockwell is also a time of competition and new challenges, peppered with moments of embarrassment or humiliation. This is most evident in illustrations showing all boys with no adults present, such as his famous very first *Saturday Evening Post* cover in May 1916, depicting a deeply humiliated boy dressed in a suit, wheeling a baby carriage past two mocking pals with baseball caps and mitts. Then there is the *Post* cover, from 1933, in which we see only the wriggling arms of a little boy who has misbehaved as he is held belly down over the lap of a frustrated mother, who also holds a book on child psychology and a punishing hairbrush.

True, Rockwell also portrayed typically idyllic pictures of boyhood from this same period, such as one showing a boy flying his kite while an older man smoking a pipe sits nearby; but such gentler images seem less likely to be remembered than a memorable *Post* cover for March 15, 1958, in which a small child stands perched on the edge of a chair with his pants lowered exposing his bottom while the doctor prepares his smarting injection. Amusing and genteel as all of these pictures of childhood are, they convey a sense of the fragility of being young. We may smile, but we also remember how excruciating those moments were for us—those times we felt that we didn't fit in, that we were being laughed at, or that we were novices when it came to a particular experience.

Rockwell himself tells us that he fully experienced both the joys and the traumas of boyhood. He had a group of peers who participated with him in the typical bonding activities of preadolescent boyhood— sports, pranks, and talk of adventure. He has fond memories of their times together, but he also admits: "When I got to be ten or eleven and began to be aware of myself and how I stood with the world, I didn't think much of myself."

HOME DUTY

Oil on canvas, first printed on the cover of
The Saturday Evening Post, *May 20, 1916.*
At the age of twenty-two, Rockwell's talent was considerable and a friend encouraged him to head to Philadelphia with a few ideas sketched out for *The Saturday Evening Post.* *Home Duty* was his first of over 300 covers for the magazine.

spent in boardinghouses on farms with his family. Well aware that he was idealizing the experience, Rockwell couldn't help insisting on the purity, simplicity, and peace of country life. This idealism of small-town America would, of course, dominate his work throughout his career, but it may not have been portrayed with so much intensity and joyousness if Rockwell had not experienced both the thrills and traumas of city life.

Rockwell's deep interest in the mythology of boyhood seems two-edged. On the one hand, boyhood served him as a source of nostalgia, a lighthearted way of examining social behavior, and an invocation of innocence. He is well known for heartwarming scenes of intergenerational cooperation, such as the 1951 *Saturday Evening Post* Thanksgiving cover depicting what seems to be a grandmother and grandson saying grace in a train station diner to the curious but respectful stares of the other passengers.

SAYING GRACE

Oil on canvas, first printed on the cover of The Saturday Evening Post, *November 24, 1951.*
Rockwell often juxtaposed small-town values with the hustle and bustle of a big city scene. Here, a visiting woman and her grandson take a moment for Grace before a meal at a city diner. Their prim clothing and composure create an interesting contrast with the cigarette-smoking coolness of the other diners, as well as the industrial landscape outside the window.

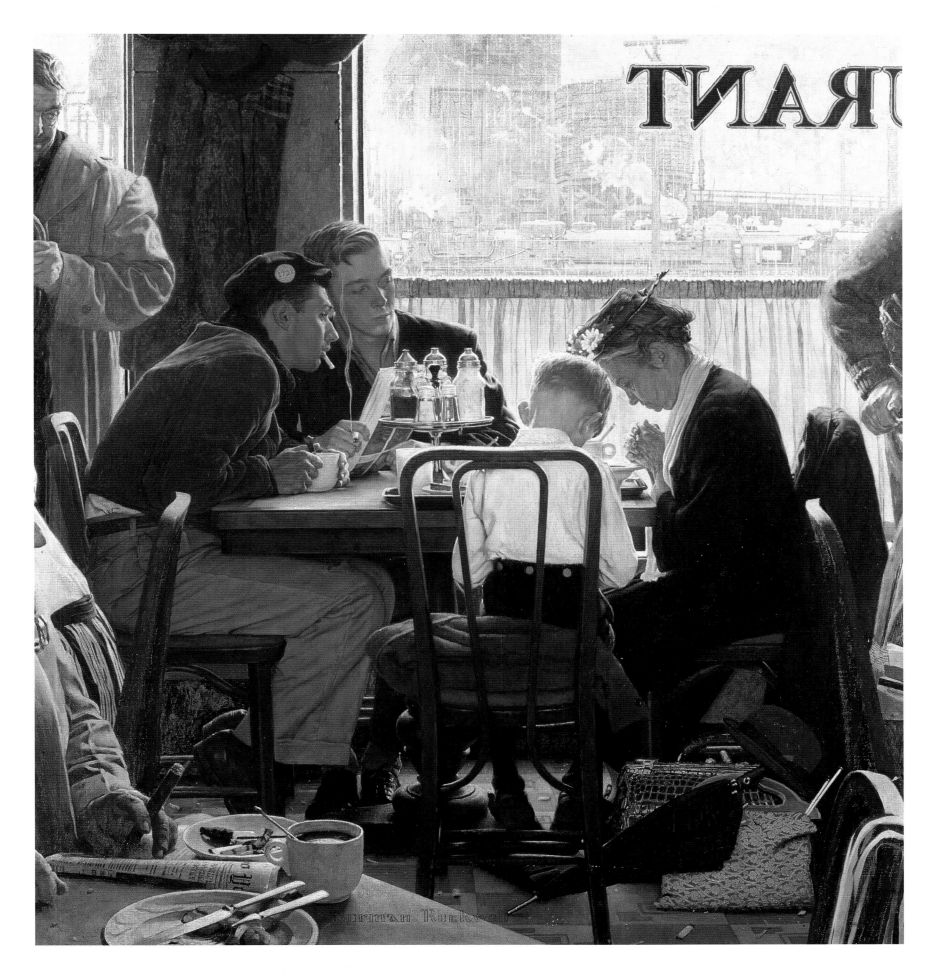

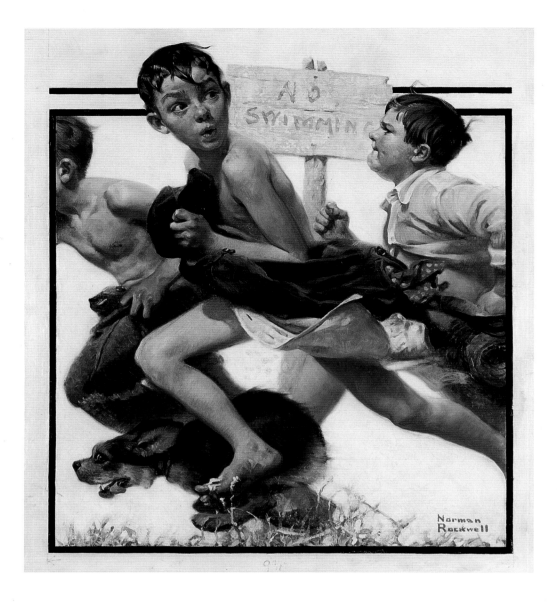

NO SWIMMING

Oil on canvas, first printed on the cover of
The Saturday Evening Post, June 4, 1921.
Throughout Rockwell's career,
young boys would be over-
represented. Rockwell's
youths were playful, mischie-
vous, and rowdy, but always
innocent. Scenes like this one
reflected young Norman's
fascination with country life.

Early Art Training

Rockwell's insecurity stemmed mostly from his phys-
icality. He describes himself as skinny and pale, with
a long neck (as adolescence approached he devel-
oped an overly large Adam's apple). He was pigeon-
toed and, because he wore round glasses, the other
kids called him Mooney. He wasn't particularly inter-
ested in athletics, but at the age of ten his sense of
physical inferiority impelled him into bouts of calis-
thenics before the bedroom mirror. He soon gave
them up, resigned to his narrow shoulders, soft arms,
and thin legs.

This doesn't mean that he overcame his insecurity
about his body and what it symbolized for him. In fact,
as he got older, he began refusing to use his high-
toned middle name, Percevel, because it made him
feel like a sissy. Matters were made worse by the fact
that his brother Jarvis, elder by a year and a half, was
the school's top athlete.

Rockwell's remedy for his sense of physical inferi-
ority was to concentrate all his energies on the thing
he did best. And almost as far back as he can remem-
ber, that thing was drawing. "All I had was the ability
to draw, which as far as I could see didn't count for
much. But because it was all I had, I began to make it
my whole life," he tells us in his autobiography. So
compelled was he by his need to draw that during his

first year in high school he spent four travel hours
every Saturday going from Mamaroneck, where the
family had moved, to New York City to study art at the
Chase School. The next year, at the age of sixteen, he
quit high school and began to study art full-time at the
National Academy.

The National Academy was a free school but
abysmally rooted in the past. Every student had to
begin study in the antique class. Rockwell spent
hours meticulously transcribing the forms of plaster
casts of Greek gods and athletes, yearning always for
live models, a sign of camaraderie from his teachers,
or a sense that art was exciting. But the National
Academy offered none of these benefits. Rockwell
had to content himself with the fact that he was re-
ceiving formal training in draftsmanship. It wasn't
until he transferred to the Art Students League a few
months later that he found an external parallel to
his own enthusiasm.

Rockwell entered the Art Students League a decade
after the start of the twentieth century, at a time
when many still thought of the illustrator as a his-
torian, journalist, and maker of classical images. In
just a few years, the chronicling of history and cur-
rent events would virtually be taken over by the art
of photography. Classical imagery would lose the cul-
tural power it had enjoyed through the nineteenth
century. Revered old-style illustrators like Frederic
Remington and Edwin Austin Abbey would soon be
dead and buried.

At the same time, a new age of media was dawning.
The illustrator would soon find enormous opportuni-
ties in advertising, as well as a new role in making
books and magazines more appealing and intriguing
to the reader. The decorative and the attention-
getting would be emphasized. Meanwhile, high art
was undergoing the Modernist revolution. This could
potentially make it accessible only to an intellectual
elite. At such a crucial juncture in Western culture,
Rockwell could have pursued his calling in any of a
number of directions.

In many ways, Rockwell had already developed a
sensibility that could not be altered by the cultural
climate he encountered at the Art Students League.
A surviving painting from 1912, when he was just
sixteen, shows elements of this style. It portrays a
large brick hearth in a wooden-raftered house with a

generous kettle simmering on a log fire. Rockwell was, and remained, interested in what he called his Dickensian outlook. Like Dickens, he wanted to portray scenes of everyday life that could be understood by almost any audience. His paintings had to be figurative and have narrative; for, like Dickens, Rockwell wanted above all to tell a story.

Rockwell ignored or perhaps was not aware of the many Dickens stories that were laced with biting and even radical social criticism; his own generally were not so styled. Yet when Rockwell entered the Art Students League, he entered as a budding artist eager to learn the tried-and-true basics of life drawing in order to ably cast the characters he made into popular narrative situations. Based on this predilection he chose the academic drawing teacher George Bridgeman and the illustration teacher Thomas Fogarty over the radical Modernist Kenneth Hayes Miller.

Bridgeman was one of the most revered teachers of the prestigious Art Students League, which had already produced such celebrated painters and illustrators as Winslow Homer and Charles Dana Gibson. He was a down-to-earth man whose most oft-quoted remark was "You can't paint a house until it's built." For him, an image on the canvas was made of the same thing that its model was made of in life: bones, muscles, and skin. It didn't matter that all of these elements were not directly visible. He made students work laboriously from the "ground up," reproducing the anatomical structures of the body so precisely that they could combine them into lifelike, action figures. In Bridgeman, Rockwell found the camaraderie that he'd been hoping for in his previous schooling. Bridgeman would stroll up to a drawing that Rockwell had been working on all week, take his place at the easel, and burst out with an appraisal, sometimes drawing a heavy charcoal line right through the drawing to illustrate the axis of action.

The other important influence on Rockwell at this time was Thomas Fogarty, the League's illustration teacher. From him Rockwell learned something about conveying an entirety of anecdote in a single picture. Fogarty insisted that his students undergo a kind of "method acting" approach to the subjects they were painting. He made them study the behavior, background, and environment of the characters in the illustrations they did, as well as the plot details of the

stories or accounts they were dealing with. As a result, Rockwell began to focus even more strongly on characterization, atmosphere, and mood.

Rockwell flourished at the Art Students League. Here, for the first time, the only thing expected of him was that thing he had always done best. He had taken a solemn oath to achieve the highest standards of illustration, and he was aware that really excelling in his craft would require a nearly superhuman effort. Certainly he also carried within him the specter of his maternal grandfather's failure as an artist and the two generations of financial deprivation his mother had had to endure. Rockwell's constant seriousness and application earned him the nickname of The Deacon.

Interestingly, Rockwell's self-image as a gawky outsider and his familiarity with sordid urban experiences never led to his taking on bohemian airs. He was surrounded by many students who flouted the unconventional personal styles one associates with such types, but he merely told himself that he had little tolerance for poseurs and ignored their presence, losing himself instead in his chosen lifestyle of monkish toil.

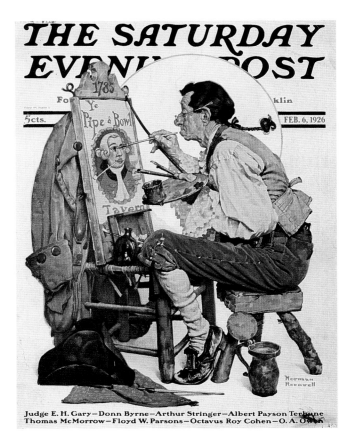

COLONIAL SIGN PAINTER

Oil on canvas, first printed on the cover of The Saturday Evening Post, *February 6, 1926.*
Rockwell began drawing scenes from the stories of Charles Dickens as a young boy, and throughout his career as an artist he painted scenes from other places and time periods, including not only Dickens's nineteenth-century England, but also Colonial America.

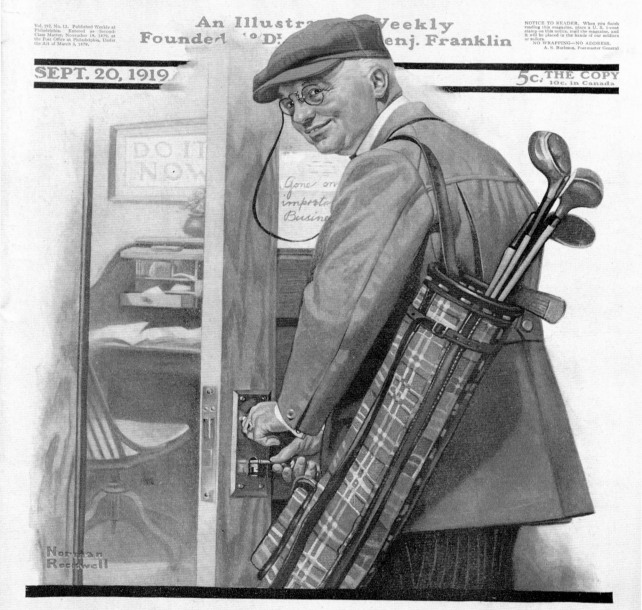

GONE ON IMPORTANT BUSINESS

Oil on canvas, first printed on the cover of

The Saturday Evening Post, *September 20, 1919.*

Rockwell at times was known to procrastinate, and this

canvas may be a gentle nod to his own minor shortcomings.

Note the "Do it now" sign above the roll top desk.

GRAMMERCY PARK

Original oil painting, 1918.

Rockwell's quiet country scenes were his trademark, although he also had a flair for capturing the more genteel side of urban life, such as this Manhattan park scene.

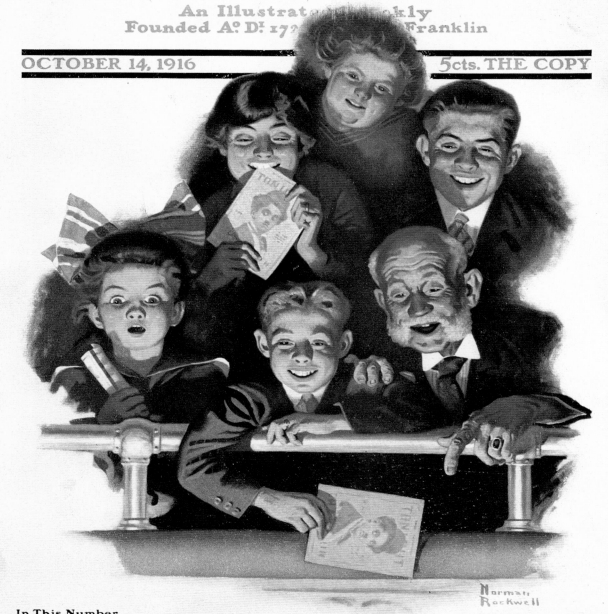

THE SATURDAY
EVENING POST

An Illustrated Weekly
Founded A.º D.ʳ 172... ...Franklin

OCTOBER 14, 1916 5cts. THE COPY

In This Number

THE BATTLE HEN OF THE REPUBLIC—By Irvin S. Cobb. THE WATER CURE—By Ring W. Lardner

FAMILY NIGHT OUT

Oil on canvas, first printed on the cover of

The Saturday Evening Post, *October 14, 1916.*

Here, Rockwell captures a family

out to see the latest film from

silent film star Charlie Chaplin.

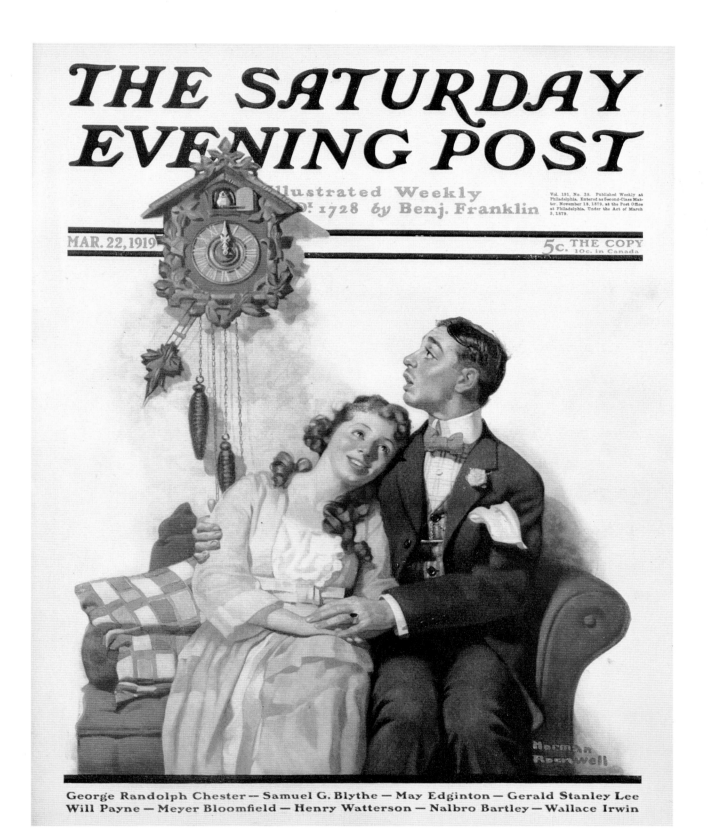

COURTING COUPLE AT MIDNIGHT

Oil on canvas, first printed on the cover of The Saturday Evening Post, *March 22, 1919.*

At the Art Students League, Rockwell studied under illustration instructor Thomas Fogarty, who emphasized the concept of telling an entire story in one picture. This tender Victorian scene exemplifies Rockwell's masterful storytelling—this young couple's date has gone past curfew.

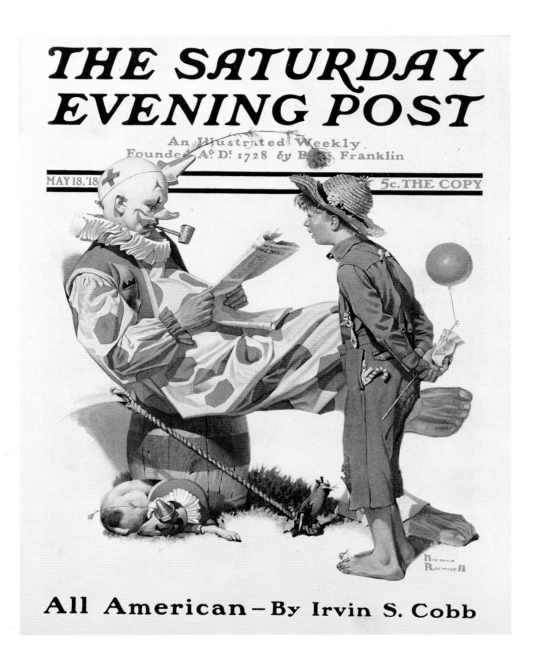

MEETING THE CLOWN

Oil on canvas, first printed on the cover of The Saturday Evening Post, May 18, 1918. Rockwell's greatest talent was his ability to capture a moment in time, and preserve its magic forever. Here, he chronicles the moment when the boy crosses the line between his own fantasy world and the clown's reality.

MAN TRYING ON SANTA BEARD AT COSTUME SHOP

Oil on canvas, first printed on the cover of The Saturday Evening Post, December 9, 1916. Rockwell often captured the magic in seemingly mundane moments. Here, he appears to acknowledge Santa as both a myth and a reality in the same breath.

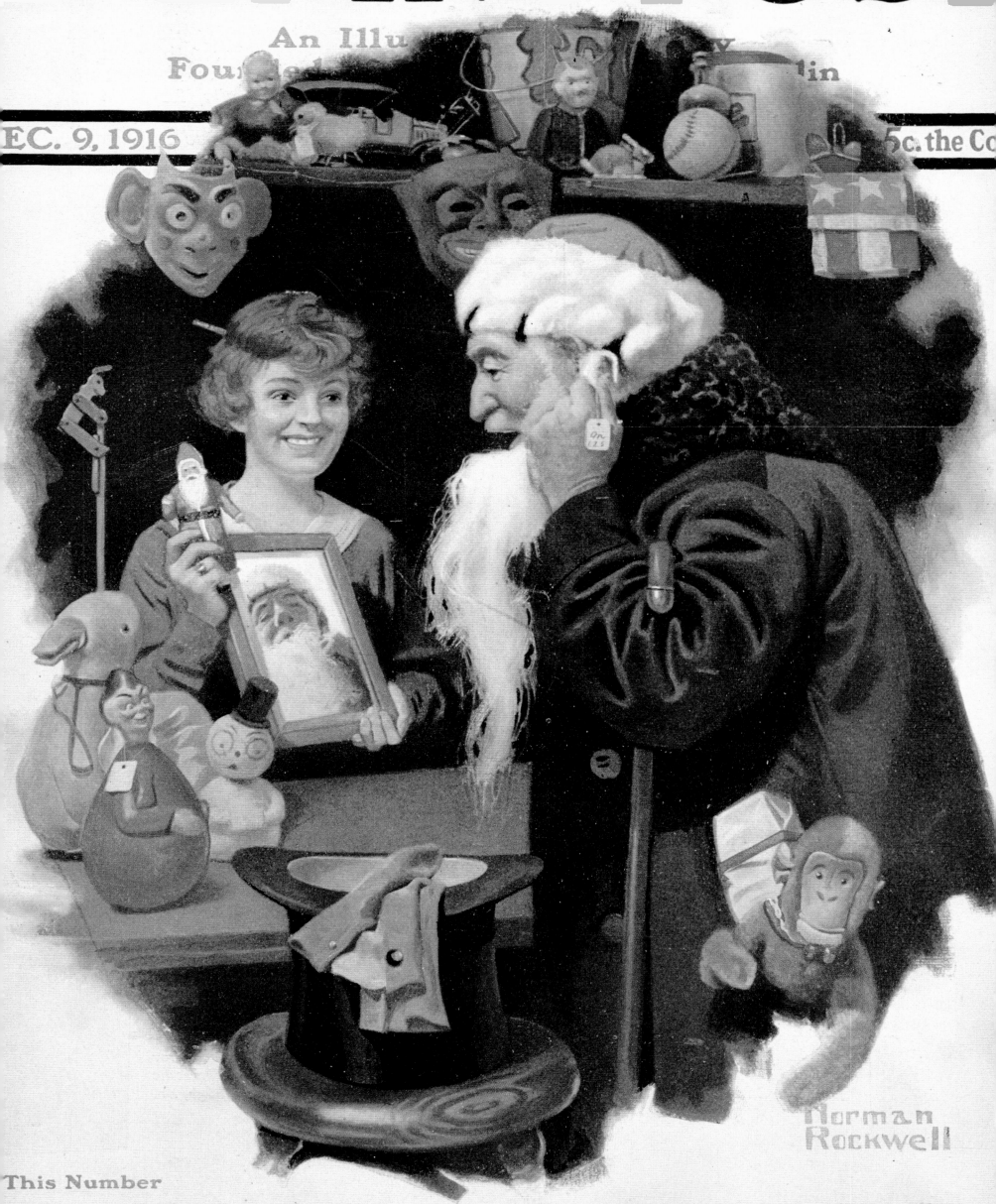

An Illu
Fou

EC. 9, 1916

5c. the Co

Norman
Rockwell

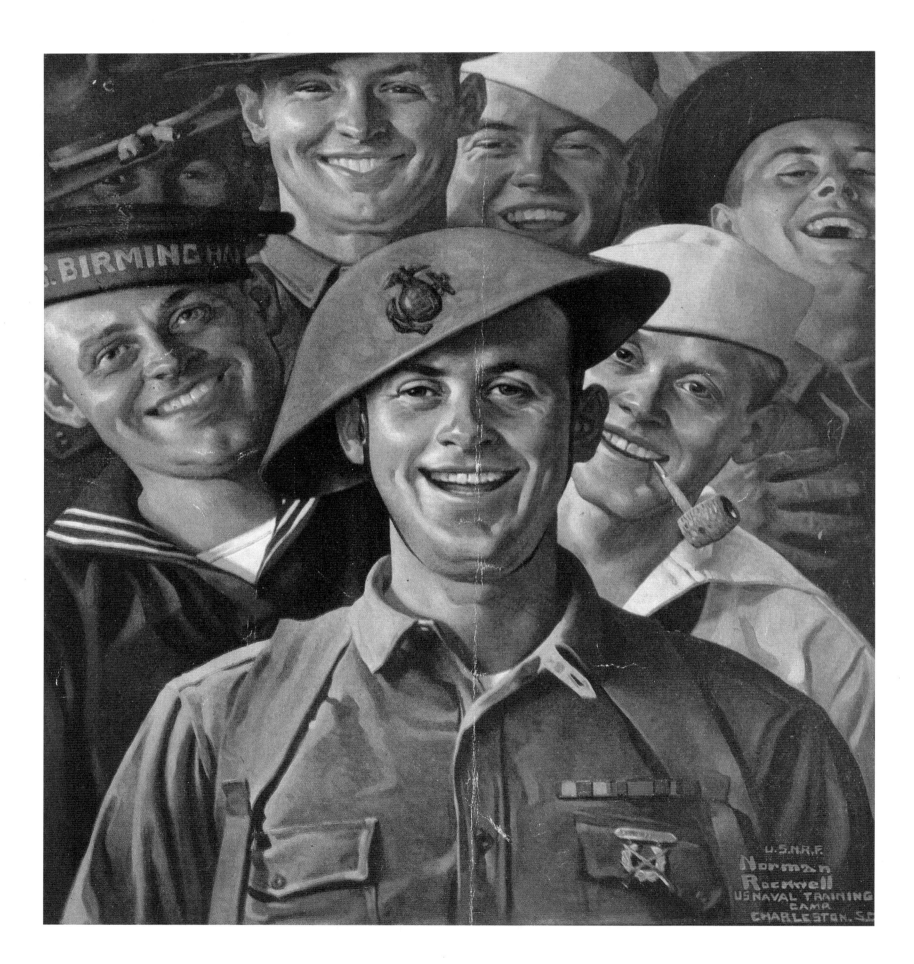

ARE WE DOWNHEARTED?

Oil on canvas, first printed on the cover of Life *magazine, November 28, 1918.*

During World War I, the rhetorical question "Are we downhearted?"
was to be answered with a resounding "No!" Here, it is answered
with resounding smiles. Painted while Rockwell was in the Navy,
this *Life* magazine cover celebrated the end of the war.

WORLD WAR I AND THE ROARING TWENTIES

Rockwell's reward for his extraordinary dedication to his work was the development of a sure-fire approach to painting. It matured over several decades but its foundations were laid during his student days.

The Rockwell Method

Rockwell began in every case with the sketch of an idea, keeping in mind the basic structural demands it would require. Then, once he had approved and developed the idea in his mind, he set about with the goal of portraying it just as Fogarty would have counseled him to do. He found his models, researched his costumes, developed a background, and located props. Next, he made individual sketches of the parts of his drawing, refining the details (in later years he would resort to photography for this stage). The last two stages usually consisted of sketching in and combining everything he had discovered into a final color painting.

Writing about Rockwell's techniques in *Norman Rockwell: A Sixty Year Retrospective*, Thomas S. Buechner, a director of the Brooklyn Museum who was one of Rockwell's greatest admirers, described these steps, also pointing out that they might vary somewhat but that the important thing about the method was an ironclad separation between the drawing and the painting. In the drawing, Rockwell incorporated the skeletal and structural foundations that Bridgeman had drummed into all his students. Then he filled in with color and texture.

Rockwell's style was down-to-earth, rich in figurative images, generous in gesture and characterization. It drew the viewer in. But such a style didn't immediately guarantee effortless entry into the plush offices of the country's top magazine editors. His climb to prominence was fast but rigorous. Throughout his schooling he found eccentric little illustration jobs to keep him fed and clothed, and soon enough he got his first professional assignment for a children's book called *Tell Me Why Stories*. Rockwell was only seventeen

at the time. The $150 he earned from the job was enough to put money down on his first studio; but the location didn't work out for long, for it turned out to be the garret of a building being run as a brothel. Finally, Rockwell and a group of other fledgling artists moved into a studio next to the Brooklyn Bridge.

By the age of nineteen, Rockwell had become the art director of *Boys' Life*, a position that may sound more lofty than it actually was; he earned only fifty dollars a month. In addition to being art director, he had to do a cover and a set of illustrations for each issue. Meanwhile, he was taking other illustration work. His themes tended to center around boyhood, out of which he himself had barely issued. He illustrated several stories by the well-known children's writer Ralph Henry Barbour—boating stories, baseball stories, and imitation Horatio Alger rags-to-riches stories. Illustrations for a Barbour story called "The Magic Football" succeed in evoking a mystical and folkloric atmosphere, replete with elfin faces and mysterious lighting.

TWO BOYS WITH SLED

Washdrawing, illustration for Boy's Life, 1912.

Rockwell's first full-time job was as the art director
at *Boy's Life* magazine. He was responsible for
a cover and two interior illustrations each month,
for which he was paid the sum of seventy-five dollars.

A PATIENT FRIEND

detail; oil on canvas,
first printed on the cover of
The Saturday Evening Post,
June 10, 1922.
Rockwell's nostalgic
boyhood scenes re-
minded adults of days
gone by, and suited
The Saturday Evening
Post just as well as
they did *Boy's Life*.

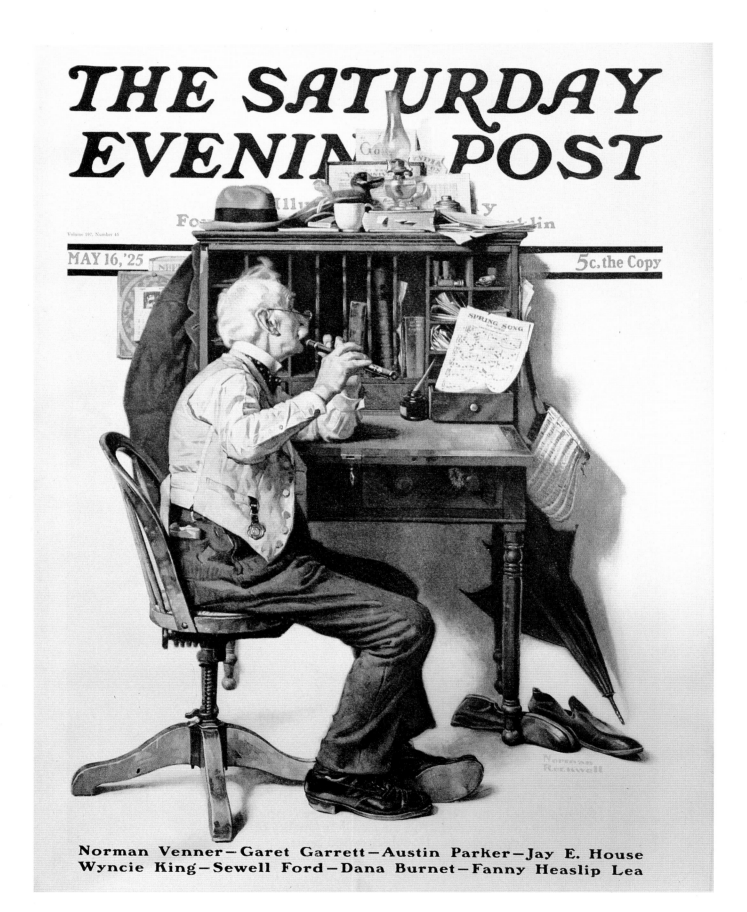

SPRING SONG

*Oil on canvas, first printed
on the cover of* The Saturday
Evening Post, *May 16, 1925.*
During the 1920s, Rock-
well's sketches began to
focus less on childhood,
and more on adults, from
teenagers to old men.

The *Post*

The story of Rockwell's first encounter with the edi-
torial offices of *The Saturday Evening Post* has been
told several times by Rockwell and others. Perhaps
the most lively version is in the book *Norman Rock-
well: Illustrator* by Arthur L. Guptill.

Rockwell is twenty-one when the story takes place.

He has moved into a studio in New Rochelle, just north
of New York City, and is still living on his fifty dollars a
month from *Boys' Life*. The young man who shared his
studio, Clyde Forsythe, was a successful cartoonist
who was already very familiar with the mentality of the
newspaper media. He kept insisting that Rockwell
needed to try to sell an illustration to the *Post*.

Intimidated though he was, Rockwell summoned his resolve. He determinedly eked out a few sketches that he thought might be sophisticated enough for such an adult publication. They were way off the mark and, under the constant urging of Forsythe, he went back to the subject with which he felt most at home: boyhood. Rockwell had a harness maker construct a gigantic black wooden case for his sketches and then he dragged it into a train headed for Philadelphia, where the offices of the *Post* were located. Upon arrival at the *Post*, Rockwell had to endure the embarrassment of being asked by writer Irvin S. Cobb if the box he was carrying were a child's coffin. But this incident was eclipsed by the results of his visit. The *Post* accepted three of his cover ideas immediately.

The first Norman Rockwell *Saturday Evening Post* cover appeared on the May 20, 1916, issue. At the time, it represented a supreme achievement for an American illustrator. It led to other offers, including covers for *Collier's, Country Gentleman, Life*, and *Popular Science*. It also led to forty-eight years of painting covers for the *Post*. And just as important for Rockwell, this cover was the beginning of a remarkable and fruitful collaboration with the imposing George Horace Lorimer.

Lorimer had built the *Post* up from nothing. He remained its mainstay form 1899 to 1936, which were its golden years. By the time Rockwell encountered him, he was already an icon in magazine publishing. Rockwell seemed to experience him as dictatorial but understanding—a compelling father figure. Lorimer was immensely possessive in a way that made Rockwell feel wanted and appreciated. At the beginning, he was not above testing Rockwell by rejecting details of a cover and making him start all over again, just to see how loyal he was. Their rapport was based partly on the felicitous ability of Rockwell to communicate his ideas to Lorimer. All such ideas were compressed dramatic scenarios—amusing anecdotes squeezed onto one page.

In his autobiography, Rockwell informs us that he would usually come to Lorimer with five ideas. He'd lay the sketches on Lorimer's desk and then begin filling in a narrative, describing the situation, characters, and past history which the story would encompass. The process was similar to today's "story pitching" in Hollywood, when a screenwriter tries to

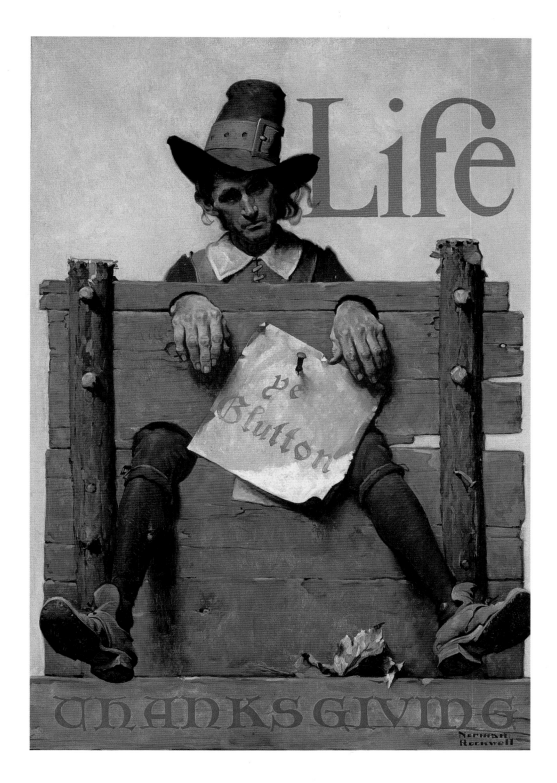

sell a script idea to a producer by telling a story in a compelling manner. Over the years, the relationship between Rockwell and Lorimer became more intimate, especially after *Liberty* magazine tried to woo Rockwell away from the *Post* and failed. However, the two men maintained strong, probably healthy boundaries with each other; Rockwell rarely saw Lorimer outside of his office.

THANKSGIVING

Oil on canvas, first printed on the cover
of Life *magazine, November 22, 1923.*
Rockwell's success with the
Post led to commissions from
other popular publications
of the day, including *Life.*

THE SATURDAY EVENING POST

An Illustrated Weekly
Founded A° D I Benj. Franklin

Vol. 191. No. 34. Published Weekly at Philadelphia. Entered as Second-Class Matter, November 18, 1879, at the Post Office at Philadelphia, Under the Act of March 3, 1879.

FEBRUARY 22, 1919

5c. THE COPY
10c. in Canada

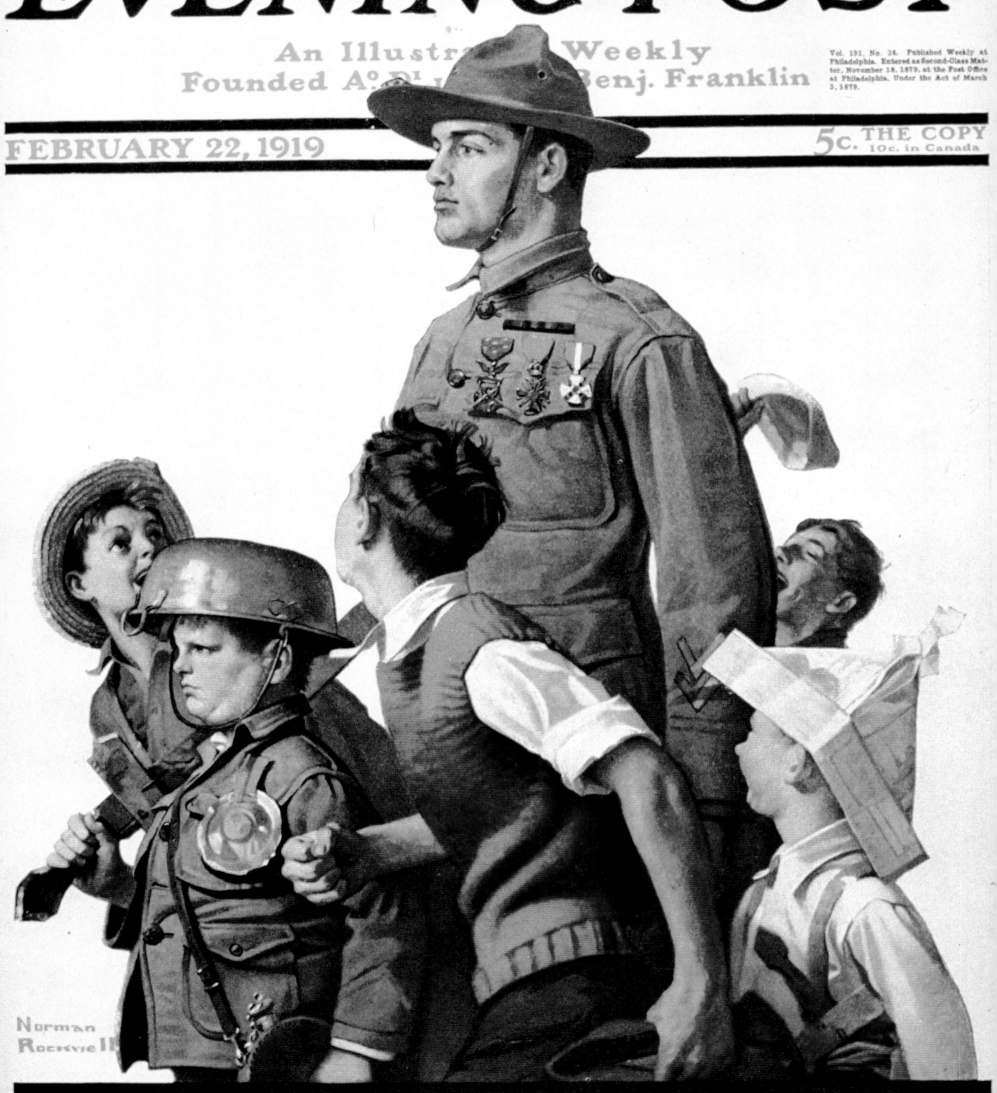

Norman
Rockwell

So This is Germany—By George Pattullo

Art and Life During and After Wartime

Rockwell's life during World War I is a story that feels like an interruption in a glorious continuum. He signed up for the navy because of the dictates of his conscience at a time when he had already established himself as an illustrator. As it turned out, his stint in the navy consisted mostly of doing portraits of officers at the camp in Charleston and raising morale by dashing off illustrations for the camp newspaper, *Afloat and Ashore*. While at camp Rockwell also painted a *Post* cover of two sailors, and a *Life* portrait of a grinning, mixed group of sailors, soldiers, and marines.

According to Thomas S. Buechner, Rockwell's subject matter changed as America entered the

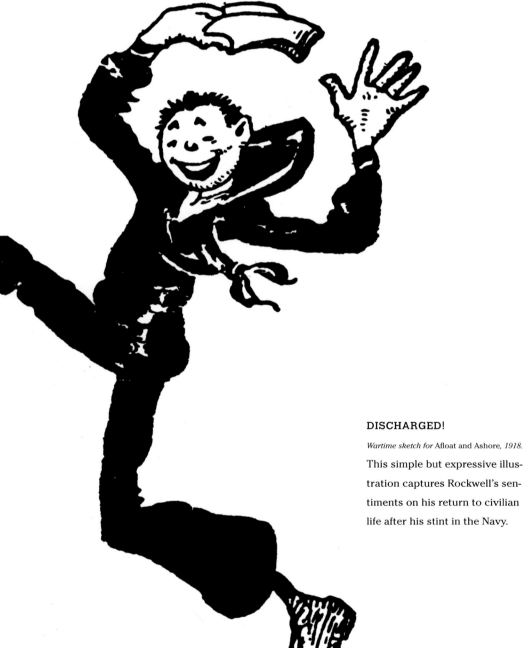

fast-paced and sophisticated 1920s. From 1916 to 1919, 90 percent of his *Post* covers included children. From 1920 to 1929, only 50 percent of them did so. Buechner feels that during the twenties, Rockwell became less interested in portraying a boy's point of view than in portraying the point of view of a man thinking *back* on his boyhood.

Early paintings were rooted firmly in the experience of the child. There is the very amusing June 3, 1916, *Post* cover which shows one boy pretending to be a circus barker while another with padding under his shirt pretends to be the circus strongman. It tells an anecdote that a child could have himself recounted.

DISCHARGED!

Wartime sketch for Afloat and Ashore, *1918.*
This simple but expressive illustration captures Rockwell's sentiments on his return to civilian life after his stint in the Navy.

SOLDIER WITH CHILDREN PLAYING

Oil on canvas, first printed on the cover of The Saturday Evening Post, *February 22, 1919.*

The boys "over there" inspired the children back home, and they in turn inspired Rockwell.

CRACKERS IN BED

Original oil painting for

Edison Mazda Lampworks, 1921.

It didn't take long for

advertisers to realize

that the warm feelings

evoked by Rockwell's

paintings could be trans-

ferred to their products.

GILDING THE EAGLE

Oil on canvas, first printed

on the cover of The Saturday

Evening Post, *May 26, 1928.*

Rockwell had a flair

for putting his everyday

characters in fairly spec-

tacular situations and

making them appear

somewhat bored, and the

results were charming.

Such quiet, folksy mes-

sages of patriotism were

Rockwell's trademark.

("You wouldn't believe the circus we put on all by ourselves today!") Likewise, Rockwell's very first *Post* cover showing the disgruntled boy with the baby carriage is a tale that could have issued from a child's conversation.

But on the *Post* cover of August 3, 1929, called *Catching the Big One,* the focus seems to be more on the late-middle-aged man, with his childish delight in catching a fish, than it does on the boy beside him. And the *Post* cover of May 26, 1928, called *Gilding the Eagle,* portrays an old man in a situation we usually associate with youth: He is hanging from the top of a flagpole like a monkey; he is there because he is painting the eagle at the top of it gold, scrutinizing his work with a weary gaze over a corncob pipe.

During the 1920s Rockwell moved somewhat away from realistic or atmospheric backgrounds, keeping them off his *Post* covers and confining them mostly to cover paintings for the *Literary Digest* or to advertisements for the Edison Mazda Company. For the *Post* covers, he often silhouetted his characters against simple geometric shapes in the deco style. Such an approach tended to undercut any serious claim of portraying absolute reality: It removed the images from the world and turned them into nostalgic icons.

Springtime, Rockwell's cover for the April 16, 1927, edition of the *Post*, is an excellent example of this type of iconization. Its theme is fanciful and imaginary. A barefoot country boy plays a piccolo, while a circle of animals on their hind legs dance around him. If Rockwell had tried to fill in the background with realistic foliage or architecture, or even if he had left the background blank, the idea would have seemed banal. But the single sky-colored circle behind the boy with the word "SPRINGTIME" emblazoned across it turns the painting into a charming curio, moves it to the generalized realm of fond memories and sentiments, and marks it as something meant to be decorative.

The geometric background shapes Rockwell used during this period isolate and focus his work, forbidding us to look beyond the quaint fantasy of the image. However, at times he impishly places an object outside that focus, like a piece of real life spilling out of a frame. The detail startles us and produces an ambivalence about what is intended to be a charming fantasy and what is intended as documentary. Accordingly, in the March 28, 1931, *Post* cover our eyes are drawn to the profiles of two runners against a circle of black, one a grim fireman with an ax intent on putting out a fire and, neck and neck with him, an exuberant boy. It's not until a minisecond later that we tend to notice the galloping dog at the bottom of the page, outside the realm of the black circle framework, his tongue protruding from a determined-looking snout. The same kind of device appears in other covers, as newspapers or books dropped from characters' hands.

In Rockwell one suspects a certain anxiety about the changing values and lifestyles during the 1920s.

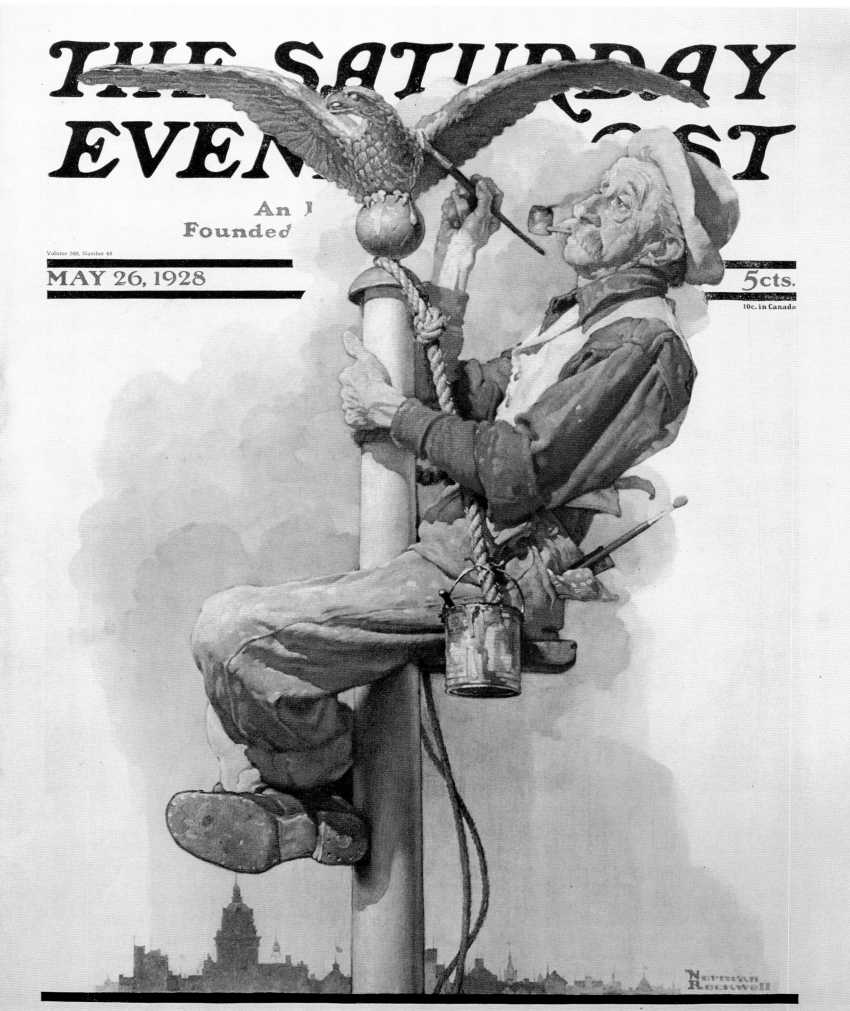

THE SATURDAY EVENING POST

An I
Founded

Volume 200, Number 48

MAY 26, 1928

5cts.

10c. in Canada

George Agnew Chamberlain—Commander Richard E. Byrd—Margaret Weymouth Jackson
Will Rogers—Dorothy Black—Booth Jameson—Samuel G. Blythe—Richard Washburn Child

FIRST OF THE MONTH

New York FUNK & WAGNALLS COMPANY *London*

PUBLIC OPINION *New York* combined with *The* LITERARY DIGEST

Vol. 68, No. 9. Whole No. 1610

FEBRUARY 26, 1921

Price 10 Cent

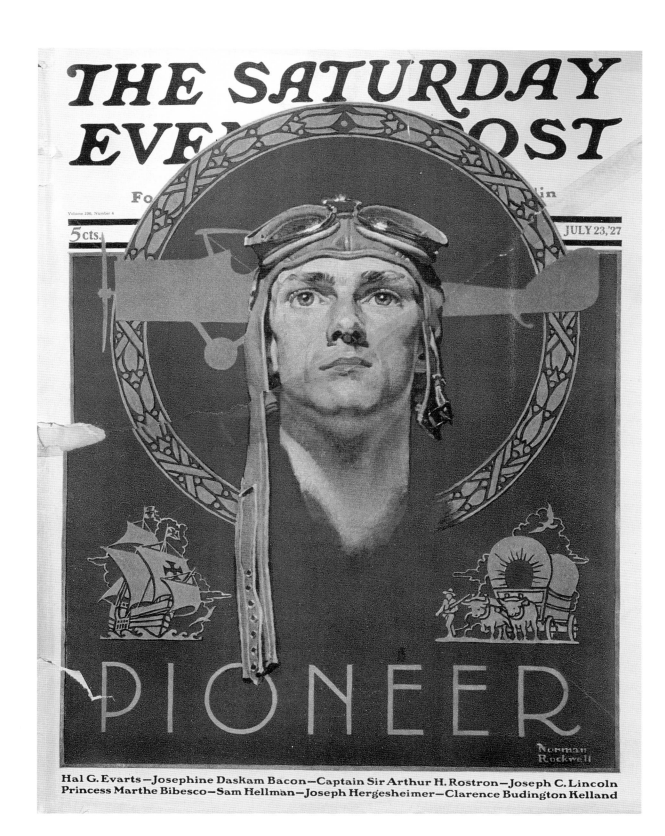

THE SATURDAY EVENING POST

Volume 200, Number 4

5 cts.

JULY 23, '27

PIONEER

Norman Rockwell

Hal G. Evarts—Josephine Daskam Bacon—Captain Sir Arthur H. Rostron—Joseph C. Lincoln
Princess Marthe Bibesco—Sam Hellman—Joseph Hergesheimer—Clarence Budington Kelland

**CHARLES LINDBERGH,
PIONEER**

Oil on canvas, first printed on the cover of
The Saturday Evening Post, *July 23, 1927.*
Although he is rarely associated with the movement, the
Art Deco style clearly had an
influence on Rockwell. Here,
the use of geometric shapes
and the type treatment reflect
the popular Deco style of the
jazz age. Lindbergh was one of
the first American heroes to be
painted by Rockwell; forty-two
years later, he would immortalize the astronauts of Apollo 11.

PAYING THE BILLS

Oil on canvas, first printed on the cover of The Literary Digest, *February 26, 1921.*

Rockwell came of age as an illustrator at precisely the right time,
just as magazines were able to run full-color images, and as old-style
fine art gave way to photography as the preferred means of illustration.

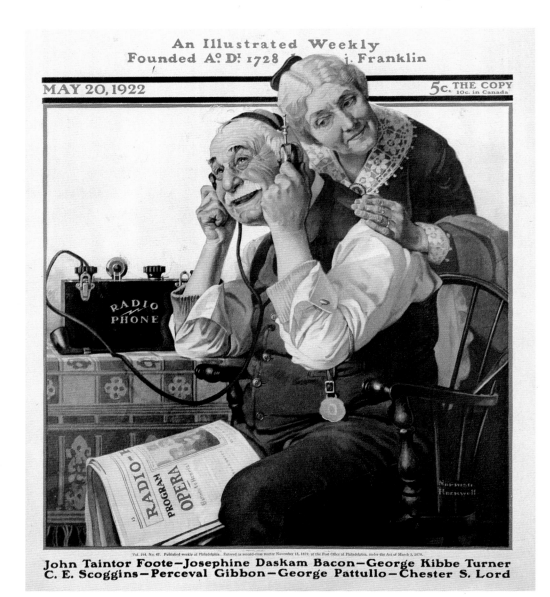

An Illustrated Weekly
Founded A.º D.¹ 1728 ... j. Franklin

MAY 20, 1922

5c. THE COPY
10c. in Canada

RADIO
PHONE

RADIO
PROGRAM
OPERA

John Taintor Foote—Josephine Daskam Bacon—George Kibbe Turner
C. E. Scoggins—Perceval Gibbon—George Pattullo—Chester S. Lord

LISTEN, MA!

*Oil on canvas, first printed on
the cover of* The Saturday
Evening Post *May 20, 1922.*
Technology moved fast
in the 1920s, and Rock-
well's art offered an intro-
duction for those who
were curious but perhaps
not quite ready for it.

He came from a deeply traditional background. His parents were religious, and their lifestyle aspired to the proper sentiments of the Victorian drawing room. Strategies for protecting children, as well as the cloistered parlor and the isolated nuclear family, were notions first encountered during the Victorian era. They led to the belief that the sanctity of the family and all of its traditions were inviolable. But following the trauma of World War I, the 1920s brought conflict and change to the very same drawing room. Women liberated themselves from the corset and moved into the work force. Class divisions were shaken. Art pushed at the boundaries of the intelligible. Technology brought information even to provincial people at a faster and faster pace. Psychoanalysis began to question the motives of love, sex, and other interpersonal relationships.

In response, as has been said, Rockwell iconized his nostalgia. But he also poked gentle fun at it, allowing the viewer to treasure its homeliness without feeling behind the times. It is at this period that, according to Buechner, Rockwell introduces an outsider into his work, a character "who is not one of us and at whom we can laugh." He may be a bum, an exhausted post-man, or a weary old flagpole painter, but the hint of alienation in him asks nothing of us. We can stare, take what we will, and leave the rest. These characters may, in fact, be subconscious projections of Rock-well's own alienation from some of the rapid and con-fusing changes of the new century. Many of them seem thoroughly tired out as they try to keep up with the fast pace of modern life.

Success and the High Life

Rockwell, though, seemed to be adapting rather quickly to the Roaring Twenties. He had become famous and well-to-do. His illustrations were seen not only on magazine covers but also in ads for Edison Mazda light bulbs, Jell-o, and Orange Crush. He toured Europe with friends, absorbing it in that sleep-less, boisterous way that only someone as young as he still was could do.

He confronted modern art by enrolling in a drawing course at Calorossi's art school, saturating himself with experimental theories picked up in European cafes, and trying to execute a Modernist cover for the *Post*. The experiment was a failure but also a bench-mark. When Lorimer rejected it, Rockwell sold it to another magazine and went back to his old style with a new spirit of self-acceptance.

In 1916, Rockwell married Irene O'Connor. Their re-lationship, however, was cold, and a week after they were married, she left to visit her parents and did not return for two months. It rapidly became clear to him that his was a loveless marriage, but a certain passiv-ity on his part as well as many social pressures resulted in the marriage lasting fourteen years, many of which were spent living with members of Irene's family.

READING HOUR

Oil on canvas, first printed on the cover of the Literary Digest *March 25, 1922.*

Rockwell's proper Victorian upbringing was often reflected in his art,

although he was more likely to portray a friendly, rural sensibility.

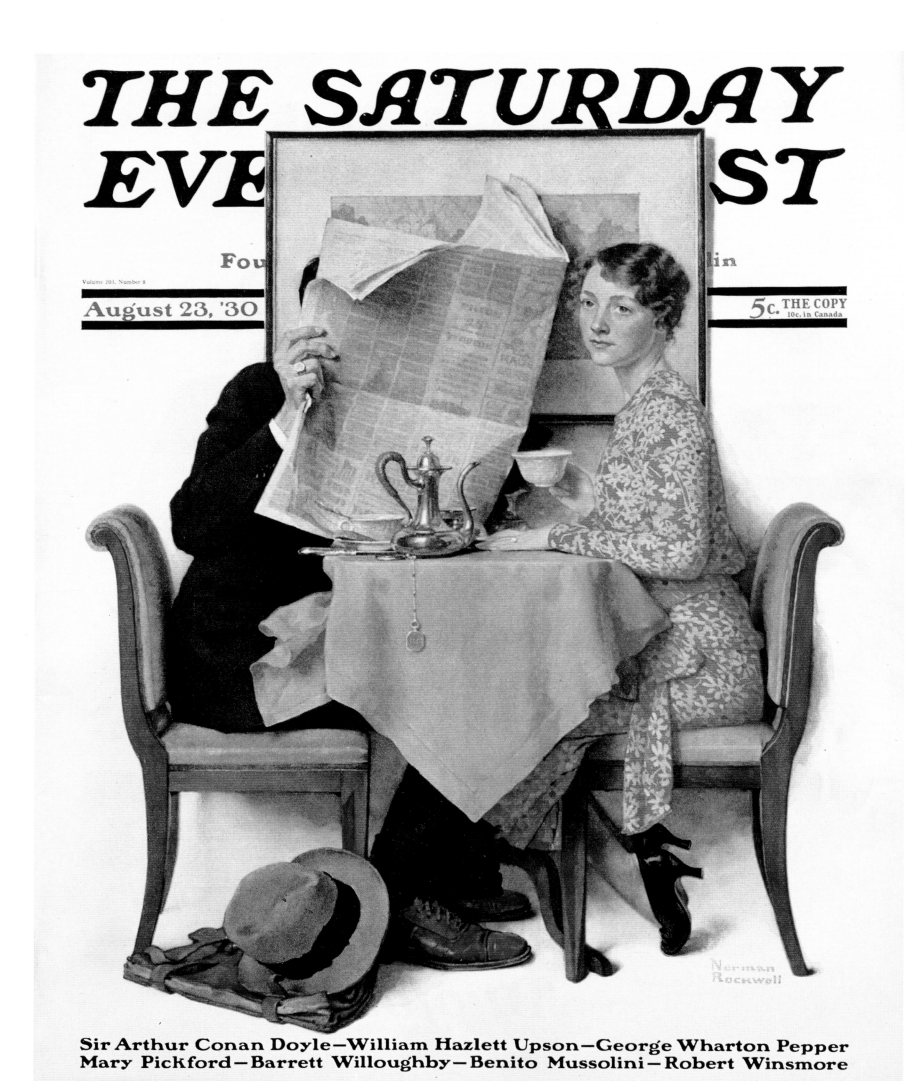

The combination of a loveless marriage and a very successful career seems to have coerced Rockwell out into society. Eventually, he and Irene entered the best circles of New Rochelle. They joined the country club and spent almost every evening out. Their lives became a succession of chic dinner parties, posh sailing expeditions, and fashionable games of golf. For perhaps the first time in his life, Rockwell took an interest in dressing in the latest fashions. He attended wild parties, learned how the rich spent their money, and was sought after by the crème de la crème of society.

He describes this period as initially exciting but as also reeking of falseness and shallow people. There were marital infidelities going on all around him, narcissistic displays of wealth, and poor examples of how to raise a family. Still, once he had become part of the social whirl, he felt powerless to extract himself from it.

One can imagine the turbulent feelings of a man like Rockwell confronted with such a social milieu. He had grown up in a completely different environment. He had felt his mother's disappointment at their status and had labored with feelings of insecurity about it himself. Now suddenly much of what he had fantasized about was being offered to him on a silver platter. It was a formula designed at first to overexcite, but disappointment and cynicism were inevitable.

For Rockwell the end of this period is marked by Irene's sudden request in 1929 for a divorce. The blow seemed to bring him to his senses, and he lost his exaggerated social ambitions. But the divorce, in the year of the big economic crash, coincided with the end of the so-called roaring twenties in America. It foreshadowed the new austerity and realism with which many Americans will be forced to confront in the next decade during the Depression.

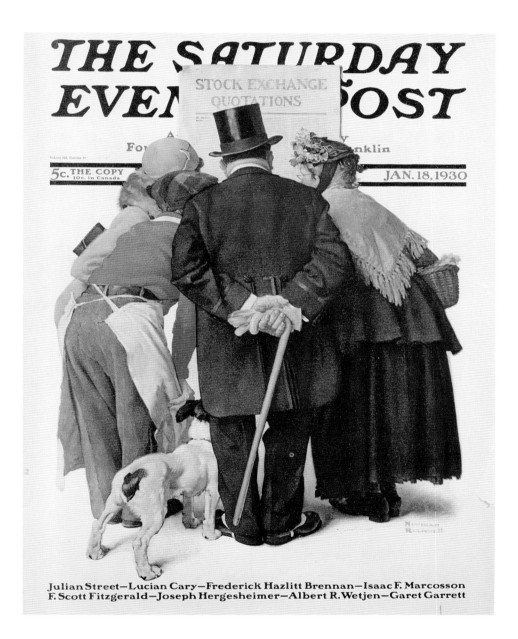

THE MORNING NEWS

Oil on canvas, first printed on the cover of

The Saturday Evening Post, *August 23, 1930.*

This painting may well reflect Rockwell's first marriage, from the noncommunicative relationship between the two characters to the poshness of their fine breakfast silver. Although they lived the high life, the marriage was loveless and ended in divorce in 1929.

STOCK EXCHANGE QUOTATIONS

Oil on canvas, first printed on the cover of

The Saturday Evening Post, *January 18, 1930.*

This image—probably conceived prior to the October crash—was quite timely when it was published in the early months of the Great Depression. It bears a tell-tale sign of Rockwell's own artistic struggles at the turn of the decade—the artist has given the grocery boy not two, but three legs.

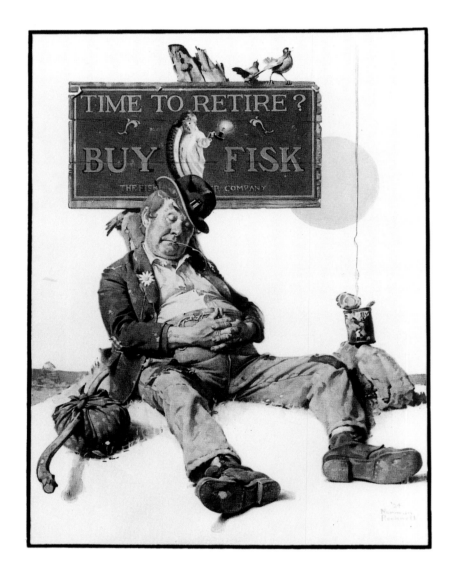

TIME TO RETIRE?
BUY FISK TIRES

Advertisement for Fisk Tires, 1923.
As a commercial artist,
Rockwell was a natural.
His humanistic style
and emotion-invoking
subject matter appealed
to consumers then,
and still does today.

THE BUGGY RIDE

Oil on canvas, first printed on the cover of The Saturday Evening Post, *September 19, 1925.*
Rockwell's use of blank or spare backgrounds gave his paintings a sense of
timelessness, and allowed him to concentrate on character and action. Given a
realistic background, many Rockwell paintings would have appeared clichéd.

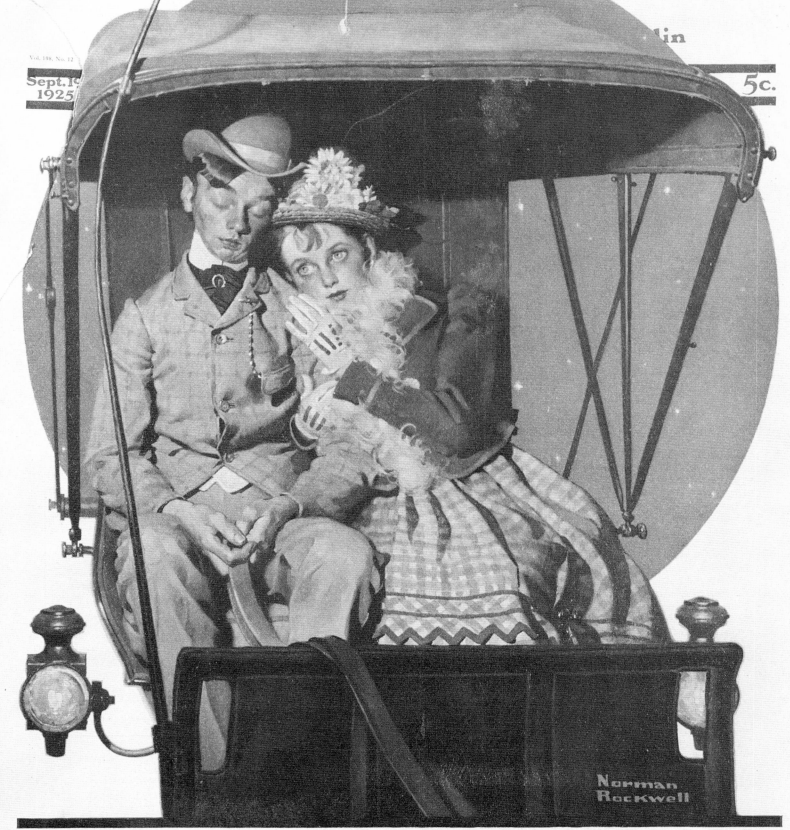

THE SATURDAY
EVENING POST

Vol. 198, No. 12

Sept. 19
1925

5c.

Norman
Rockwell

Harry Leon Wilson — Harris Dickson — Octavus Roy Cohen — Wythe Williams
P. G. Wodehouse — Barney Oldfield — Arthur Stringer — Maude Parker Child

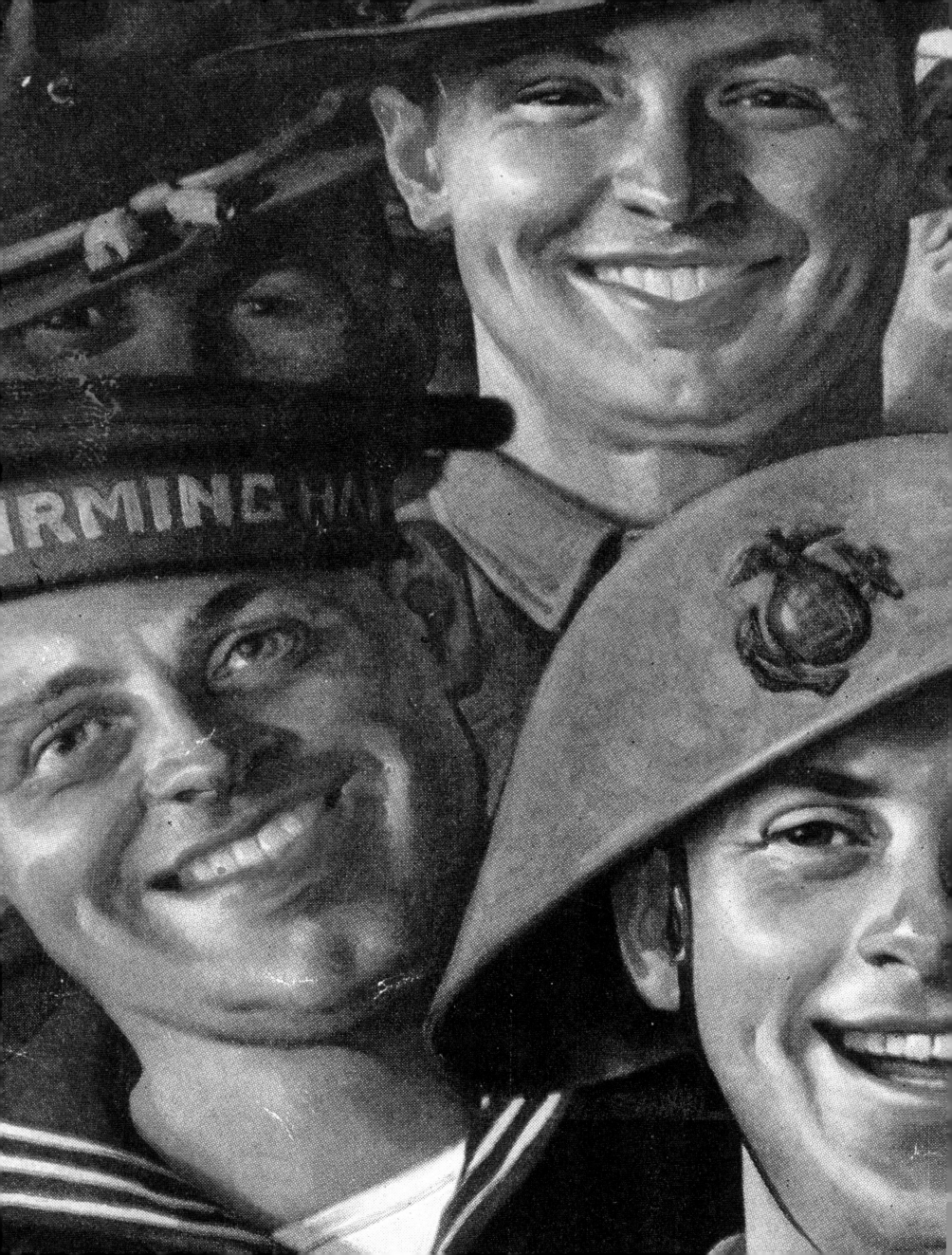

**ARE WE
DOWNHEARTED?**

*detail; oil on canvas, first
printed on the cover of* Life
magazine, November 28, 1918.
Rockwell's wartime
art reflected the
contemporary spirit
of the nation, from
this optimistic
World War I painting
to his more somber
Vietnam-era work.

THE GOSSIPS

Oil on canvas, first printed on the cover of
The Saturday Evening Post, *January 12, 1929.*
By the late 1920s, Rockwell was
moving in social circles that were
far beyond the homespun scenes
he painted. Although he found it
initially exciting, Rockwell
quickly tired of the falseness and
shallowness of the wealthy set,
and began once again to long for
the simple life.

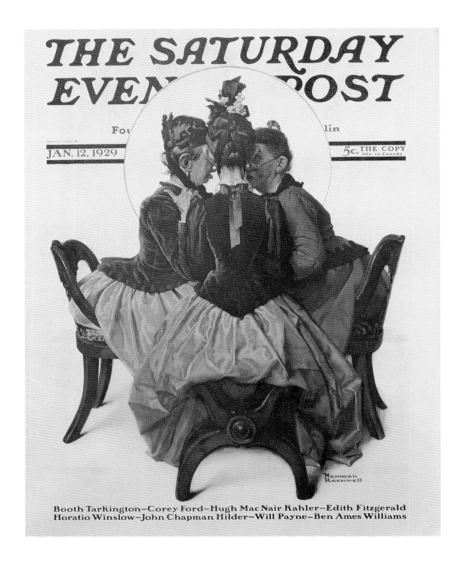

THE LITTLE SPOONERS

Oil on canvas, first printed on the cover of The Saturday Evening Post, *April 24, 1926.*
Alternatively titled *Young Love Watching the Sunset,* Rockwell's
courting couple captures the essence of innocent romance.

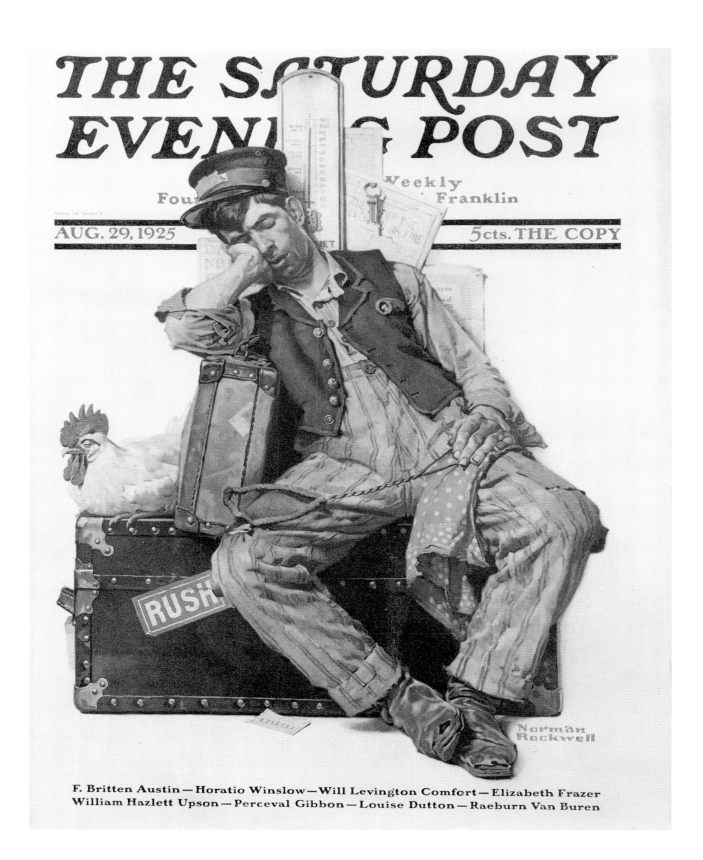

ASLEEP ON THE JOB

Oil on canvas, first printed on the cover of

The Saturday Evening Post *August 29, 1925.*

The mercury is hovering near 100

in this late August issue, and Rockwell

captures the feelings of the over-

whelmed Everyman working in the heat.

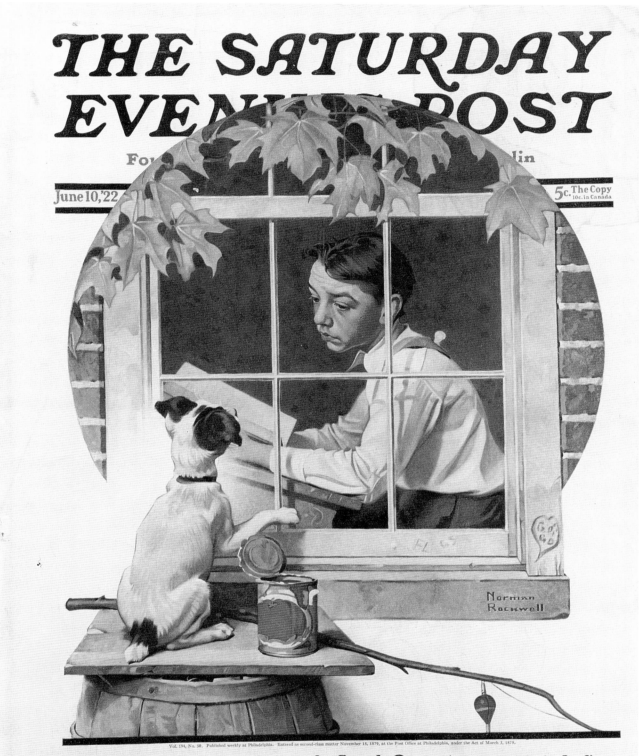

A PATIENT FRIEND

Oil on canvas, first printed on the cover of The Saturday Evening Post, *June 10, 1922.*

Rockwell frequently concentrated his scenes inside or around a

geometric shape, reflecting the Art Deco style popular in the day.

He often included outside elements—such as the dog, barrel, and the

bottom of the window in this scene—that gave a strong sense

of action without the use of an elaborate and distracting background.

**HOBBYIST
SCRATCHING HIS HEAD**

Oil on canvas, first printed on the cover of
Popular Science Monthly, *October 1920.*
As a commercial illustrator,
Rockwell did not have the
complete freedom that other
artists had. His paintings
needed to be approved by
editors at every step, from
concept through finished prod-
uct, and he had to work with-
in the confines of the cover
size, always leaving space
for the magazine's masthead,
as the red box above the
figure's head indicates.

WELCOME TO ELMVILLE

Oil on canvas, first printed on the cover of The Saturday Evening Post, *April 20, 1929.*
Speed traps didn't arrive with the advent of radar; Rockwell was caught
speeding in Amenia, New York, just as he passed the "Welcome" sign. He changed
the name of the town, but otherwise immortalized the time-keeping sheriff.

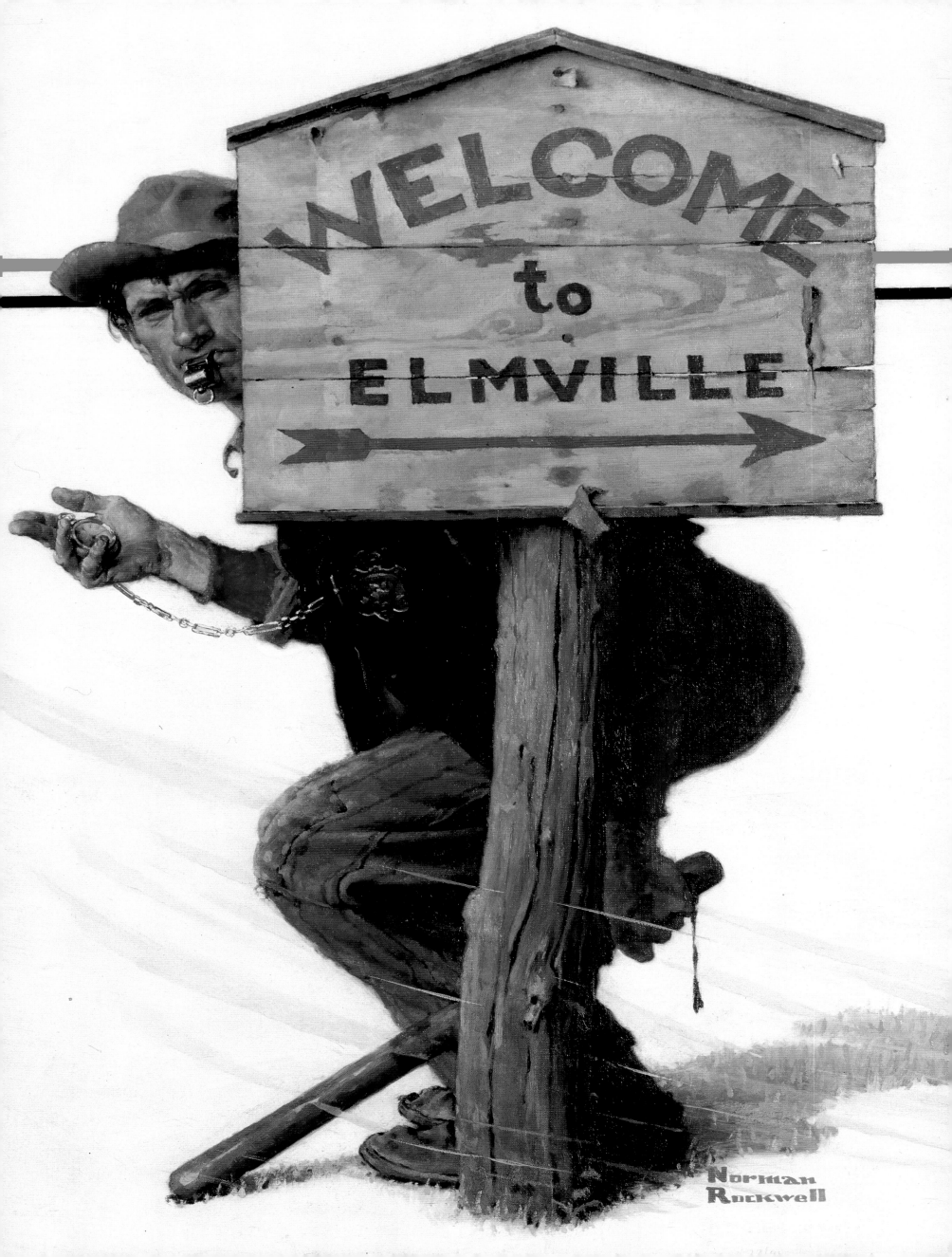

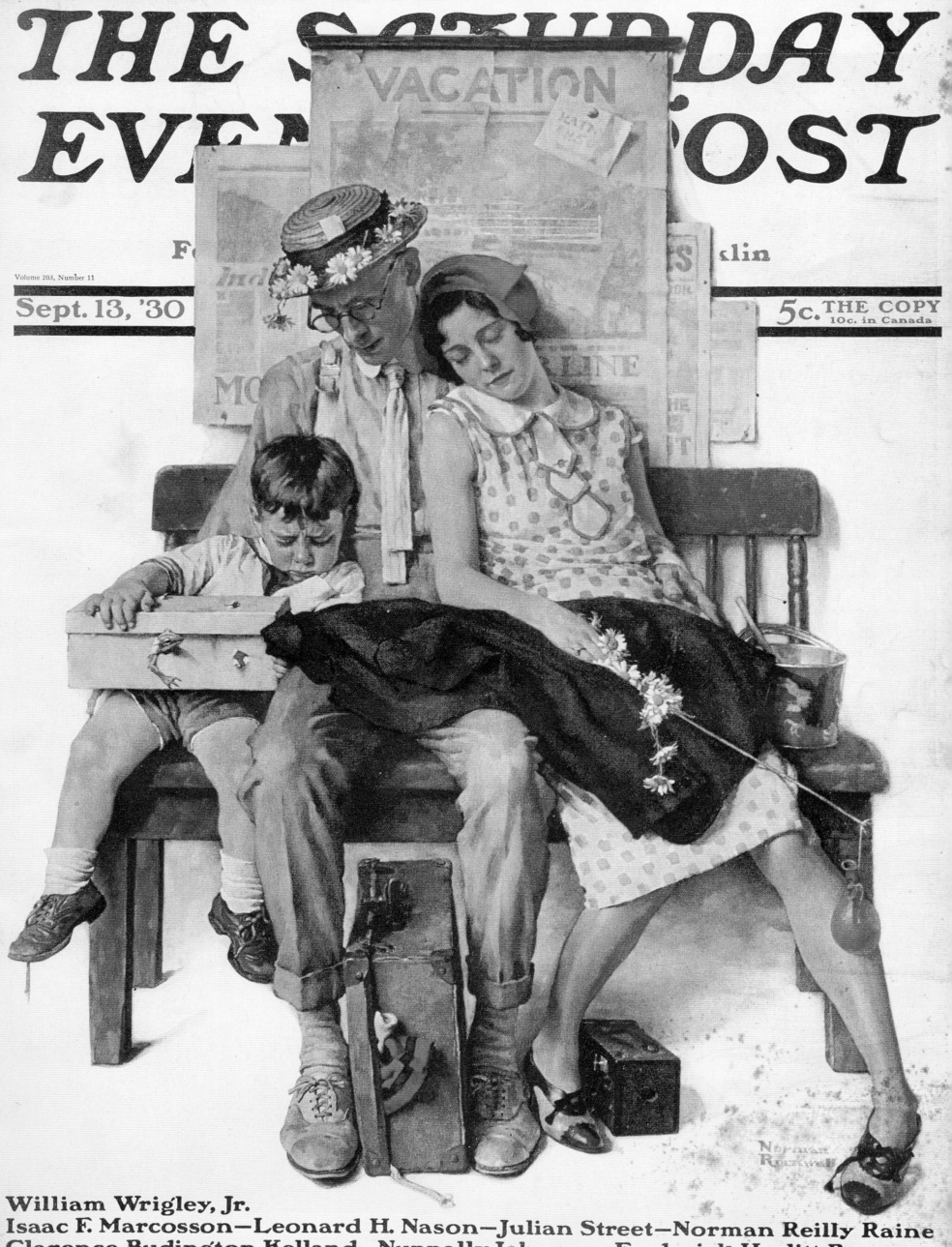

CHAPTER THREE

SUCCEEDING
IN DEPRESSION
AMERICA

Rockwell's work during the Great Depression largely ignores the economic calamity that gripped the nation, accentuating the positive for a middle-class audience seeking reassurance. Perhaps he was able to offer that sense of reassurance to the public because his own life had achieved a new maturity and stability. He was also well off financially. However, the fruits of this new stage in his life did not come all that easily. First he had to undergo a period of artistic crisis and anguished bachelorhood in New York following his divorce from Irene.

Economy of Means

After the break-up with Irene, Rockwell moved alone to the Hotel des Artistes in Manhattan, where he rented a duplex that he furnished using the services of an interior decorator. He also began taking riding lessons. The stage was set for another chapter of the swank life, this time without any attachments; but again, Rockwell really didn't take to it.

He made attempts at entering Manhattan's artistic milieu, lunching three or four days a week with the distinguished but already out-of-date portrait artist Emil Fuchs. Before long, Fuchs's sad pretensions, designed to cover up the fact that he was no longer the chosen portraitist of the rich and distinguished, got to Rockwell. Even Rockwell's own work was beginning to fill him with grave doubts. For the first time in his life, he describes himself as something short of a

perfectionist, banging away at paintings that never seemed to look quite right, then, because of urban annoyances, to which he had never taken kindly, resorting to easy solutions.

One *Post* cover, from January 18, 1930, accidentally included a telltale sign of Rockwell's new impatience and cursoriness. If we examine the aproned pant leg of the grocery boy in that cover carefully, we see that Rockwell gave him three legs, two that are straight and one that is bent at the knee! Rockwell himself did not notice it until years later. This is not to say that the work shows any loss of invention or originality on Rockwell's part. In fact, his placement of all the characters—including the dog—with their backs to the viewer hints of progress in conveying anecdote with an ingenious economy of means.

That cover and other work from the years 1929 and 1930 show an impressive simplicity and refinement in line. Rockwell's work is less embellished, bolder, and perhaps more candid. For example, in a *Post* cover from September 13, 1930, a man, his wife, and their small child, returning from vacation, are slumped against each other in sleep. The suitcase between the man's feet has been sloppily packed and a piece of clothing is sticking out of it. The man's straw hat is ringed with daisies. The scene seems totally natural yet archetypal at the same time. It seems Rockwell's demoralized feelings of this period did not show up in his work as often as he may have thought they did.

HOME FROM VACATION

Oil on canvas, first printed on the cover of The Saturday Evening Post, *September 13, 1930.*

Although Rockwell's Depression-era work can be described as somewhat escapist,

it includes less of the optimism and idealism that resounded so heavily in his earlier

work. Here, the child's deflated umbrella, untied shoes, and uncomfortable position

vaguely hint at the difficulties—or at least the discomfort—of life in the early 1930s.

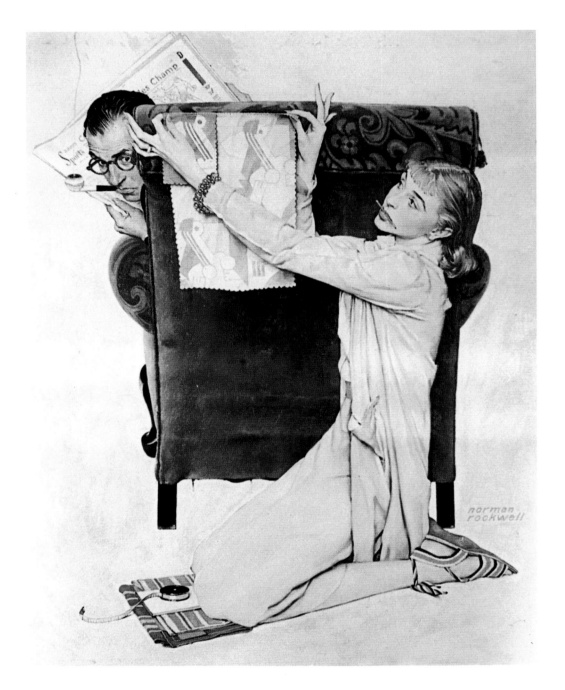

THE DECORATOR

Oil on canvas, first printed on the cover of
The Saturday Evening Post, March 30, 1940.
Here, a man sits in his arm-
chair while a young woman
takes care of the decorating.
After his divorce from Irene,
Rockwell hired a professional
decorator to design his New
York apartment.

who took a vital and intelligent interest in his work. Two years later, in 1932, their first son, Jerry, was born, and the family of three traveled to Paris.

Art Therapy

Back home, Rockwell applied himself to his work. However, even domestic bliss did not seem capable of shaking him out of the sense that he had hit a new creative low. His work no longer pleased him. Rockwell dates the beginning of this decline with his temporary adoption of dynamic symmetry. It was a theory founded upon rules of proportion supposedly derived from Greek art. It proved to be a waste of time, and Rockwell soon abandoned it.

He also flirted with gritty realism by trying to portray more sordid subject matter. He painted a canvas showing a gangster lying dead next to a bar. The attempt is symptomatic of the lingering doubt that would return to plague him for his entire career: How relevant, he wanted to know, am I to this rapidly changing century? But just as he had every other time, he ended by returning to his preferred themes and techniques. With few external signs to guide him, he weathered his creative crisis by working as stubbornly as he had done at the Art Students League. Even if he could not conceptualize a new vision, he was determined to paint his way through to one.

According to Rockwell, magazine illustration was the "occupational therapy" that saved him and gave him new artistic life. He explained how suitable this type of work was to someone suffering from a temporary lack of inspiration. Rather than having to think of an anecdote, as he did for the *Post* covers, he had only to think of how to portray one. All the details of costume, expression, and gesture were already there; or at least they were there in the writers he admired, who eschewed aesthetic experimentation and provided him with naturalistic narratives.

Rockwell also appears to have achieved a new level of wryness in his humor at the beginning of the 1930s. The *Post* cover from November 25, 1933, which shows a mother about to spank a child with a hairbrush while she consults her psychology book, is a witty parody of modern approaches to childrearing becoming popular at the time. And a 1930 cover illustration of a woman weathering breakfast while her husband hides his face in the morning paper is another successful mini-comedy of manners, a light though cuttingly apt portrait of domesticity.

In 1930 Rockwell fled to Los Angeles to escape the art editor of *Good Housekeeping*, who claimed that Rockwell had made a verbal agreement to illustrate the life of Christ. While there, he met Mary Barstow, whom he married that same year. Their fortuitous union was the beginning of a domestic tranquillity Rockwell had never before experienced. But perhaps more importantly, here was the discovery of a partner

CHILD PSYCHOLOGY

Oil on canvas, first printed on the cover of The Saturday Evening Post, *November 25, 1933.*
Rockwell's *Post* covers of the early '30s show a new wryness and
more cynical outlook, always with a warm sense of humor that was
never offensive. This popular scene juxtaposes an old-fashioned
method of child discipline with the new, "modern" approach.

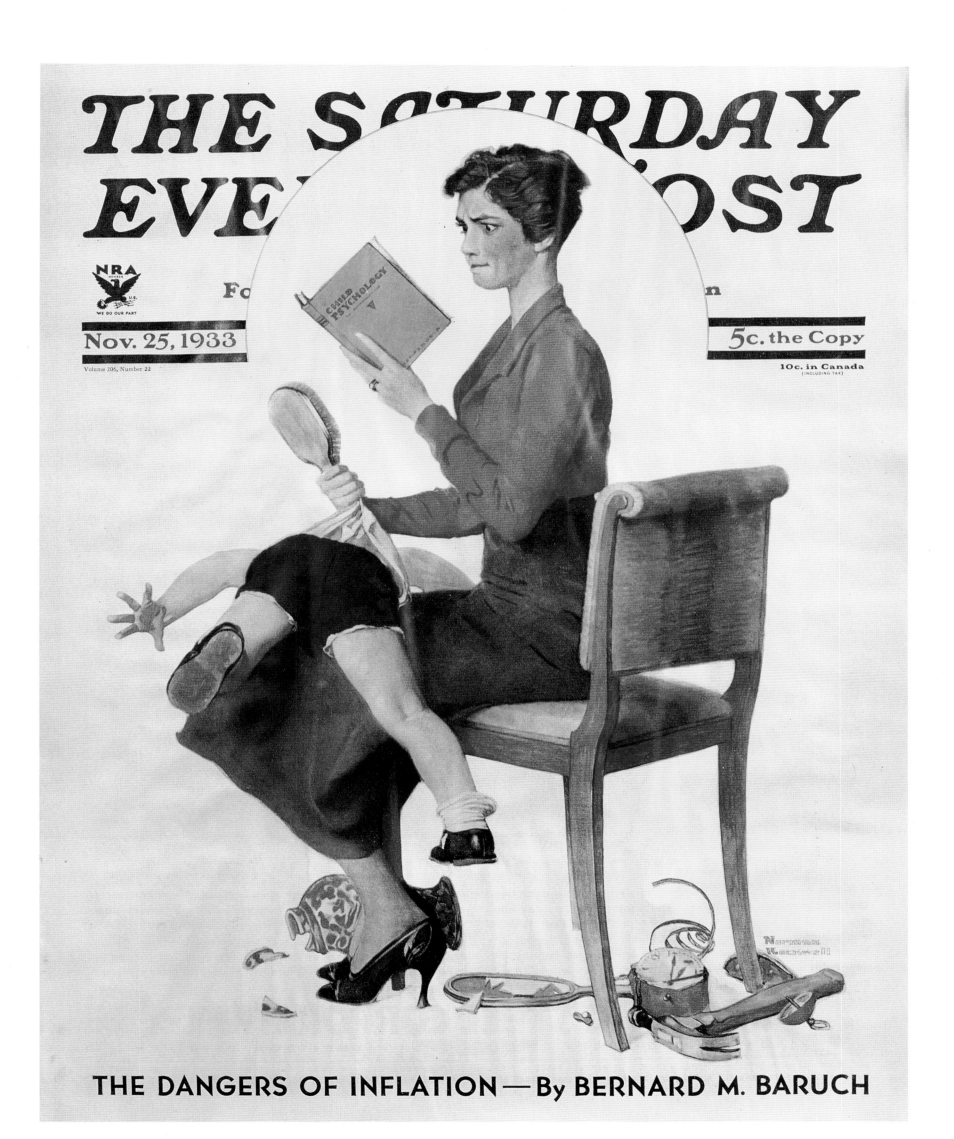

THE DANGERS OF INFLATION—By BERNARD M. BARUCH

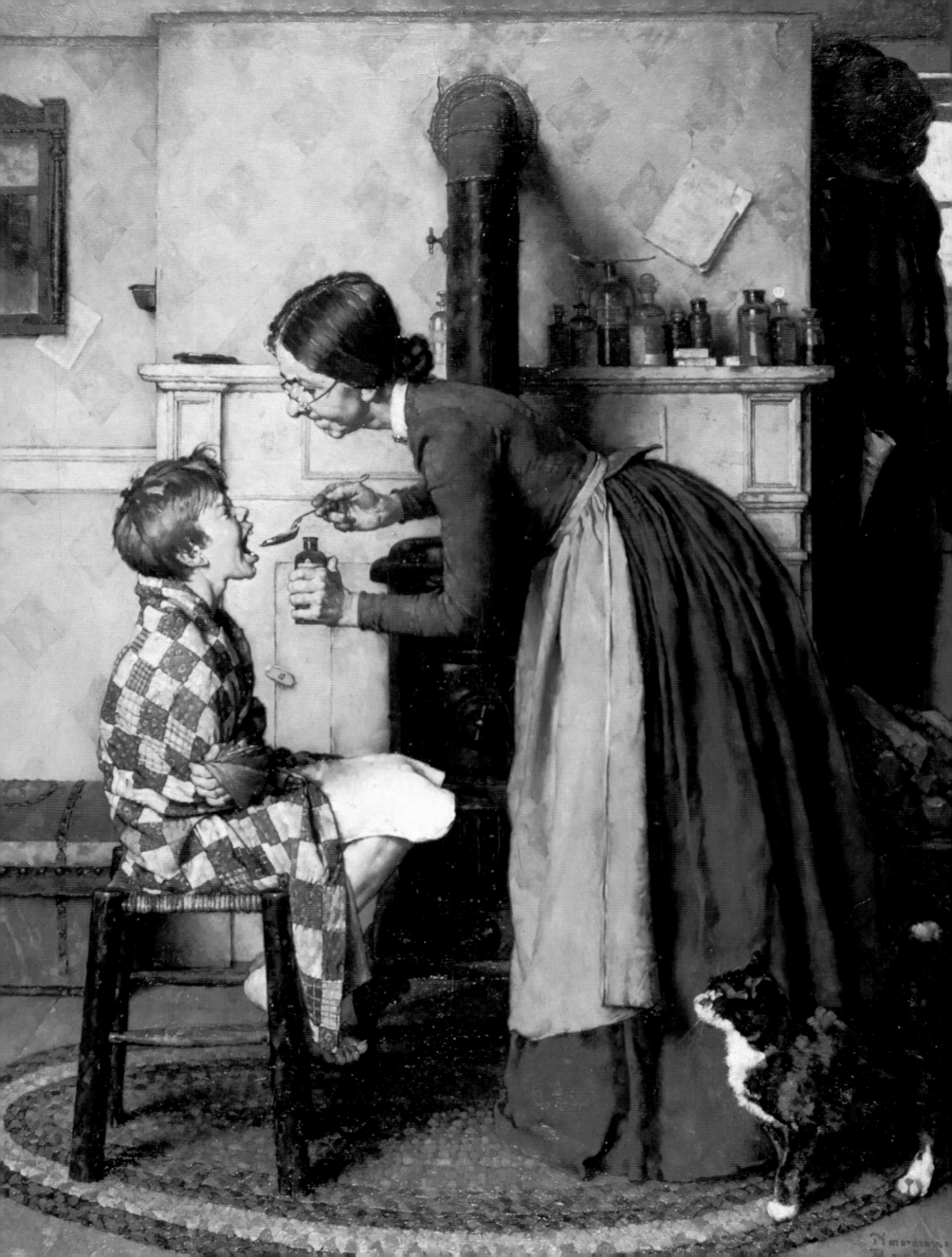

Rockwell and Mark Twain

Nineteen thirty-five marked the end of Rockwell's creative slump. The publisher of Heritage Press and Limited Editions Club books had asked him to illustrate *Tom Sawyer* and *Huckleberry Finn*. It was the perfect assignment for him at the time.

The stories and details were, of course, already masterfully evoked in Twain's novels. The situations described matched Rockwell's sense of whimsy and boyhood nostalgia like a glove fits a hand. Rockwell also took to Twain's brand of Americana. The precise details in the author's writing about life in a small southern town during the latter half of the nineteenth century charmed the painter. In portraying them, there would be no confrontation with his ongoing inner conflict between traditional and modern art. On the other hand, illustrating Twain was just the kind of bracing and challenging tonic Rockwell needed then. He wanted to add something new to *Tom Sawyer* and *Huckleberry Finn*, something that all the previous attempts of other artists had failed to illustrate.

It was with a sense of excitement that he traveled to Hannibal, Missouri, to immerse himself in the town where Twain had spent his boyhood. Rockwell was astonished to discover that much of the material included in Twain's novels had been lifted in precise detail from that town, details which still remained there. He discovered that there really was a woodshed next to Twain's home, just like the one Tom Sawyer could see from his window. He found out that other illustrators had misrepresented the cave where Tom and Becky get lost—there were no stalactites in it.

The town itself seemed totally devoted to the memory of Mark Twain. There was a museum, a hotel, a meat market, and several other establishments, all consecrated to the noted author. There were elderly people who claimed acquaintance with Twain and were eager to furnish Rockwell with (possibly apocryphal) details of his life. What Rockwell learned about Twain provides us with further links between these two artists.

An old judge who claimed to have known Twain said that Twain had been sickly and sensitive as a boy. The rough-and-tumble adventures he described in his books were fantasies about being more robust and adventurous then he actually was. About this observation, Rockwell commented, "If he [Twain] had actually done these things, possibly he would have been such an extrovert that he could not have written about them." The remark makes us wonder what Rockwell would have and would not have done if he himself had been the robust athlete his brother was. Rockwell well understood the relationships among regret, insecurity, fantasy, and creativity.

Rockwell was so determined to achieve a high level of authenticity in his illustrations for Twain's works that he began collecting clothing that would serve to represent the period. He instinctively knew that no costume could convey to him the lived-in feeling that real clothes project. So he temporarily became a southern rural "rag-picker," buying the worn hats, wrinkled trousers, and top-coats from Hannibal's inhabitants. He even traded pants with an old farmer right on the spot because he knew it was the only way to get the worn and sun-bleached affect that would connote Huck Finn.

Once Rockwell had completed his research and assembled his costumes and props, he began choosing models. He decided, for example, to use one of his regulars, Fred Hildebrandt, as the schoolmaster. Hildebrandt was one of dozens of models that Rockwell depended upon to serve up anatomical structures, hold emotional expressions, and inspire him with their sense of humanity. Rockwell has offered us detailed descriptions of these people that betray a deep appreciation of their foibles or kindnesses. One of his favorite models was James K. Van Brunt, a gnarled ex-military man whose vitality and inventiveness caused Rockwell to use him more times than some editors wanted. Rockwell had him shave and regrow his mustache to keep his image freshened for the public eye. He even used him to portray three gossiping old aunts, an innovative subject for a time when almost no other artist would portray a woman who was not attractive.

The outcome of all of this preparation for *Tom Sawyer* and *Huckleberry Finn* was eight paintings in full color, a drawing for the binding, and a chapter heading—for each of the two books. They were an enormous success and earned Rockwell a high level of esteem as a book illustrator. In some of the illustrations Rockwell favors a painterly, atmospheric approach, with detailed backgrounds. In others, he stuck to that habit he had developed for magazine covers of leaving out most or all of the background details in order to create uninterrupted silhouettes.

SPRING TONIC

Oil on canvas, illustration for The Adventures of Tom Sawyer, *1936.* Rockwell researched exensively before beginning his series of illustrations for *Tom Sawyer* and *Huckleberry Finn.* A long trip to Hannibal, Missouri, gave Rockwell a wealth of information on Twain, as well as props and costumes for his models.

All in all, his brushstrokes in these paintings seem looser than usual, and far more dynamic.

There is even a slight expressionistic tinge to his characterizations in these accomplished works. Some offer big, bold gestural scenes, such as the portrayal of Tom Sawyer getting switched for talking to Huck Finn in class. This illustration has a free, wild quality— a surrender to high emotion that one doesn't usually associate with Rockwell. Our view is of the schoolmaster's back as he stands straddle-legged and bent, one arm looped around the terrified, barefoot Tom Sawyer, who is thrashing his legs in the air. A rumpled red handkerchief peeks from the folds of the schoolmaster's topcoat and a book has been dropped on the floor. The schoolmaster has raised a switch into the air and is about to lash it across Tom's bottom.

The most incredible thing about it, though, is the number of witnesses to Tom's thrashing that Rockwell was able to include. All of them are in the background, and each one of them projects his or her individual emotional reaction. To the left is a coarse-featured boy, laughing gloatingly. To the right are girls with various expressions of dismay, fear,

and embarrassed fascination. Rockwell's comment about his illustration was that it was incredibly difficult for the models to hold their poses. Setting it up was one of the experiences that finally convinced him to incorporate photography into the process of making a painting.

Painting and Photography

Using photography to help make a painting filled Rockwell initially with a sense of embarrassment and shame. It seemed to belie those earnest hours spent in life-drawing class poring over the ankle bone, fingers, or toes of a still model. He cites two important cultural and technological changes as impetus for his new dependence upon photography. The first change was the fact that patient professional models were harder to come by. Most were getting used to posing for photographs and had neither the skill, the time, nor the inclination to spend hours in one position with the same expression fixed on their face. The photographer could capture a pose, position, or persona in a matter of seconds.

The other reason was that a revolution in candid photography was causing younger illustrators to reappraise the style of illustration that viewed its subject matter always from the same frontal angle. The work of these young illustrators was flooding into the offices of New York publishers, and it favored disturbing perspectives or sophisticated glimpses of movement.

Around 1937, Rockwell began the practice of having a photographer take multiple photos of models or settings before he did a painting. He never copied the photos slavishly, of course. He only used them as a reference source for perspective, detail, gesture, or anatomy. Now he had two means of recording at hand. Dozens of snapshots as well as hours of life-drawing usually went into the construction of a Rockwell piece.

It is difficult to tell whether the medium of photography had an effect upon Rockwell's aesthetic. Much of the work that comes afterward, in the 1940s and 1950s, tends to suggest a nascent photo-realism. Features are more finely drawn and planes seem flatter. However, this might just be the artist's adaptation to a plainer, more suburbanized period in America, during which the country shed its last links to the culture of the nineteenth century.

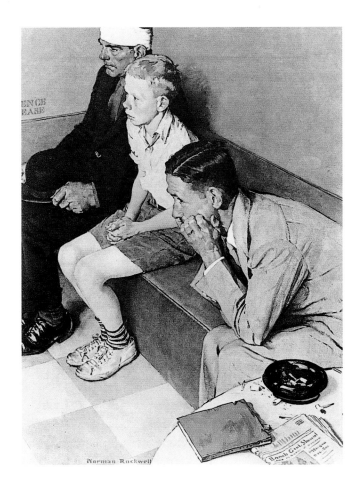

A MOMENT OF TENSE-NESS IN A HOSPITAL WAITING ROOM

Illustration for a story called ".22" by Price Day, in The Saturday Evening Post, *October 16, 1937.* By the mid-1930s, Rockwell had found a happy family life with Mary, but his domestic bliss did not translate easily into artistic inspiration, and he found himself lacking for ideas. Rockwell found illustrating stories for magazines and books to be the therapy that gave him new artistic life.

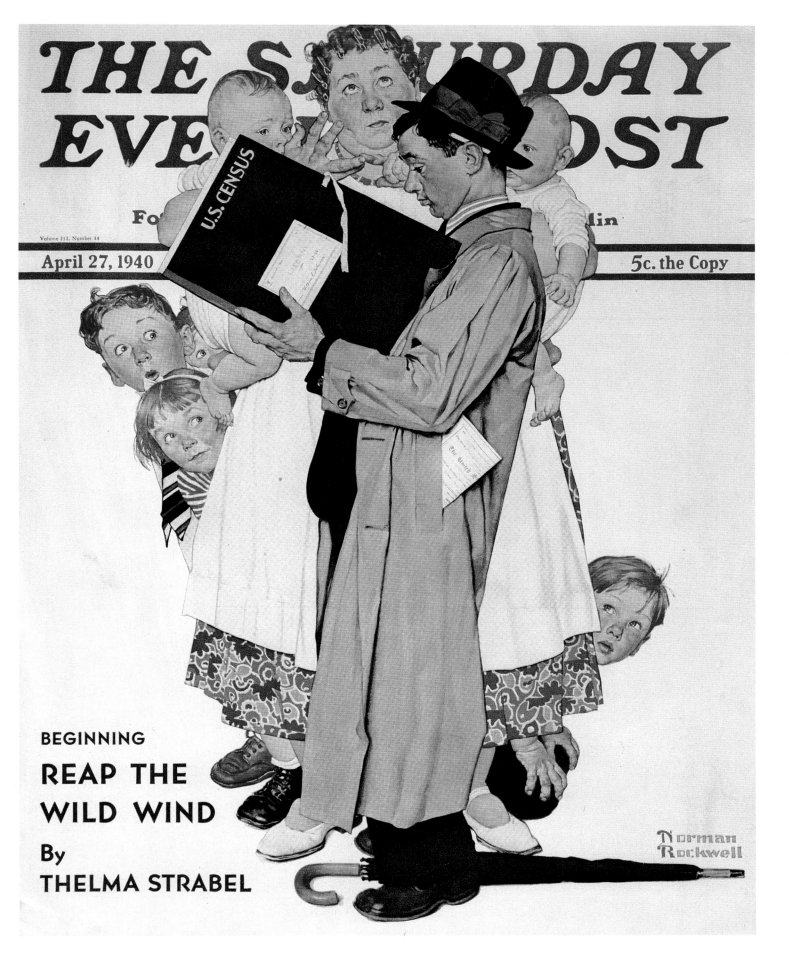

THE SATURDAY EVENING POST

Volume 212, Number 44

April 27, 1940

For... lin

5c. the Copy

U.S. CENSUS

BEGINNING
**REAP THE
WILD WIND**
By
THELMA STRABEL

Norman Rockwell

FOLLOWING PAGE:

**FAMILY
SAYING GRACE**

*Oil on canvas, first printed
on the cover of* The Ladies
Home Journal, *August 1939.*
Over the years,
Rockwell produced a
number of paintings
featuring individuals
or families with
their hands clasped
in prayer. Here, a
family says Grace
before a meal.

THE CENSUS TAKER

*Oil on canvas, first printed
on the cover of* The Saturday
Evening Post, *April 27, 1940.*
Rockwell produces the
illusion of cramped
space without any
background at all—the
positioning of the fig-
ures clearly indicates
that they are standing
in a doorway.

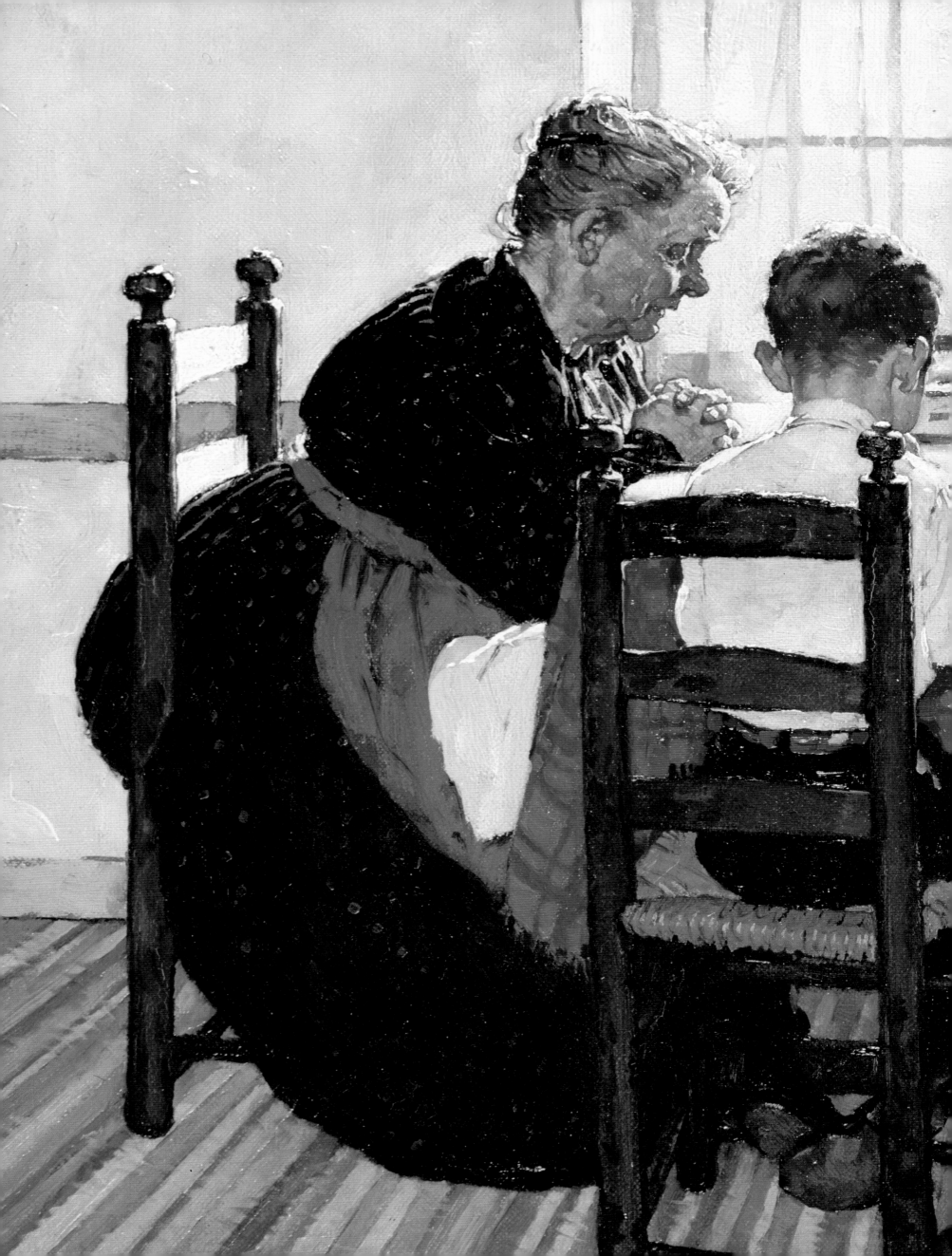

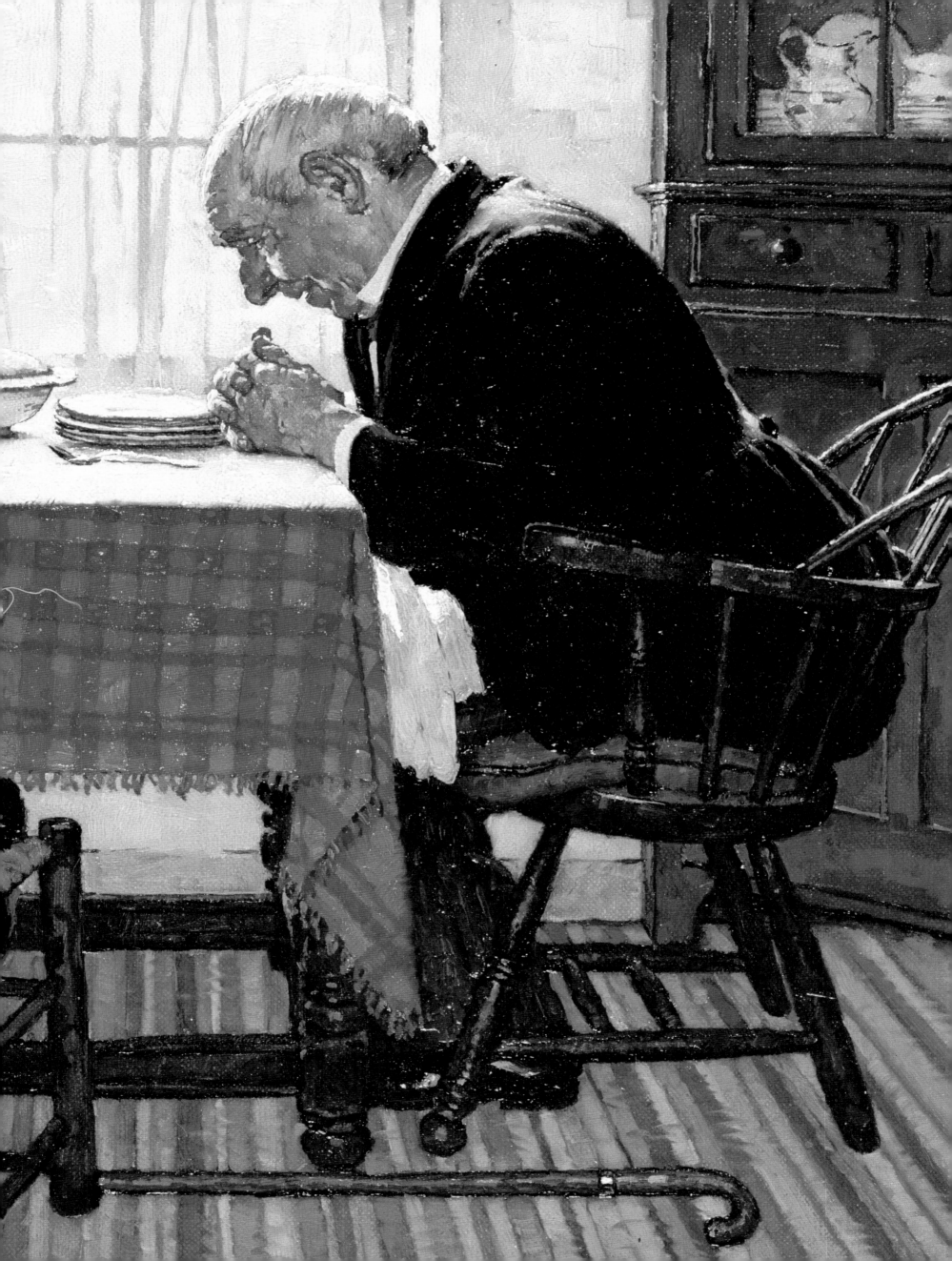

MARBLES

Oil on canvas, first printed
on the cover of The
Saturday Evening Post,
September 2, 1939.
Young boys once
dominated Rock-
well's canvases;
however, from 1930
to 1939, he produced
only ten works in
which boys played
a central role.

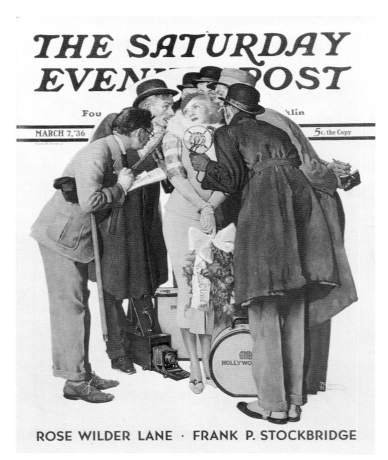

THE MOVIE STAR

Oil on canvas, first printed on
the cover of The Saturday
Evening Post, *March 7, 1936.*
During the Depres-
sion, Hollywood
studios churned out
joyful films stocked
with singing, dancing,
and glamor for a
nation hungry for
escapist entertain-
ment. Rockwell's
work mirrored the
Hollywood model,
here capturing a stun-
ning movie star amid
an adoring crowd.

A New Approach in Difficult Times

Buechner points out that during the 1930s the num-
ber of *Post* covers devoted to nostalgic boyhood
decrease significantly. From 1930 to 1939, only ten of
them have children as their main subject. This does-
n't mean that Rockwell had given up optimistic
themes or an interest in Americana. His work during
this period seems to fall into two categories that
could both be called escapist.

The first category includes the paintings, book
illustrations, and murals Rockwell completed that
make reference to the canonical past. These include
the *Tom Sawyer* and *Huck Finn* illustrations; illustra-
tions for a biography of Louisa May Alcott; a somber
oil painting from 1938 called *Whig and Tory*; a
painterly evocation of Washington Irving's American
literary character Ichabod Crane, done in the late
thirties; and a mural whimsically evoking the Last
Ride of Paul Revere, done for the Nassau Tavern in
Princeton in 1937. All of these works are firmly
rooted—not only in terms of basic themes, but in
terms of painterly values—in the nineteenth century.
They speak of a culture that is remote from the
day-to-day pressures of the Depression years. Their
charm seems to offer a cozy and genteel escape
from current anxieties.

The second category of works is distinctly contem-
porary, often related to advertising and popular
entertainment, which was crucial to the public
morale during the Depression years. Works which
might be said to be a part of this category are Rock-
well's *Post* cover of May 24, 1930, depicting Gary
Cooper being made up for his film role as the Texan;
the already mentioned comical portrait of the mother
with the psychology book who is disciplining her
child; an oil painting for the *Ladies' Home Journal*
which shows two romantic teenagers sitting atop a
world globe; and a painting for the Dolores & Eddie
Gaiety Dance Team for the June 12, 1937, *Post* cover.

These works are perhaps proof of Buechner's as-
sertion that Rockwell's approach during the 1930s
"became less sentimental and the past was treated as
decorative rather than nostalgic." However, there are
several outstanding exceptions to any "decorative" or
even nostalgic tendencies in these years, such as the
already mentioned 1930 portrait of the husband, wife,
and child asleep in a train station. This painting has a
tenderness and lack of pretense that have nothing to

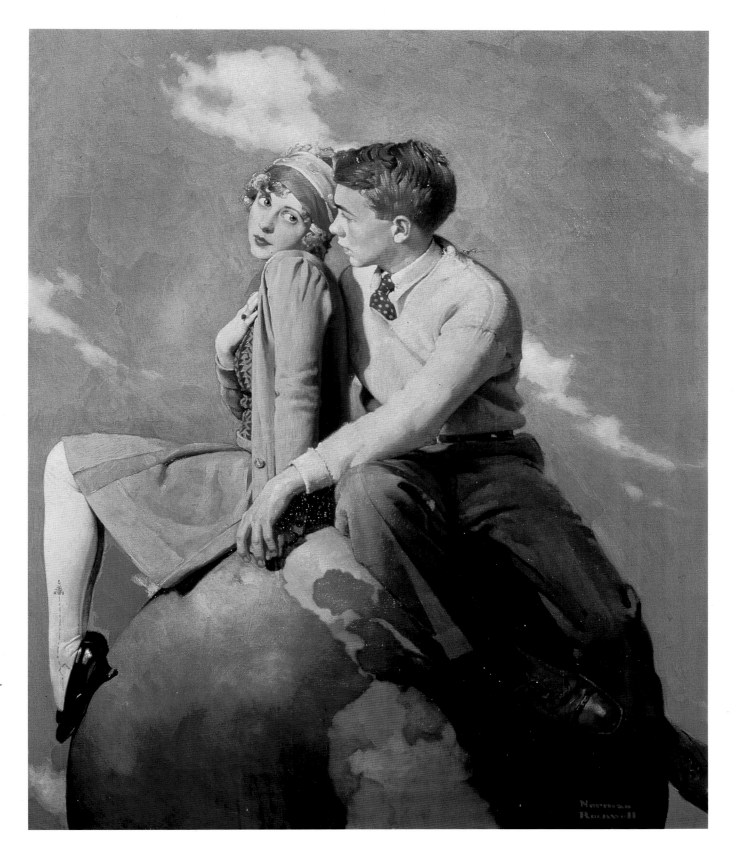

ON TOP OF THE WORLD

Oil on canvas, first printed on the cover of Ladies' Home Journal, *1933.* Once again, Rockwell offers a breather from reality, depicting young lovers far removed from Depression America.

do with escapist inclinations. The flowers on the man's hat, the woman's and child's untied shoelaces, the deflated red balloon on a stick, and the fact that the child has to sleep with a box of fishing tackle on his lap all strike a note of sweet imperfection, pathos, and realism that hint vaguely at the difficult, or at least uncomfortable, years of the Depression.

Economic difficulties are suggested even more strongly in the boldly ironic *Santa on a Train,* painted for the December 28, 1940, *Post* cover. It shows a middle-aged man on a subway or commuter train hunched into his black overcoat and hat, his Santa costume and pocketed Santa cap protruding incongruously from it. Since his eyes are closed, he may be dozing, but the preoccupied, depressed look on his face colors the Santa image with a gentle cynicism. We get the idea that he is a man beyond his prime who needs work, and that's the reason he's agreed to play Santa. Meanwhile, an intrigued boy holding packages with the label of the store where Santa is appearing peeks at him around the corner of a partition. He seems to represent the child getting his first taste of the ruses and hard realities behind the fantasies of youth.

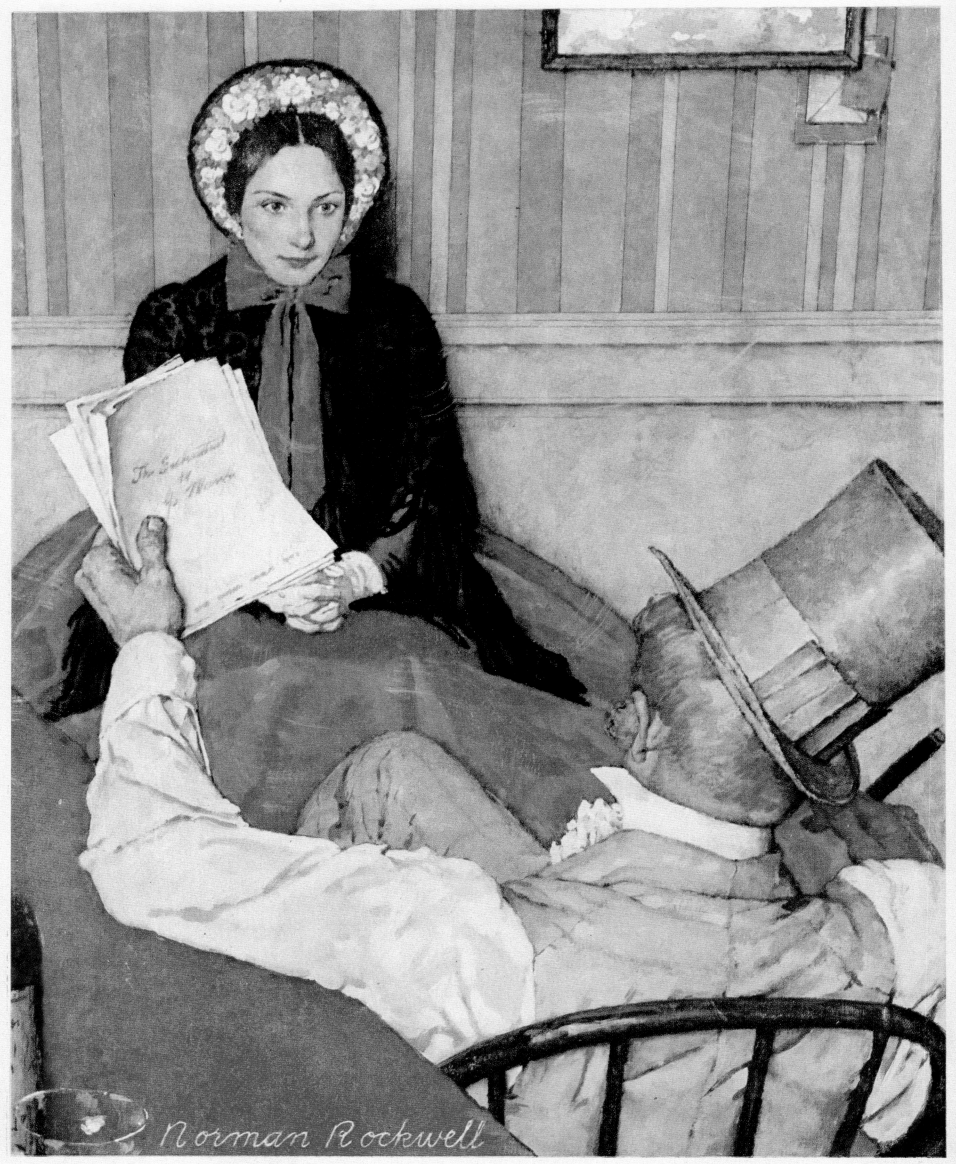

Jo concocted a thrilling tale, dressed herself in her best
and boldly carried it to the editor of the Weekly Volcano

LITTLE WOMEN—*Chapter 34*

CROQUET GAME

Oil on canvas, first printed on the cover of The Saturday Evening Post, *September 5, 1931.*

Rockwell created a number of fanciful images intended as escapist pleasures during the depths of the Depression. Some were modern, featuring movie stars and glamorous scenes, while others—like this one—harkened back to nineteenth-century culture, far removed from the grim realities of the Depression.

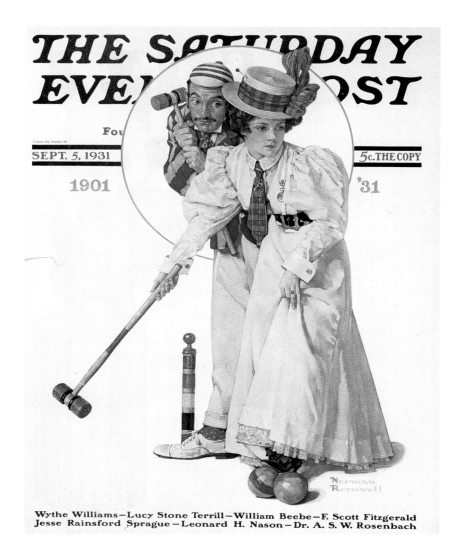

LOUISA MAY ALCOTT

Illustration in oil for "Most Beloved American Writer," by Katherine Anthony, Woman's Home Companion, *December 1937–March 1938.*

Rockwell produced a number of illustrations for classic American stories during the 1930s, including this portrait of Louisa May Alcott for a biography, and paintings for *Tom Sawyer* and *The Legend of Sleepy Hollow.*

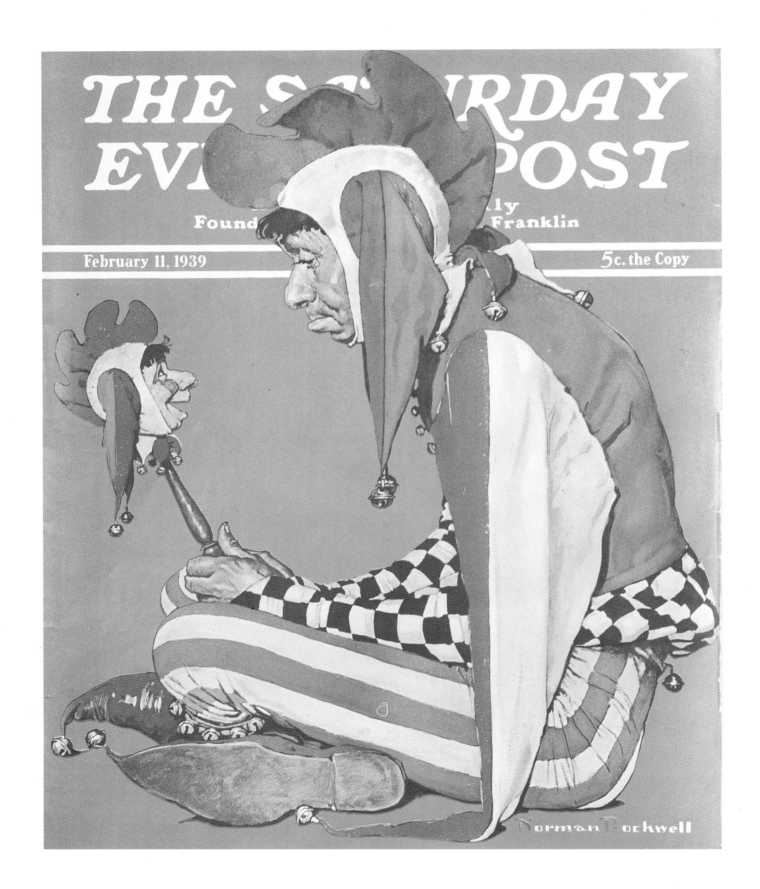

THE COURT JESTER

Oil on canvas, first printed on the cover of The Saturday Evening Post, *February 11, 1939.*

The melancholy jester is mocked by a smiling image of
himself, perhaps hinting at the artist's own dilemma, for he too
was unable to express his less optimistic feelings in his art.

79

WET PAINT

Oil on canvas, first printed on the cover of The Saturday Evening Post, *April 12, 1930.*

At the turn of the decade, Rockwell was newly divorced and the nation was in the grips of the Great Depression. Yet rarely did personal or public woes make their way onto Rockwell's canvas. Here, a vibrant and thoroughly modern young woman rushes to get herself—and her artwork—out of the rain.

THE LETTERMAN

Oil on canvas, first printed on the cover of The Saturday Evening Post, *November 19, 1938.*

While researching Twain for a series of illustrations for *Tom Sawyer* and *Huckleberry Finn,* Rockwell found that he and young Samuel Clemens had both been fairly non-athletic as young boys, and suggested that this was the reason why both of them created such rough-and-tumble young male characters. Their insecurity, Rockwell suggested, was largely responsible for their creations.

SANTA PLOTTING HIS ROUTE

Oil on canvas, first printed on the cover of The Saturday Evening Post, *December 16, 1939.*

Rockwell's Christmas covers for the *Post* were always popular, and the artist was challenged with the opportunity to outdo himself each year.

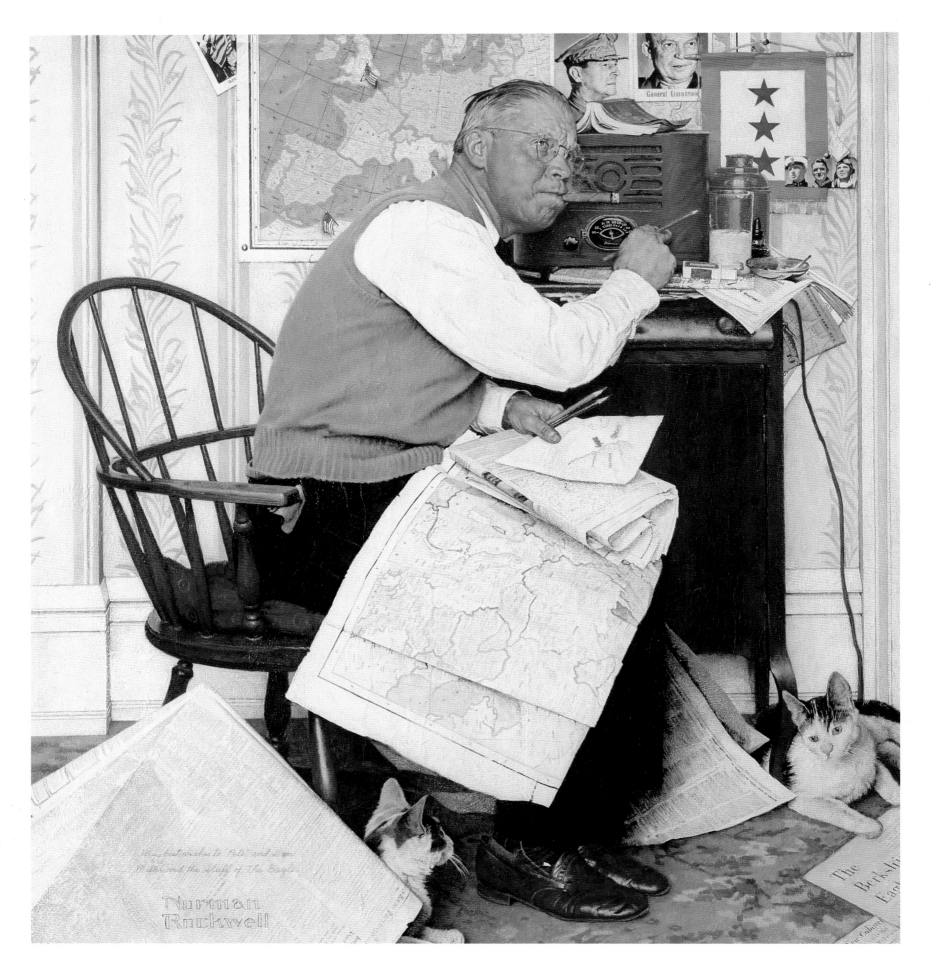

THE FOUR FREEDOMS AND THE WAR YEARS

Like the boy who sees Santa taking a break on a train, Rockwell himself was beginning to face life's hard realities. He, Mary, and their sons (who by 1936 numbered three) had moved into a country home not far from Arlington, Vermont, a small, rustic town halfway between Dorset and Bennington. Rockwell came with all the expectations of idyllic country life that someone of his nature could form; but, as he explained in his autobiography, "I soon realized that we hadn't discovered utopia."

A Life in the Country

Rockwell began noticing that the family across the way lived in dire poverty. And although he was intrigued by the rough-and-tumble stories of the local undersheriff, when he asked him to pose for a *Post* cover the man arrived at his studio with a broken collarbone and a swollen hand that he'd gotten during an attempt to arrest two unruly teenagers.

Being offered a grittier take on rural life invigorated Rockwell rather than demoralized him. He found that country living had a reality and energy that he was able to deal with. He and his family rapidly integrated into the town. Its events and people became inseparable from his inspiration and his painting.

Rockwell was in great need of involvement and inspiration. George Lorimer had retired from the *Post* in the mid-thirties, depriving Rockwell of the stern yet nurturing authority figure who had guided his career at the renowned magazine. He was replaced first by Wesley Stout, an editor whom Rockwell said

unfailingly made him rework his covers, and finally by Ben Hibbs, who was responsible for revitalizing the *Post* and bringing it into the new decade.

Hibbs was a precursor of the casual, hard-working, unceremonious editor of today. He spent the day in the office in his shirt sleeves and did not bother wielding a power image by the dramatic placement of his desk before an imposing skyline or by overly authoritative behavior. He could delegate responsibility and, most important for the artist, he was very supportive of Rockwell's work. In 1942 Hibbs changed the cover banner of the *Post*, adopting a new style of lettering. Now Rockwell had to design his covers to go under or around the type, whereas in the past they had gone behind it.

The War Effort

Meanwhile, Rockwell was developing a new approach to his imagery. In his zeal to contribute during this second World War, he created motivational and human interest covers, sketches, and posters that gave people a glimpse of wartime America and inspired them to get involved in the war effort. During World War I he had faked some overseas scenes by using models and costumes. This time he confined himself to civilian scenes having to do with the war or else to real reportage.

The most celebrated of Rockwell's wartime art is the series of paintings called "The Four Freedoms." They were an attempt to make the 1941 Four Freedoms proclamation of the Atlantic Charter more

LISTENING TO WAR NEWS

Oil on canvas, first printed on the cover of The Saturday Evening Post, *April 29, 1944.*

Whereas during World War I Rockwell had fabricated scenes from the warfront, during the Second
World War, he concentrated on civilian involvement and real first-hand reportage. World War II was the
first war that occurred in the wireless era, and listening to war news became a nightly ritual for many.

Rockwell would speak at length about his sudden flash of inspiration for this series. He had been completely intimidated in having to deal with such lofty, rather abstract subject matter—with such crucial implications for the war effort. Then, late one night, he remembered a local town meeting in which a man had stood and bravely voiced a very unpopular opinion. Rockwell had been impressed by the calmness with which the townspeople were willing to hear the dissenter out. This situation gave him the basis for *Freedom of Speech*.

Yet Rockwell had a hard time getting a focus for this painting. He tells us that first he developed the idea of showing a large town meeting, with the lone dissenter standing up in the center of it. Then, and possibly because the use of photography had made him flexible about the angle of his perspective, he got the idea of an extreme close-up on the dissenter and the several people around him. As we look at the painting, our point of view seems to be from the level of those who are sitting, craning their necks to see the standing speaker, whose gaze is fixed forward and upward, as if upon some ideal.

What strikes us most about this intimate perspective is the number of attitudes Rockwell was able to squeeze into his narrow framework. The white-haired man beside the speaker seems to be listening with bemused tolerance, perhaps tinged slightly with irony. The upturned eyes of the woman next to him seem guarded, perhaps startled by the speaker's boldness. The man next to her hasn't bothered to shift his gaze to the speaker, but his slightly arched eyebrows and pursed lips seem to indicate disapproval, or at least a lack of interest.

Rockwell's interpretation of the Four Freedoms shrunk their applicability so that his audience could relate to them. He tailor-made them for the average

LIBERTY GIRL

Oil on canvas, first printed on the cover of The Saturday Evening Post, *September 4, 1943.* While the men were off fighting in World War II, the women back home took up the slack to keep the country running. Here, Rockwell's Liberty Girl shoulders the burden of her extra responsibilities.

accessible to every American. In many ways Rockwell's devotion to the series was a very successful attempt on his part to deal with a nagging conflict. He was attracted to the minutiae of day-to-day life, to small towns, and to unremarkable, everyday America; but he saw no use in continuing to paint if his work did not somehow delve into the deeper truths of human experience. He wanted to be accessible without being hackneyed. Still, he was nervous when it came to the "grand" subjects of human existence. "I just can't handle world-shattering subjects," he said in his autobiography. "They're beyond me, above me. Not that I ever stop trying. I'm very forgetful of my failures, and every new idea fills me with hope."

FREEDOM OF SPEECH

Oil on canvas, From The Four Freedoms series; first printed in The Saturday Evening Post, *February 20, 1943.* Inspired by a town meeting in rural New England at which he witnessed a farmer voicing an unpopular opinion, Rockwell was determined to capture the calm tolerance of the townspeople as well as the bravery of the speaker. Painting from the perspective of a seated participant, Rockwell places the viewer right in the meeting room.

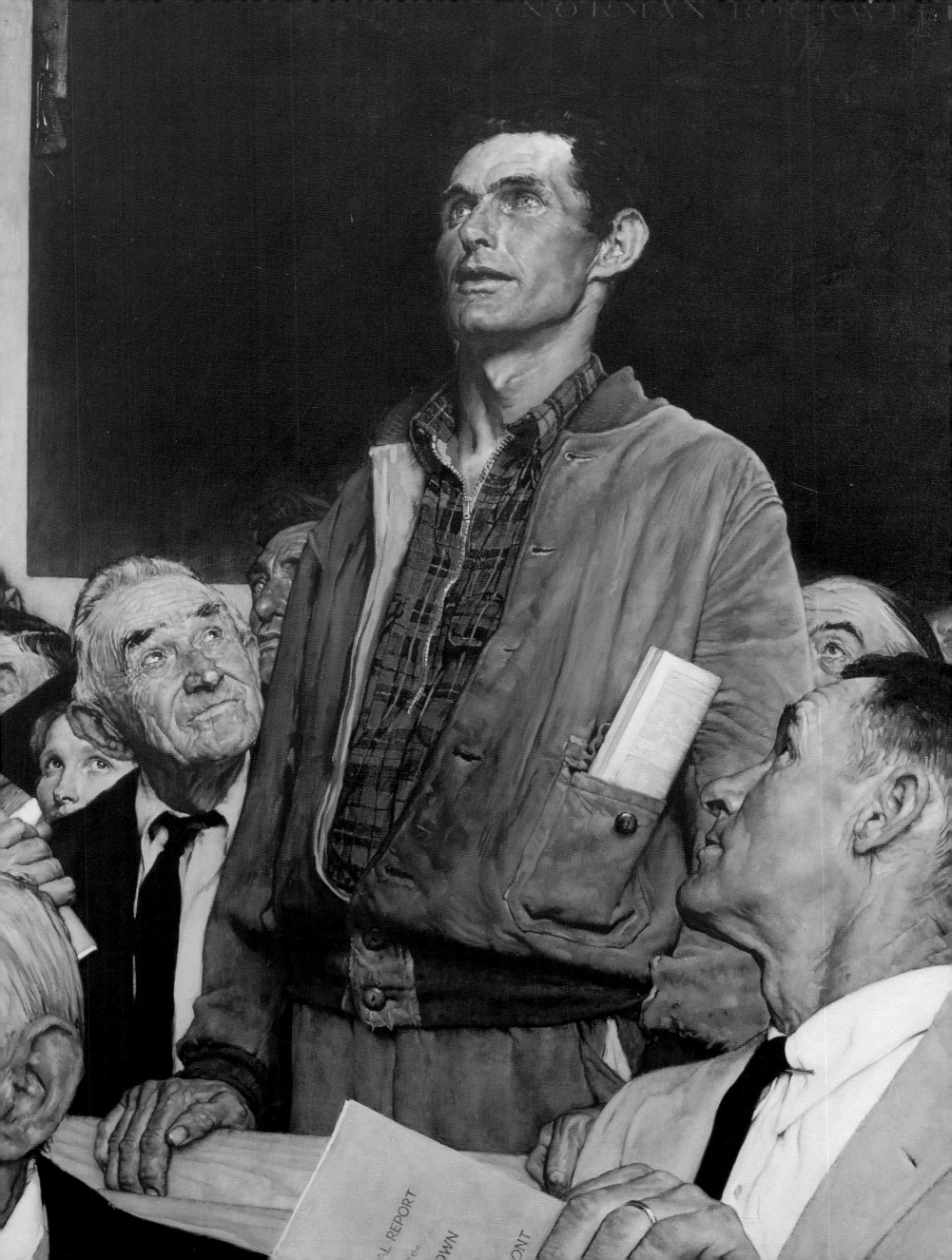

well-fed American, who wanted to know what these abstract concepts could possibly have to do with his or her life. So specifically American was Rockwell's interpretation that some reports from war-torn Europe, which was suffering from food shortages, cast cynical aspersions on the painting *Freedom from Want,* which shows a well-fed family grinning at the arrival of an enormous roast turkey.

Buechner uses the Four Freedoms as a way of discussing Rockwell's new relationship to the art of photography. He points out that each of the four paintings puts the viewer in a different relationship with the subject: close to the speaker of *Freedom of Speech* and seeing him from the angle of those who are sitting; in *Freedom of Religion,* exceedingly close to and on the same visual level as the subjects; several yards away from the peaceful family in *Freedom from Fear;* and sitting, virtually at one end of the dining room table, in *Freedom from Want.* Buechner also points out how these works betray a new dependence upon photography, so that Rockwell is constrained by obscuring with paint the lines established by the photographs he used. This makes the surface look thin, with all the paint crowded within the outlines.

Three of the four paintings—*Freedom from Want, Freedom from Fear,* and *Freedom of Speech*—achieve a naturalistic effect by including ample background detail. However, *Freedom of Religion,* which is so crowded with figures that there is no room for background, is more archetypal, the necessity being to represent a variety of religious behavior within one space. It took Rockwell two months to get this particular work right, mostly because there was no naturalistic space where identifiable members of each of the religions would be likely to congregate.

ROSIE THE RIVETER

Oil on canvas, first published on the cover

of The Saturday Evening Post, *May 29, 1943.*

Rockwell acknowledges that by filling in at the factories,

women were not only helping out on the home front,

but playing an active role in winning the war. Note the

copy of Hitler's *Mein Kampf* crushed beneath Rosie's feet.

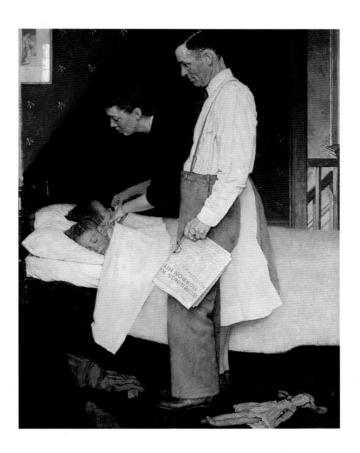

FREEDOM FROM FEAR

Oil on canvas, From The Four Freedoms

series; first printed in The Saturday

Evening Post, *March 13, 1943.*

As war tore through Europe and the Pacific, Americans lived with the not-so-distant threat of an attack on their own shores. Rockwell's *Freedom from Fear* probably touched a nerve with many Americans, particularly those who lived along either coast.

Surprisingly, Rockwell was at first unable to convince the United States government to sponsor his Four Freedoms series. They were instead published early in 1943 inside the *Post,* accompanied by essays about each of the four freedoms. It wasn't until then that the government voiced its enthusiasm, praising the inspiring messages of the series. They were published at a time when the war on the fronts seemed a losing battle, and they worked to boost the morale of many Americans. Eventually, Rockwell's "Four Freedoms" were taken on a tour of the nation by the Treasury Department and used to sell over a hundred million dollars worth of war bonds.

Another famous Rockwell work during the war was the *Post* cover Rockwell completed in 1943 showing *Rosie the Riveter,* a stout and staunch defense worker wearing overalls. Rosie became a symbol for the war effort on the home front and never lost her popularity throughout the rest of the war. Few knew that Rockwell had not used a live model for this cover. "Rosie" was actually an adaptation of Michelangelo's "Isaiah."

NORMAN ROCKWELL VISITS A RATION BOARD

Oil on canvas, illustration for The Saturday Evening Post, *July 15, 1944.*

During the war years, rationing scarce goods became an everyday reality of civilians' role in the war effort. Rockwell visited a ration board in Manchester, Vermont to do research for this painting, which appeared as an interior spread in the *Post*. He placed himself in the work, seated to the left.

THE SATURDAY EVENING

POST

OCTOBER 5, 1946 10¢

THE CASE OF ·
ERLE STANLEY GARDNER
By ALVA JOHNSTON

WASHINGTON, D.C.
By GEORGE SESSIONS PERRY

WILLIE GILLIS

**WILLIE GILLIS
IN COLLEGE**

*Oil on canvas, first published
on the cover of* The Saturday
Evening Post, *October 5, 1946.*
Rockwell followed the
fictional Willie Gillis
through his military
career, ending with its
natural conclusion—
Willie attending college
on the G.I. Bill.

The Willie Gillis series

Rockwell's involvement in boosting wartime morale also took the form of posters, calendars, *Post* covers, and other illustrations. He trailed paratroopers through their maneuvers, going up with them in a plane and then spending a night on a train with them, sketching them as they lounged, dozed, told tall tales, wrote home, watched a blonde out a window, or shaved. His black-and-white sketches of these activities appeared in the *Post*, which informed the reader that army censors would have refused to allow photographers to record the details of the scene but that Rockwell had caught it as perhaps no camera could. And he had.

In these sketches, Rockwell's talent as a gentle caricaturist is full blown. We see "Ole Sarge" from the back, his fat neck spilling over his collar; and a line of lanky paratroopers, their tough little chins pulled

sharply back, their caps balanced jauntily on their close-shaven heads. Some of them are "types," familiar to most Americans, but others, such as the careful sketch next to the signature "Ralph H. Bogle, capt.," have an individuality whose details Rockwell was able to render with extraordinary economy.

When Rockwell worked in the studio, he resorted to models to represent his military men. His most successful illustrations done in this manner were the "Willie Gillis" series. This series came from an idea that Rockwell had for depicting the adventures of a young civilian who has just been drafted and finds himself caught up in military life. Rockwell's wife came up with the moniker "Willie Gillis," and one night at a square dance Rockwell realized he had found Willie in the person of Bob Buck, a young sawmill worker whom Rockwell thought was exempt from the draft. Rockwell painted him as a young recruit who has just received a package marked "Food: No Delay" and is being closely followed by a group of much stronger, much older enlisted men intent on getting a share of the booty. He followed him through an imaginary military career ranging from basic training to service in India. The paintings were an enormous success, but, to Rockwell's dismay, Buck managed to get into the navy.

Rockwell was left without a model. He had to rely upon some photos of Buck which he used in a painting showing Willie's girlfriend, alone, faithful, and asleep before midnight on New Year's Eve, with photos of Willie on the wall above her bed. Rockwell used the photos again in a somewhat hackneyed *Post* cover from September 16, 1944, showing several generations of fighting Gillises from the Revolutionary War onward, juxtaposed against the smiling contemporary G.I. Gillis.

GILLIS MEN IN UNIFORM

Oil on canvas, first printed on the cover of
The Saturday Evening Post, *September 16, 1944.*
When his Willie Gillis model went into the Navy, Rockwell found
himself without a face and figure from which to draw the popular
character. Working from photos of the model, Rockwell satisfied
the public—and the *Posts'*—demand for more Gillis covers by
creating settings in which only Gillis' face appeared.

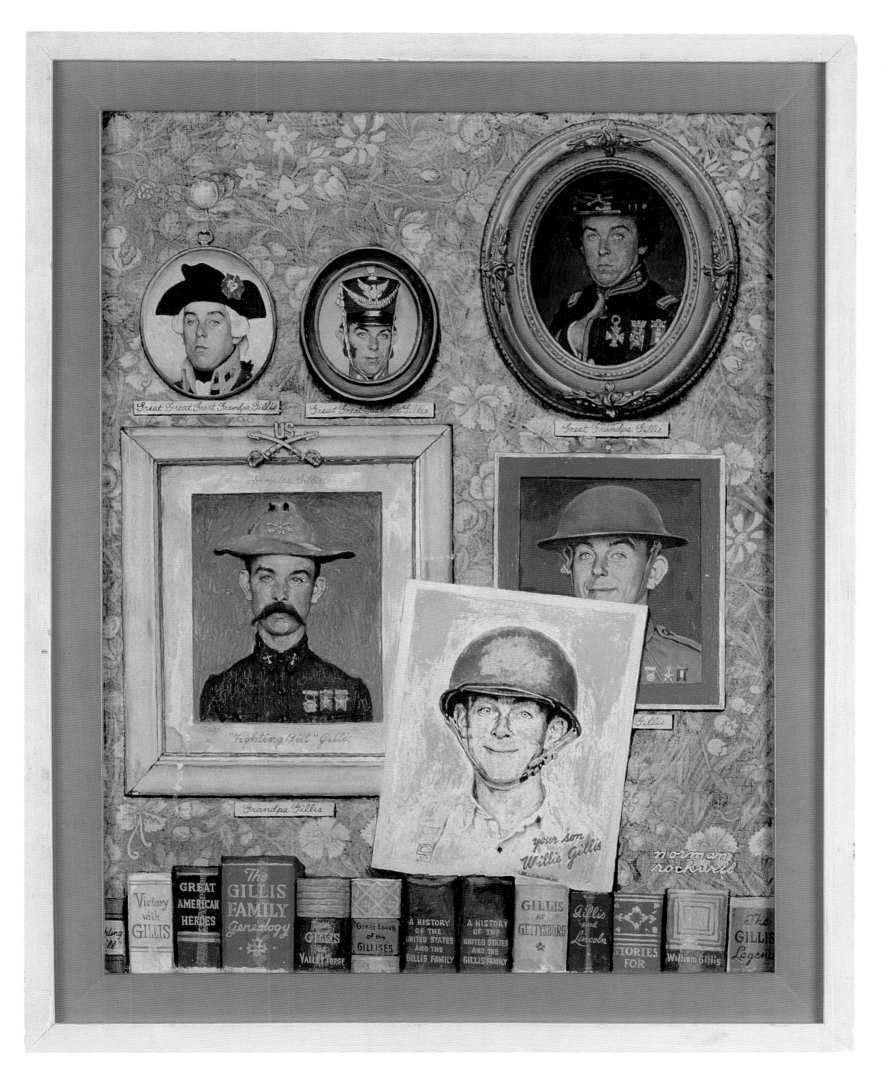

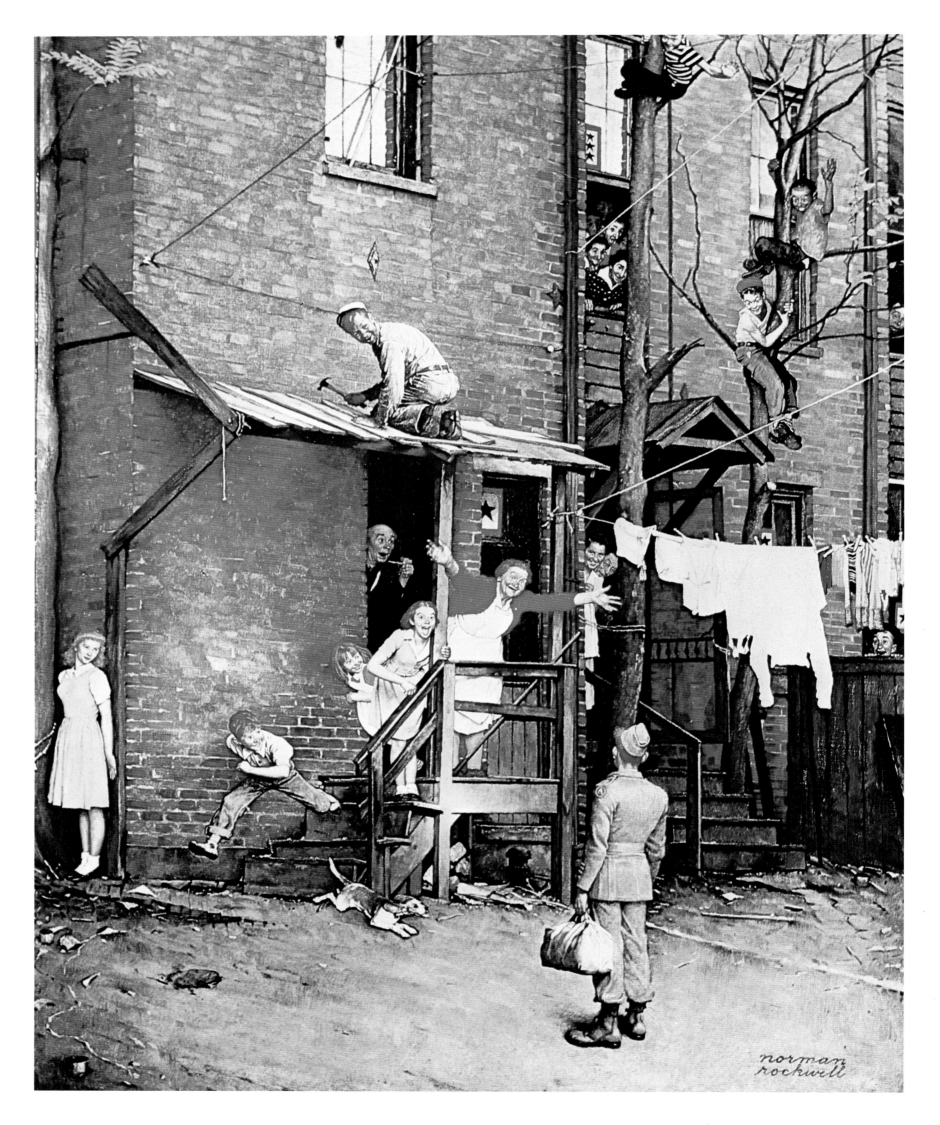

Postwar Realism

When the war came to an end, Rockwell painted several memorable homecoming covers. One portrayed a marine recounting the landing at Iwo Jima to some friends in a garage; another extremely evocative cover depicted a sailor, who had just come home, basking in a hammock, his shoes kicked off and a dog in his lap. A third showed the reactions of some tenement dwellers to a G.I.'s homecoming. This painting is complex, boisterous, and charming, with some multiracial elements that, up to this time, were unusual for Rockwell. Of the three boys hanging and grinning down at the G.I. from their perch on tree trunks, one is black. Although it is hard to decide whether the neighbors peering from their window in the building next door are pointedly Italian, Jewish, or some other ethnicity, they are decidedly non-Anglo-Saxon looking.

It was during this period that Rockwell fully developed his capacity to render detailed architectural backgrounds. His tenement painting realistically shows the bricks and wooden back porch structures of a tenement. This is a long way from his thirties-era silhouettes set against stark, often geometric backgrounds. Developing such backgrounds must have represented quite a challenge for Rockwell, for, although he now placed his figures in very complicated architectural settings, they lost nothing of their naturalistic gestures and body language.

He had, he tells us, taken an increased interest in setting. For his *Post* cover of April 6, 1946, portraying two charwomen sneaking a peek at a discarded program after a theater performance, Rockwell went to a theater to sketch and photograph the aisles. He also took measurements to get his proportions right, and this despite the fact that little more than a few seats in the darkened theater can be seen in this particular painting.

HOMECOMING G.I.

Oil on canvas, first published on the cover of The Saturday Evening Post, *May 26, 1945.*

Alive with action and full of charming details, this homecoming scene is distinctively multicultural, with a realistic background and alive with action.

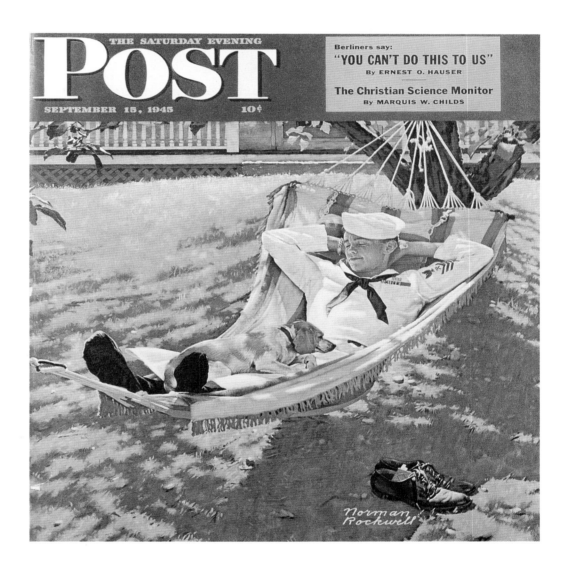

All in all, the new emphasis on setting entrenches Rockwell even more firmly in the realist camp, an effect that is heightened by the changing visual perspectives possible to him through the use of photographic studies. In these paintings, the viewer tends to "get lost" in the pleasure of the details, each one of which confirms that the painting is "real."

In a 1948 oil painting for an advertisement for the Watchmakers of Switzerland, our eyes are drawn even more irresistibly to the repaired watches hanging on the wall behind the watchmaker than to the people in the painting. And in a July 24, 1948, cover for the *Post*, called *County Agricultural Agent,* it is the red expanse of barn wall, with its interesting defects, that leads us horizontally across the painting and offers equal emphasis to each figure pictured.

HOME ON LEAVE

Oil on canvas, first published on the cover of The Saturday Evening Post, *September 15, 1945.* Here, Rockwell once again paints the warm comforts of home, as a sailor naps in his own backyard, his faithful dog on his lap.

American Icon

In 1943 Rockwell suffered one of the major traumas of his life. As he was switching off the light in his studio late one evening, he must have dropped a few embers from his pipe onto a cushion, for that night his studio burned to the ground. He lost original paintings, drawings, and notes as well as costumes, books, prints, and antiques. Rockwell gave up his home and moved into a house in the town of Arlington, where he built himself another studio.

As a way of lightening up the incident, Rockwell did a page of very amusing sketches for the *Post* entitled "My Studio Burns." They reassert his capacity for caricature and please us by their willingness to indulge in self-parody. But they also make us consider the kind of strength involved in turning such a disastrous experience into a piece of public entertainment.

By that time in his career, however, Rockwell seemed to be more secure and open than he had ever been. And he was receiving real attention from art critics. In 1941, he had been given a one-man show at the Milwaukee Art Institute. His "Four Freedoms" had been praised as a true aesthetic accomplishment and exploited as a meaningful donation to the war effort by the government. In 1945 Rockwell was profiled in the *New Yorker*. And in a few years he would be doing a calendar series for Brown & Bigelow and Christmas cards for Hallmark.

In 1946 Rockwell was the subject of a monograph by Arthur Guptill, which obliged other critics—whether they liked it or not—to take him more seriously. In that monograph Guptill provides detailed descriptions of Rockwell's home in Arlington, his studio, his physical appearance, and his artistic techniques. At the beginning of the study, Guptill takes the reader past the requisite quaint inns, historical plaques, and Protestant church into West Arlington, and over a covered bridge dating from 1852, to the colonial farmhouse where Rockwell and his family now lived. The reader is treated to an intimate description of Rockwell's studio, which is reached from the house via a charming flagstone walk that winds pat a smokehouse, garage, and corncrib.

The studio is a barnlike building, designed by architect Payson Rex Webber, based on the one that had burned. It has a dark room, a room with a work bench, and a main studio, where Rockwell works. Light can be controlled or eliminated altogether by shades, and a balcony contains racks for pictures, frames, and canvases. We are also treated to a handsome photo portrait of the artist, pipe in mouth, a cluster of brushes in one hand, while the other hand paints a canvas on an easel.

"The artist is tall, wiry, and energetic—boyish for his years," the caption below the photograph informs us. "An indefatigable worker, he has produced during three decades an amazing number of pictures." The monograph continues, in obsessive detail, describing just how Rockwell paints a picture, all the charms of his personality, and all the quaint appeal of his life with his family. What we are left with, all in all, is a portrait of an American icon, someone who, at last, sits comfortably atop a bridge connecting America's need for serious art to its love of popular entertainment.

MERRY CHRISTMAS

Oil on canvas, first printed on the cover of The Saturday Evening Post, *December 26, 1942.* Rockwell takes a moment away from the very serious and often tragic news of the day to remind *Post* readers of the joys of the season.

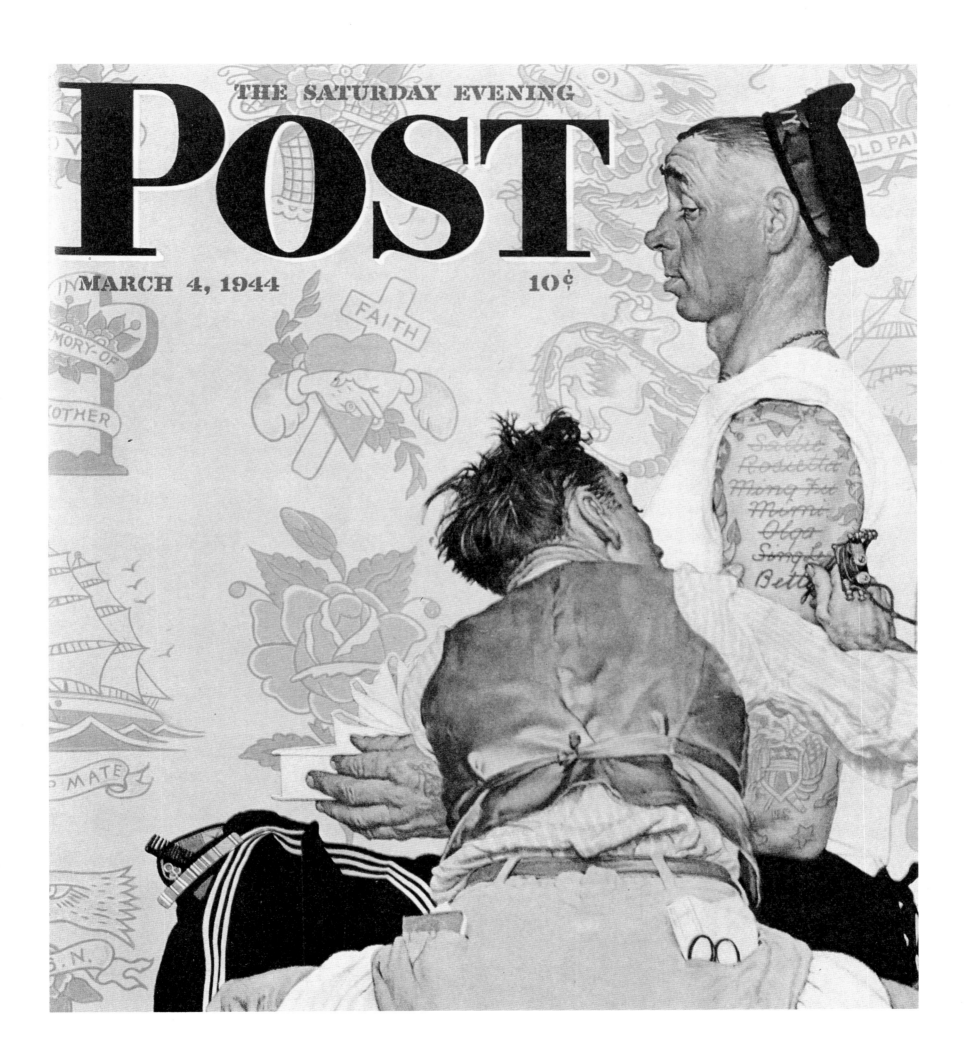

THE TATOO ARTIST

Oil on canvas, first published on the cover of The Saturday Evening Post, *March 4, 1944.*

Rockwell frequently used his friends and family as models for his paintings. His friend close friend

and fellow illustrator Mead Schaeffer posed as the tattoo artist in this classic scene.

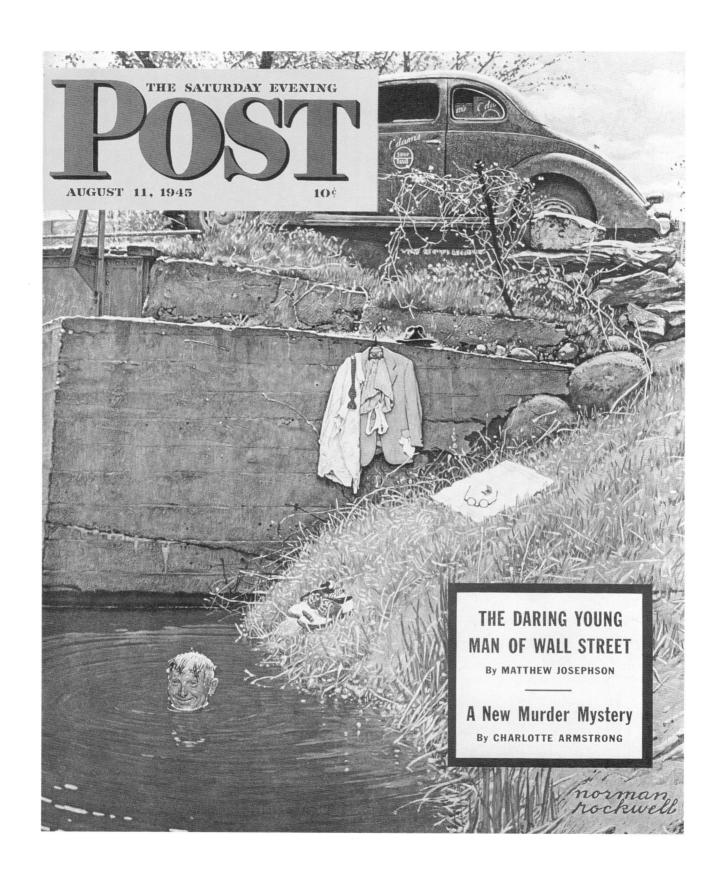

THE SATURDAY EVENING POST

AUGUST 11, 1945 10¢

THE DARING YOUNG
MAN OF WALL STREET
By MATTHEW JOSEPHSON

A New Murder Mystery
By CHARLOTTE ARMSTRONG

SWIMMING HOLE

Oil on canvas, first published on the cover of The Saturday Evening Post, *August 11, 1945.*

While most of Rockwell's earlier work was dominated by figures

with at most a sparse background, here Rockwell develops

an entire scene in which the character plays only a minimal role.

APRIL FOOL

Oil on canvas, first published on the cover of The Saturday Evening Post, *April 3, 1943.*

In the 1940s Rockwell grew more interested in and adept at
conceiving complex backgrounds. Here, he fills the scene with surrealistic
impossibilities, challenging the viewer to find all forty-five of his tricks.

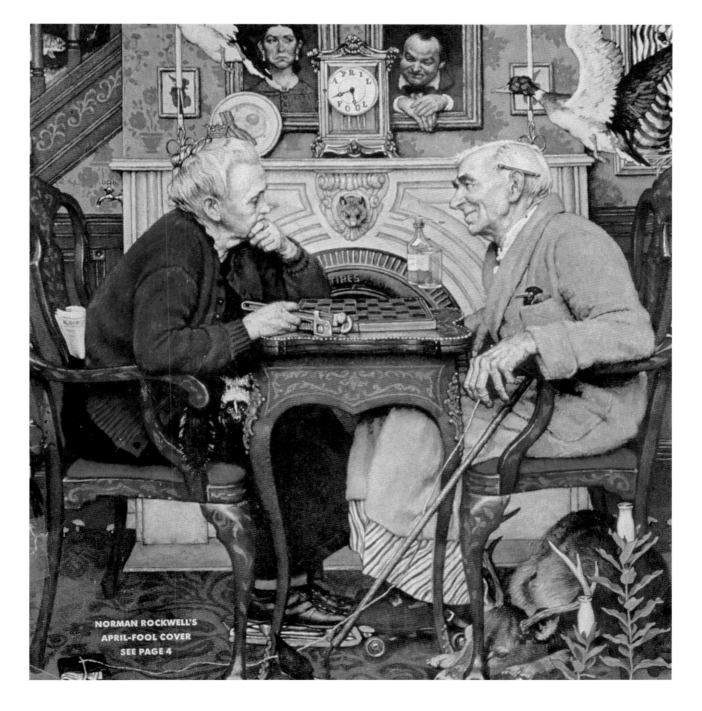

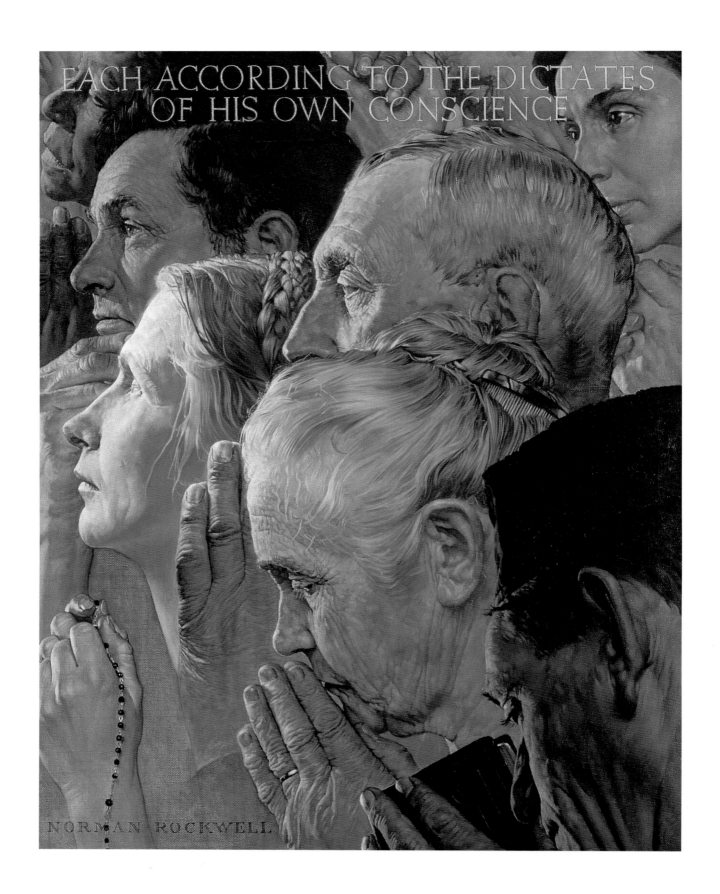

FREEDOM OF WORSHIP

Oil on canvas, From The Four Freedoms series;

first printed in The Saturday Evening Post, *February 1943.*

Initially, Rockwell had difficulty expressing freedom of religion.

He had been able to set each of the other scenes in a

natural, realistic setting, but he was unable to create a situation

which captured a diversity of religious expression in one place.

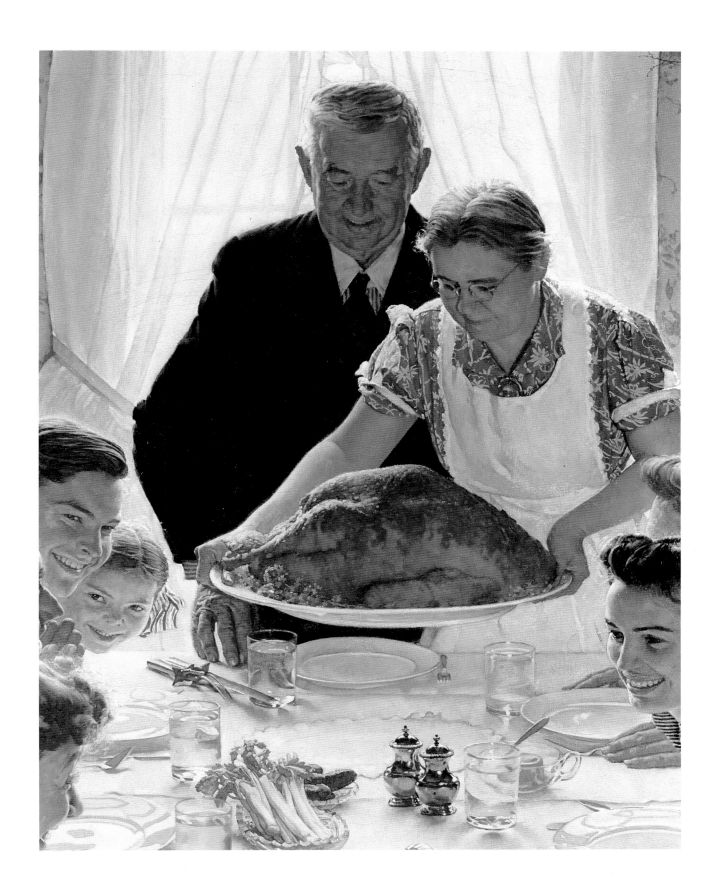

FREEDOM FROM WANT

Oil on canvas, From The Four Freedoms series;

first printed in The Saturday Evening Post, *March 6, 1943.*

The Four Freedoms were outlined by President Roosevelt in a Congressional address
in January 1941, and were incorporated into the Atlantic Charter a few months
prior to the United States' entry into World War II. Rockwell's series was intended
to make the lofty ideals of the Four Freedoms understandable on a personal level.

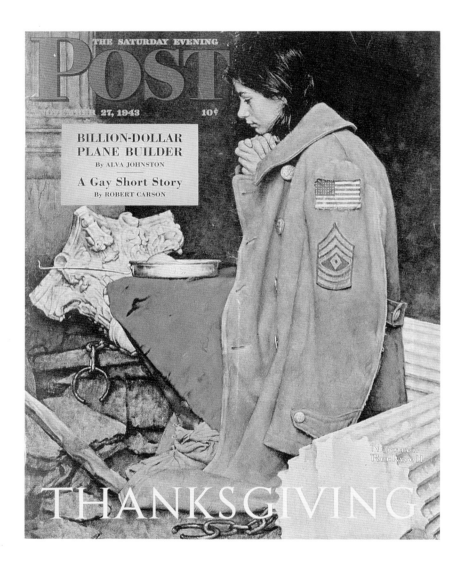

THANKSGIVING

*Oil on canvas, first printed
on the cover of* The Saturday
Evening Post, *November 27, 1943.*
Rockwell's 1943 Thanksgiving
cover for the *Post* shows
not an American family, but a
European woman in a war-torn
setting, wrapped in an Ameri-
can soldier's coat. Her head
is bowed in grateful prayer
as she prepares a meal in a
United States Army-issue pan.

HOME FOR THANKSGIVING

Oil on canvas, first printed on the cover of The Saturday Evening Post, *November 24, 1945.*
Here Rockwell captures the soldier at home for the holidays, peeling potatoes
with his mother before the holiday meal. His uniform contrasts with the
simple, mundane nature of the task at hand, and his warm expression suggests
that these are the kinds of pleasures that soldiers miss most about home.

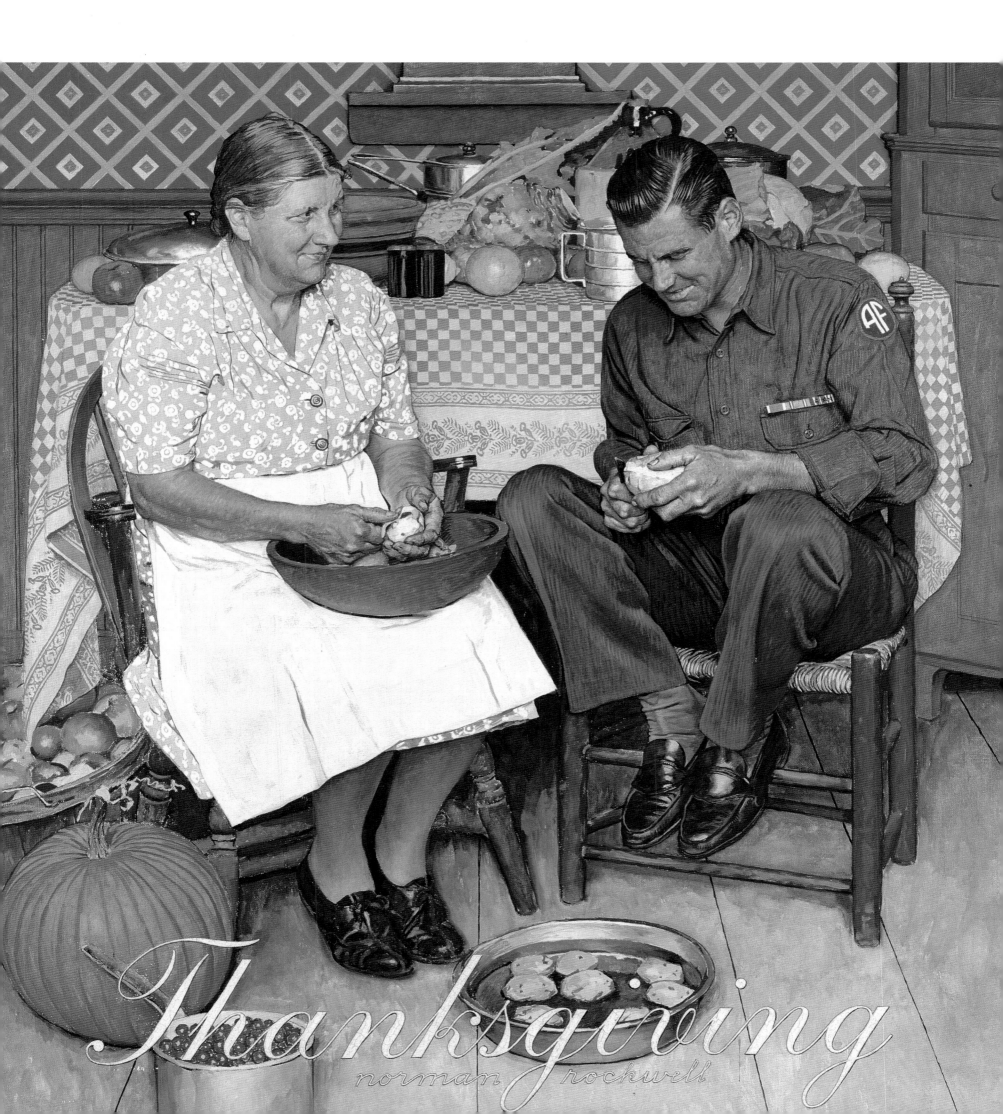

Thanksgiving

norman rockwell

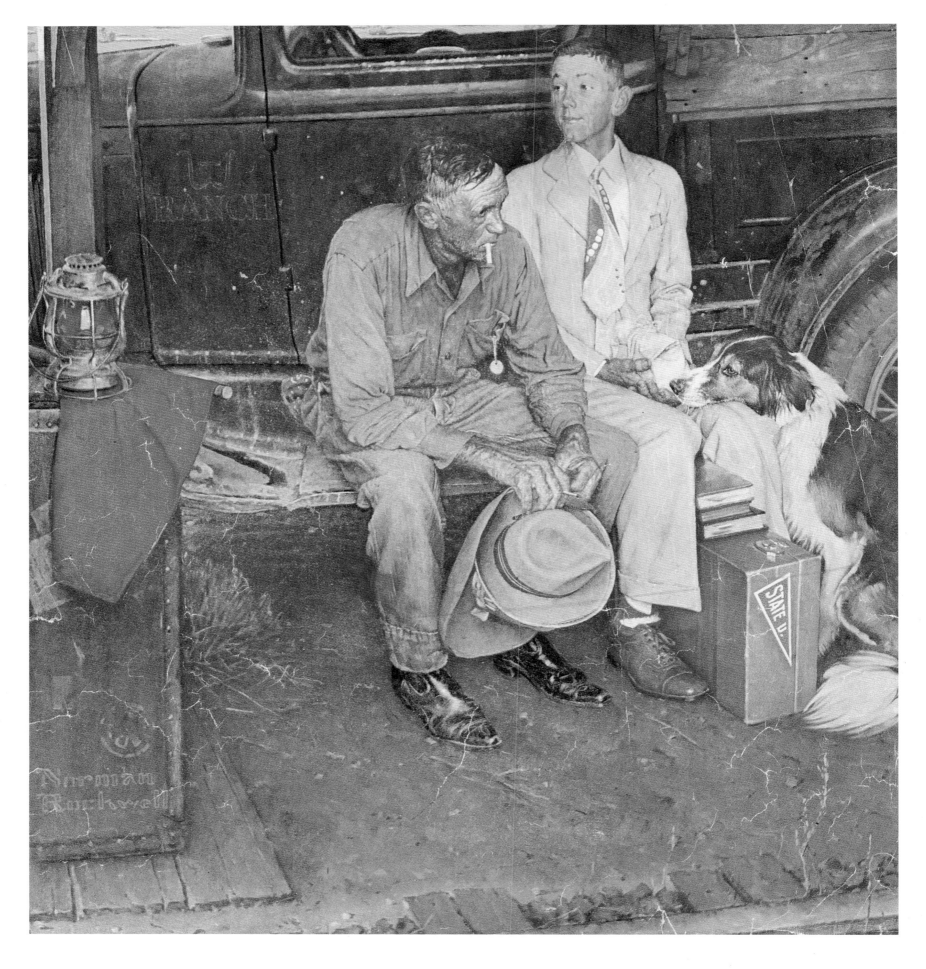

POST-WAR AMERICA

By the 1950s, one editor at the *Post* surmised that a Rockwell cover could stimulate an extra 50,000 to 75,000 in newsstand sales. However, those familiar with Rockwell's life would be the first to point out his hatred of artistic complacency.

The fact that he had become an American icon with an adoring audience and a stable family may have been exactly what began to fill him with a profound sense of restlessness. It was an emotional disability that reared its head at every watershed in his long and dynamic career. It always took the same shape: disillusionment and insecurity, a feeling that he had lost his creativity, and despair; and it was always followed by determined work and then triumph.

Breaking Home Ties

Such a crisis came again when Rockwell and his family, on his urging, left Arlington in Vermont in 1953 to move to Stockbridge, Massachusetts, in the Berkshires. Rockwell thought a change of scene would help him, but, initially, it did not. This time he sank into a real depression.

Rockwell sought help at the Austin Riggs Center, a psychiatric institution in Stockbridge. He wasn't coming apart but he had weathered such crises enough times to have finally come to the decision of wanting others' help in dealing with them. Fortunately, he found the renowned psychoanalyst Erik Erikson, who had been a colleague of Anna Freud and had been the first to develop the concept of "identity crisis."

Rockwell's talks with Erikson proved invaluable in pulling him out his own crisis of identity, and soon his faith in himself as a creative artist was restored.

This period of uncertainty, similar to the one at the start of the 1930s, may have had more of an effect upon his own image of himself than on his actual creative output. Throughout his life, there are a number of discrepancies between his evaluation of the work he produced and others' opinion of it. In 1954 and 1955, still laboring under the burden of his crisis, he painted what some critics consider two of his best pictures.

Breaking Home Ties, the September 25, 1954, *Post* cover, portrays two generations of rural men, most likely a father and son. They are sitting on the running board of a very outdated-looking vehicle, waiting for the train that is to take the eager, nattily dressed young man to college. In contrast to the son's jaunty anticipation is his weather-beaten dad's mildly defeated posture and downcast face, as he muses on the wide gap that is about to separate the two. Seemingly in sympathy with the father is the collie resting its head on the boy's lap, as if urging him not to break the traditional ties that have kept the family in the same place, and perhaps same position in society, for so many generations.

Another work, *Marriage License,* for the June 11, 1955, *Post* cover, demonstrates Rockwell's skill in creating the atmosphere of an interior. A couple with many years ahead of them are carefully filling out a

BREAKING HOME TIES

Oil on canvas, first printed on the cover of The Saturday Evening Post, *September 25, 1954.*

In what is perhaps one of Rockwell's most poignant images, an eager young farm boy awaits
the train that will carry him off to college. His father sits beside him, proud yet apprehensive.

marriage license, while the old clerk, who has no doubt seen so many couples come and go, is lost in his own musings, sitting slightly slumped at his desk, his hands folded on his lap. Outside the window it is sunny and bright. Inside the bureaucratic office, all is old and dark. The contrast in the picture between the new or bright and the dark or old is played out on two levels—one between the conservatively dressed old man and the modern yellow-clad young woman and the other between the gloom of the office and the bright future of the about-to-be-wed couple that lies outside the office. The office is so dark that it is difficult to make out many details, but some objects gleam as if touched by a Vermeer-like light.

Another *Post* cover for that period was the Thanksgiving scene in a train station, where the old lady bows her head in prayer while most of the other passengers stare in curiosity. Rockwell used a neighbor as his model for the old lady, but she died before the painting was published. And he placed his eldest son Jarvis, already a young man, in the painting. We see only the back of the little boy, whose shorn head is also bent in prayer. In a way, this work presents us with the same duality as that evident in *Marriage License,* the clash between the old and the new. But here the old seems to put contemporary America to shame, gently inquiring if it has lost its spiritual values.

Midcentury American Dreams

Rockwell stuck to all his usual themes during the 1950s, especially the subject of boyhood. Throughout his career, he had been associated with the Boy Scouts of America, often painting for their calendar scenes symbolic of young male bonding, mentoring, adventure, and cooperation. From 1926 to 1976, he would illustrate the official Boy Scout calendar every year but one. An often reproduced painting in this genre is that done for the 1950 Boy Scout calendar. It shows a cub scout gazing with serious curiosity at a mural of Washington, his hands clasped in prayer, while an

MARRIAGE LICENSE

Oil on canvas, first printed on the cover of The Saturday Evening Post, *June 11, 1955.*
Rockwell captures the same moment from two distinct
points of view. For the young couple, this is a once-in-a-life-
time event; for the clerk, it's merely another day at the office.

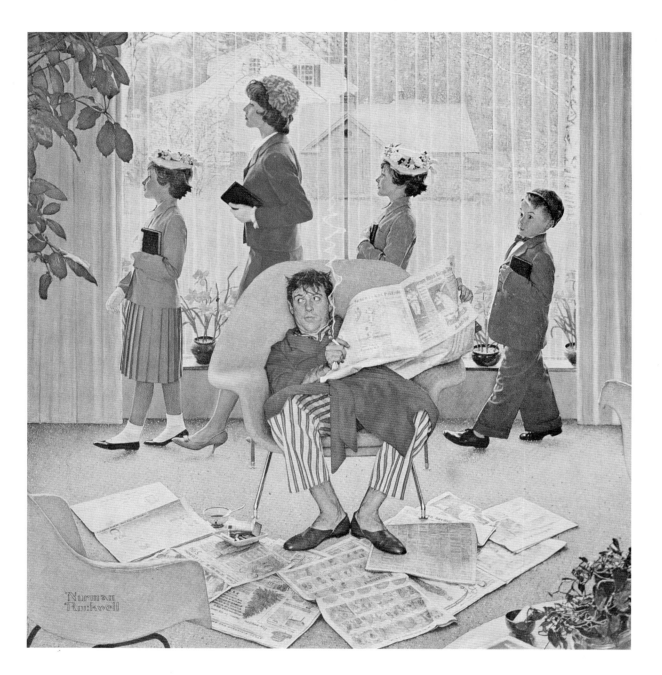

EASTER MORNING

*Oil on canvas, first printed on the cover of
The Saturday Evening Post, May 16, 1959.*
While mother and children
head off to church, father
ducks down behind his
newspaper. Though he was
raised in a religious house-
hold and clearly incorpor-
ated Christian ideals into
his paintings, Rockwell rarely
attended church himself.

noticeable in another *Post* cover,
painted for the April 29, 1950, issue.
The view is of a barber shop as seen
through a window. It is after closing
time, and the half-darkened shop with
its pot-bellied stove seems sunk into
a past from which it can barely be
recovered. The keepers of this past
are in an adjoining room. They are
three old men gathered around a table
while one plays a violin. The golden
light coming from that room illumi-
nates part of the barber shop, like
the enduring though never complete
light of memory.

Rockwell was by this time a *given* of
American culture. His works were dis-
seminated not only on *Post* covers but
in advertisements for Mutual Life In-
surance Company, Crest Toothpaste,
Parker Pens, and American Telephone
and Telegraph. The ads tended to be
much more straightforward than the
Post covers, illustrative of realism
rather than caricature, and of reas-
suring, homey themes instead of
irony or wistfulness.

A 1959 advertisement for Massa-
chusetts Mutual Life Insurance Com-
pany shows two children washing a
trusting dog in a metal washtub while
a pipe-smoking adult looks on in
paternal amusement. Another draw-
ing for the same company, completed
in 1955, depicts a little girl playing dress-up before a
mirror, her hem lifted so that she can get a glimpse of
the high heels she has put on.

Rockwell had succeeded by the 1950s in imposing
his vision of America upon American minds. Those
who came from classes and ethnicities familiar with
his mythology were reassured by his work. Those
who were outsiders to it, but who saw it daily in vari-
ous media, used it as a learning tool, a way to con-
ceptualize middle-class values and mentalities. In *The
Atlantic Monthly*, novelist Wright Morris had written
about Rockwell: "He has taught a generation of Amer-
icans to see. They look about them and see, almost
everywhere they look, what Norman Rockwell sees."

older adolescent boy, dressed as a scout in short
pants, clasps the younger lad round the shoulders, as
if presenting to him the higher code of morality, piety,
and social service represented by Washington.

More than ever, for Rockwell, the subject of boy-
hood was infused with an almost obstinate nostalgia.
However, in the works completed during the 1950s,
one sometimes senses a new, wistful distance be-
tween Rockwell and his subject matter—almost as if
the artist were placing it upon a pedestal. This effect
could be due to the fact that Rockwell's themes were
quickly becoming historical Americana, whereas his
work was presenting them as contemporary.

The feeling of wistful, idealized distance is very

GOING AND COMING

Oil on canvas, first printed on the cover of The Saturday Evening Post, *August 30, 1947.*

In two separate canvases, Rockwell captures an American family at the beginning and the end of a long

outing. The long car trip has clearly taken its toll on mom, dad, and children; grandmother appears unfazed.

The Saturday Evening POST

October 13, 1956 – 15¢

The Case for The Republicans
By Minority Leader JOE MARTIN

Political Portraiture

Not only corporate America was interested in the Rockwellian vision. Political America was also seeking his services. His genius for capturing the nuances of personality made him invaluable as a chronicler of politicians. No camera could record the humanity or vitality of the human expression as he frequently could. Politicians wanted such qualities communicated to their public. Or, as Wright Morris put it, while discussing the political portraits: "It was left to Rockwell to reveal what the camera angles concealed and to give the people the facts—insofar as they were self-evident."

In 1952 Rockwell was summoned to Denver to make preliminary sketches and photographs for some portraits of General Dwight Eisenhower. Rockwell was, as he recounts in his autobiography, rather overwhelmed by the opportunity for such close contact with the celebrated man. Ike's expressiveness and changing moods charmed the primarily apolitical painter. Surviving sketches show the future president as determined, candid, and even—in one picture—slightly pugnacious. But the pose that Rockwell finally settled on presents Eisenhower as bright, guileless, and grinning, with a direct, unguarded gaze.

Rockwell's portrait of Adlai Stevenson, completed in 1956, is just as successful. Stevenson's smile is benign but reserved, his eyes full of clarity, wisdom, and forthrightness. Said Wright Morris of that portrait: "We see the wit and intellectual cut down to our size, not cut down with malice but rather with affection, as the neighbors of a famous man know him to be—a simple regular guy . . . One of us, that is. Not at all the sort of egghead we had heard about."

Even the portrait of Richard Nixon, completed in 1960, captures a sense of gentle determination that Nixon may have possessed but that would be recast as much darker as the years rolled on and his perceived behavior became vilified. An oil painting of John F. Kennedy for the *Post* that Rockwell made in 1960 takes exactly the same approach. Kennedy is portrayed as a man—or rather, as Man—confronting the future with determination, but also with deep sensitivity and humanity.

In the end, it did not seem to matter which politician belonging to what party Rockwell painted. He was more interested in seeing each figure both as a man and as a symbol of the American dream than he was in revealing those morbid details of character that psychoanalysis says make up the individual, or those unscrupulous urges that tabloids now tell us define most of our politicians.

PORTRAIT OF EISENHOWER

Oil on canvas, first printed on the cover of
The Saturday Evening Post, *October 13, 1956.*
Rockwell opted for a direct, honest portrait of Dwight D. Eisenhower, with a warm yet uncompromising expression. Rockwell said that Eisenhower had the most expressive face he ever painted.

PORTRAIT OF JOHN F. KENNEDY

Oil on canvas, first printed on the cover of The Saturday Evening Post, *October 20, 1960.* In 1960, Rockwell produced portraits of both Kennedy and Nixon as they campaigned for the White House. Kennedy's portrait was reprinted on the *Post* cover after his death.

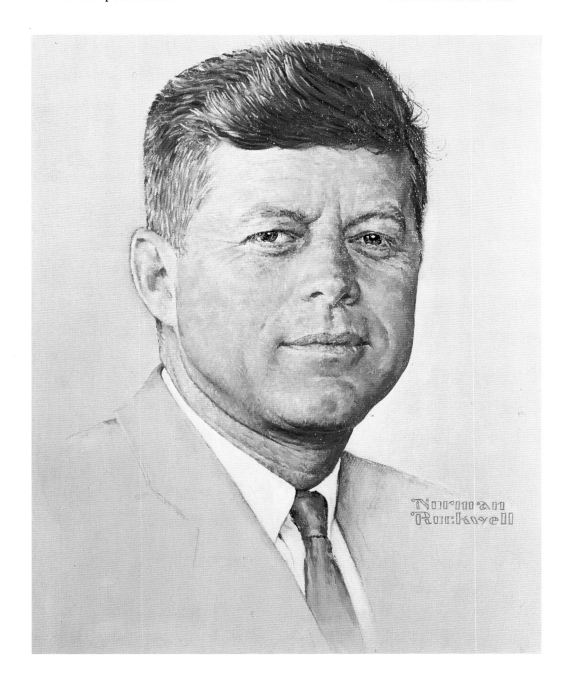

The Charms of Maturity

Rockwell's first house in Stockbridge was by the cemetery. His studio was in the center of town over a meat market. He was pleased with the humble, earnest image as an artist that it conveyed. Eventually, he would move to another house and remodel the barn behind it as a studio, but for the time being he enjoyed his daily contact with the local people. Some blossomed into friendships as it had in Arling-

ton, and the townspeople became his models.

For the March 15, 1958, cover of the *Post,* he painted *Before the Shot,* with its memorable image of the little boy with his pants lowered while the doctor prepares an injection. He used his own doctor, Donald Campbell, as a model. He also reproduced Campbell's home office, though he changed the color of the floor, moved a desk, and added a window. A neighbor's son, named Edward Locke, posed as the little boy.

Thirty-one years later, upon the doctor's retirement, *People* magazine would restage the painting as a photograph for their pages. When interviewed, the good doctor would convey a description of Rockwell that was totally in keeping with his public image. "We all liked the son of a gun," he told the reporter. "He'd ride his bike to his office above the grocery store every day, as regular as clockwork. He was a hardworking guy, but always ready with a smile and a hello, always time to talk. There was certainly a lot of the milk of human kindness in his veins."

Dr. Campbell also told about an incident in which Rockwell had come to the aid of Campbell's traumatized four-year-old daughter, who had been chased by a dog as she road her bike. "Norman came along, calmed her tears and then put her on his knee," said Campbell. "He drew her a series of pictures, of a little girl riding a bicycle, then being chased by a dog and falling off the bike. The last panel showed the dog licking the little girl's face, and he said, 'See? The dog only wanted to kiss.'" The gesture reads like

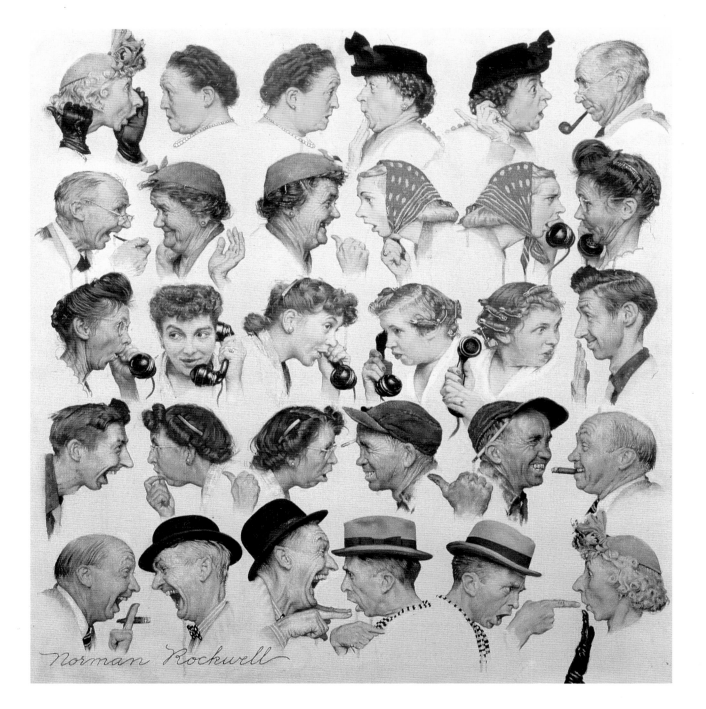

Norman Rockwell

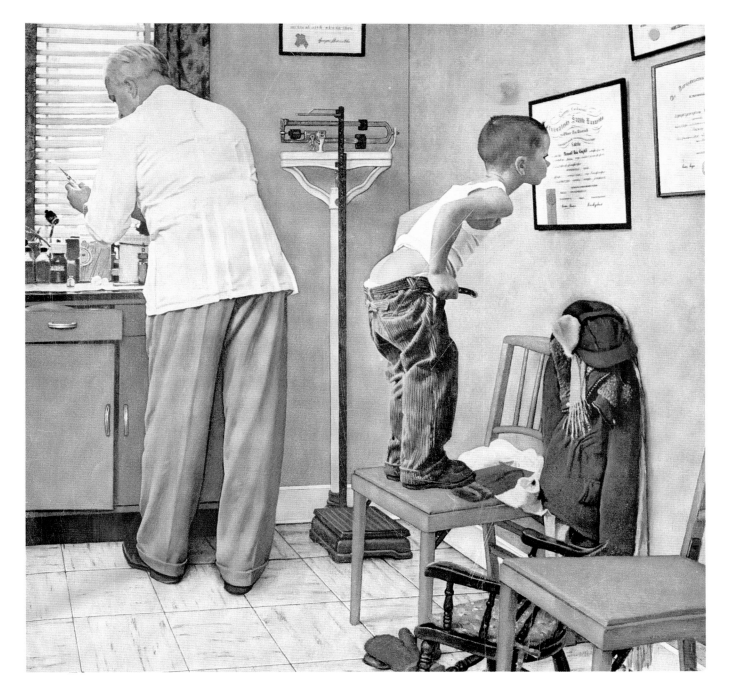

BEFORE THE SHOT

Oil on canvas, first printed on the cover of The Saturday Evening Post, *March 15, 1958.* One of Rockwell's most enduring images, *Before the Shot* adorned the walls of countless doctors' offices around the country. Upon the retirement of Donald Campbell, Rockwell's own doctor and model for the image, *People* magazine restaged the image as a photograph.

typical Rockwellian sublimation. When things don't go exactly right, they can always be reinterpreted by the medium of art.

In 1957 Rockwell created a series of calendar illustrations called *The Four Seasons*, which featured studies of an elderly couple. He explained his motives for portraying them as follows:

> In a world that puts such importance on the pursuit of youth, it is good to consider, occasionally, the charms—and the comforts—of maturity. For whatever else may be said, maturity fosters familiarity which in turn gives feelings of security and understanding that are valuable. In these days of continuing change, I have tried to show these feelings in the paintings for the new Four Seasons calendar.

> My pictures show two people who, after living together for many years, have reached the stage of

sympathy and compatibility for which all of us strive. They know their weaknesses and their strengths. They are comfortable and secure in their relationships with each other. And while Mother presumably takes Father's strong points for granted, she's still trying tolerantly to keep him on the straight and narrow when signs of frailty appear.

This was, perhaps, Rockwell's baldest verbal statement in favor of age and old ways. In *The Atlantic Monthly*, Wright Morris poked gentle fun at it: "Maturity, whatever else may be said, seen through the forbearance of Mr. Rockwell, seems to be an adolescent pipe dream of the genial aspects of senility. The pursuit of youth is made more visible, rather than less, in these gentle fuddy-duddies, Mom and Pop, and their pathetic inability to grow up. . . . Nothing will touch them but the postman with his monthly retirement check."

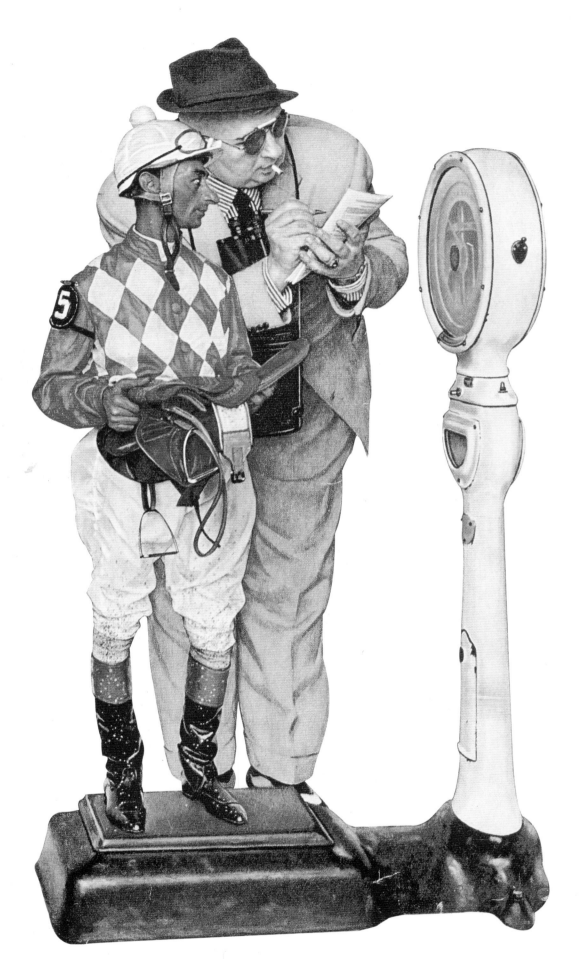

WEIGHING IN

Oil on canvas, first printed on the cover of

The Saturday Evening Post, *October 24, 1959.*

Horse jockey Eddie Arcaro is shown here in

mud-splashed silks, weighing in before a big race.

The Culture Wars

Was Rockwell becoming as out of touch, as such remarks implied? Certainly his work shows little recognition of the thunderous upheaval among the young lurking under the serene facade of the fifties and about to explode in the next decade.

While Rockwell continued to paint his scenes of small-town life, rock 'n roll, Marilyn Monroe, James Dean, Elvis Presley, and juvenile delinquent gangs had already upset cultural notions of popular music, sexual decency, and youth. Television was threatening to supplant Rockwell's medium as a cheap way of disseminating nostalgic America. The Cold War and Communist scares were forcing complacent Americans toward a more international perspective. Rockwell must have felt these encroaching changes and he must have questioned his work in relationship to them.

A 1958 *Newsweek* profile of Rockwell contained a photo of him at his easel with the caption: "Illustrator Rockwell: Some serious doubts at 64." It portrayed him as wondering what would have happened "if I hadn't gone commercial," and claimed that next year, when he turned sixty-five, Rockwell intended to see "'if there's anything else in me' besides calendar illustration and *Saturday Evening Post* covers." At this point in Rockwell's career, the article claimed, only one of his works was in an established museum. The Metropolitan Museum of Art had bought the canvas *Freedom of Speech* for $250. Rockwell's only hope at the time was that he would be remembered as the creator of "authentic period pieces." He also hoped that his three sons, all emerging artists, would win the critical acclaim he had never achieved.

As the decade drew to a close, Rockwell would begin to think about tackling some of the critical social issues surrounding race and international relations. He would approach these momentous subjects earnestly and with all his graphic skills at their pinnacle.

Eventually, his sixty-year career would become a thing for others to become nostalgic about. A later Rockwell revival would lionize him as one of the greatest of American illustrators. Throughout all of this, he would continue to work tirelessly, always humble and rarely heeding the coming signs that he was to receive a permanent place in the annals of American art.

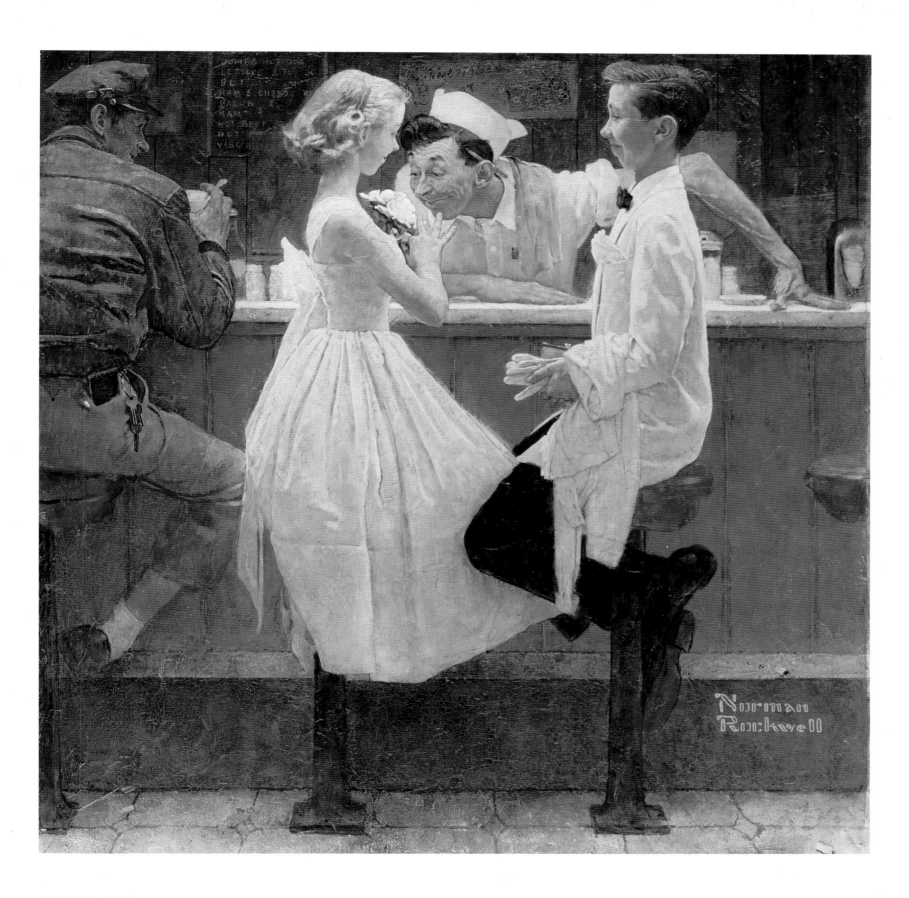

AFTER THE PROM

Oil on canvas, first printed on the cover of The Saturday Evening Post, *May 27, 1957.*

In the late 1950s, teenage America was developing its own culture, and rock 'n roll,

movies, and television were threatening Rockwell's homespun notions of adolescence.

ELECT CASEY

*Oil on canvas, first printed
on the cover of* The Saturday
Evening Post, *November 8, 1958.*
The charming optimism
of the campaign poster makes
an intriguing background
for the exhausted would-be
politician, as he tries to figure
out just what to do next.

THE HOLDOUT

Oil on canvas, first printed on the cover of The Saturday Evening Post, *February 14, 1959.*
Rockwell takes a peek inside the jury room, revealing what would soon be viewed
as a fairly sexist scene, as a jury of eleven men argue with the female holdout.

CHECKUP

Oil on canvas, first printed on the cover of
The Saturday Evening Post, *September 7, 1957.*
Rockwell's children were more
realistic than cute, with missing
teeth, skinned knees, and mussed hair.

A FAMILY TREE

Oil on canvas, first printed on the cover of The Saturday Evening Post, *October 24, 1959.*

Rockwell came up with the idea for *A Family Tree* while

shaving, what he claimed to be his most creative time of day.

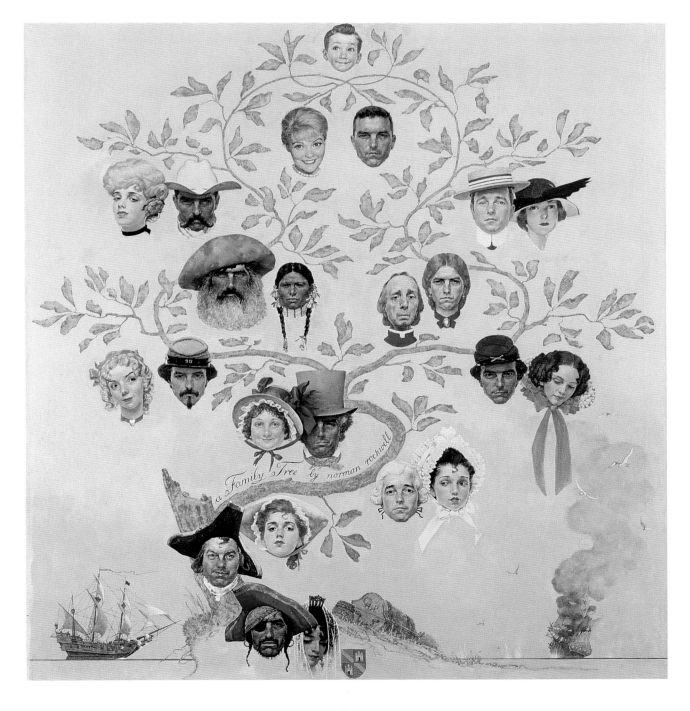

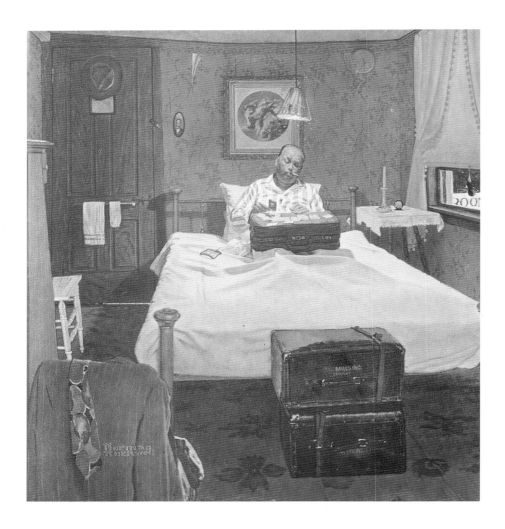

SOLITAIRE

Oil on canvas, first printed
on the cover of The Saturday
Evening Post, *August 19, 1950.*
Rockwell portrays the
lonely life of the traveling
businessman here, in the
days before there was
television in every room.

NEW TELEVISION SET

Oil on canvas, first printed on the cover of The Saturday Evening Post, *November 5, 1949.*

Rockwell captures a moment that defined the 1950s for many American families:

the arrival of their first television set, and the installation of the new antenna.

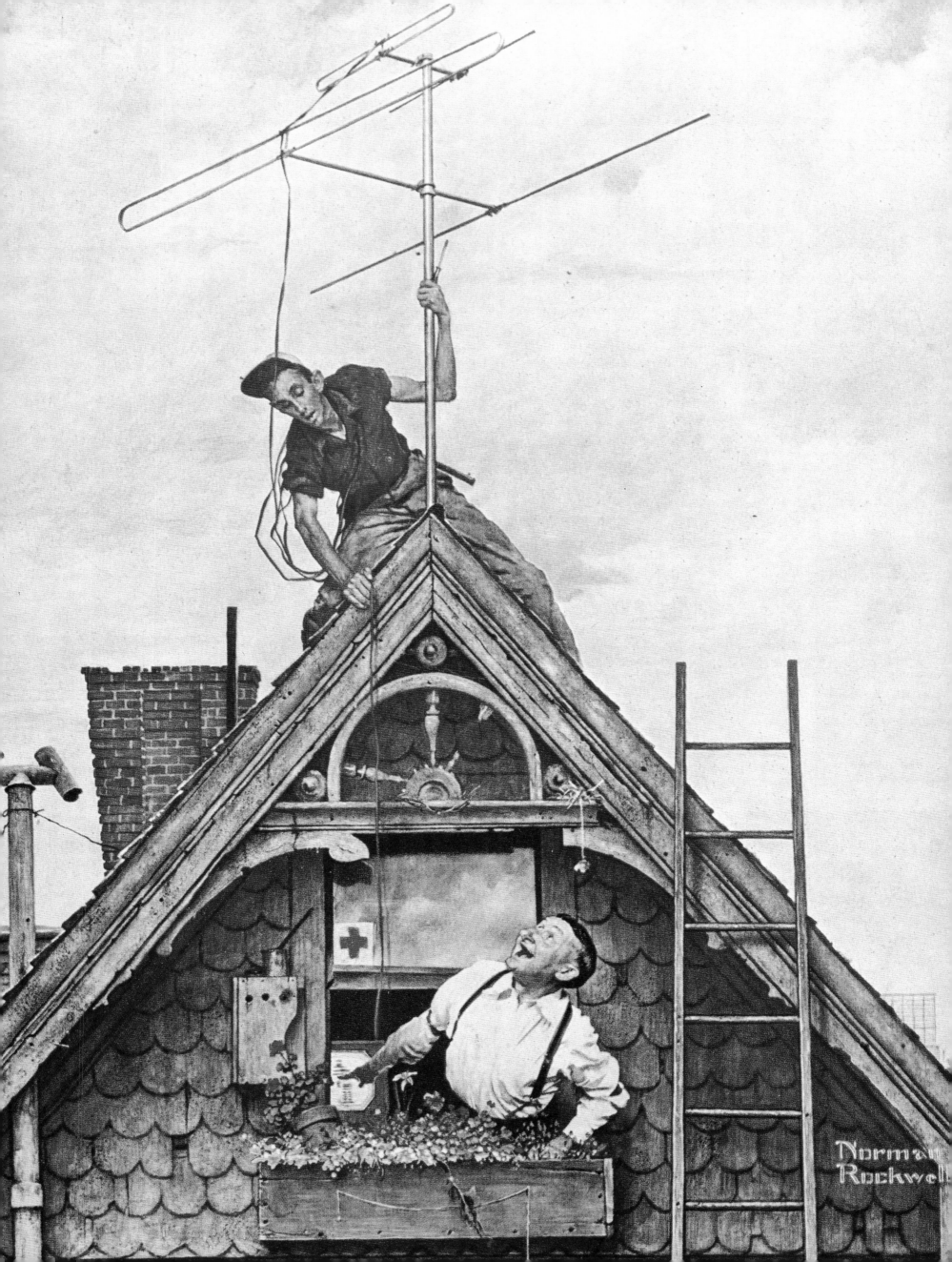

TURBULENT TIMES AND A ROCKWELL REVIVAL

Near the end of the 1950s Rockwell was to suffer another trauma. His wife Mary died suddenly in 1959. Rockwell did not remain a widower long. In October of 1961 he married a woman named Mary L. Punderson, a retired English instructor at a private girls' academy. He sketched her profile beside his own in 1967, and they look astonishingly alike.

Generations

The coming decade revived Rockwell's interest in the generation gap, an issue that was becoming increasingly crucial to him as he aged and American society entered another cycle of change. But this time there was a new take on the subject.

In his earlier work, images of intergenerational cooperation and shared pleasures underscored a mutually supportive relationship between parents or grandparents and young people. They flew kites, washed the dog, said grace, or went fishing together. By the 1960s, Rockwell had to admit that many of the young were scorning traditional intergenerational styles and forging their own subcultures and makeshift families. What is more, biological family gatherings were less often those of the extended family, because many people had left their home towns. Many homes no longer housed three generations because grandparents were being

shunted off to nursing homes. A revolution in sexual mores was about to leave some older people feeling perplexed and excluded.

Such an exclusion of older, more traditional people from the flow of American life is hinted at early in the decade in a 1960 *Post* cover by Rockwell, which shows three white-haired gentlemen through the window of the University Club in New York City. The club is a massive stone building with a velvet-curtained window about six feet above the sidewalk. It's a symbol of respectability and staunch conservatism. The gentlemen inside have been distracted from their newspapers to watch a scene on the sidewalk that involves a sailor in intimate conversation with a pert young woman, just below the window of the club. The old gentlemen strike us as captives of a solemn, rather unexciting world, enviously eyeing the free and spirited image of their lost youth.

One other mature passerby in the bottom left-hand of the frame is taken by the scene as well. He is in shirtsleeves and tie and smoking a pipe. Although he is glancing at the sailor and his girl, he is not craning to see them like the old men are. His posture seems more resigned, a little somber. When we study him closely we are struck by his resemblance to Norman Rockwell.

THE UNIVERSITY CLUB

Oil on canvas, first printed on the cover of The Saturday Evening Post, *August 27, 1960.*

Rockwell's original conception was a simple view inside an exclusive New York
university club. He felt it lacking, and so added the sailor and his girl outside,
creating a brilliant contrast between the smitten youths and the older businessmen.

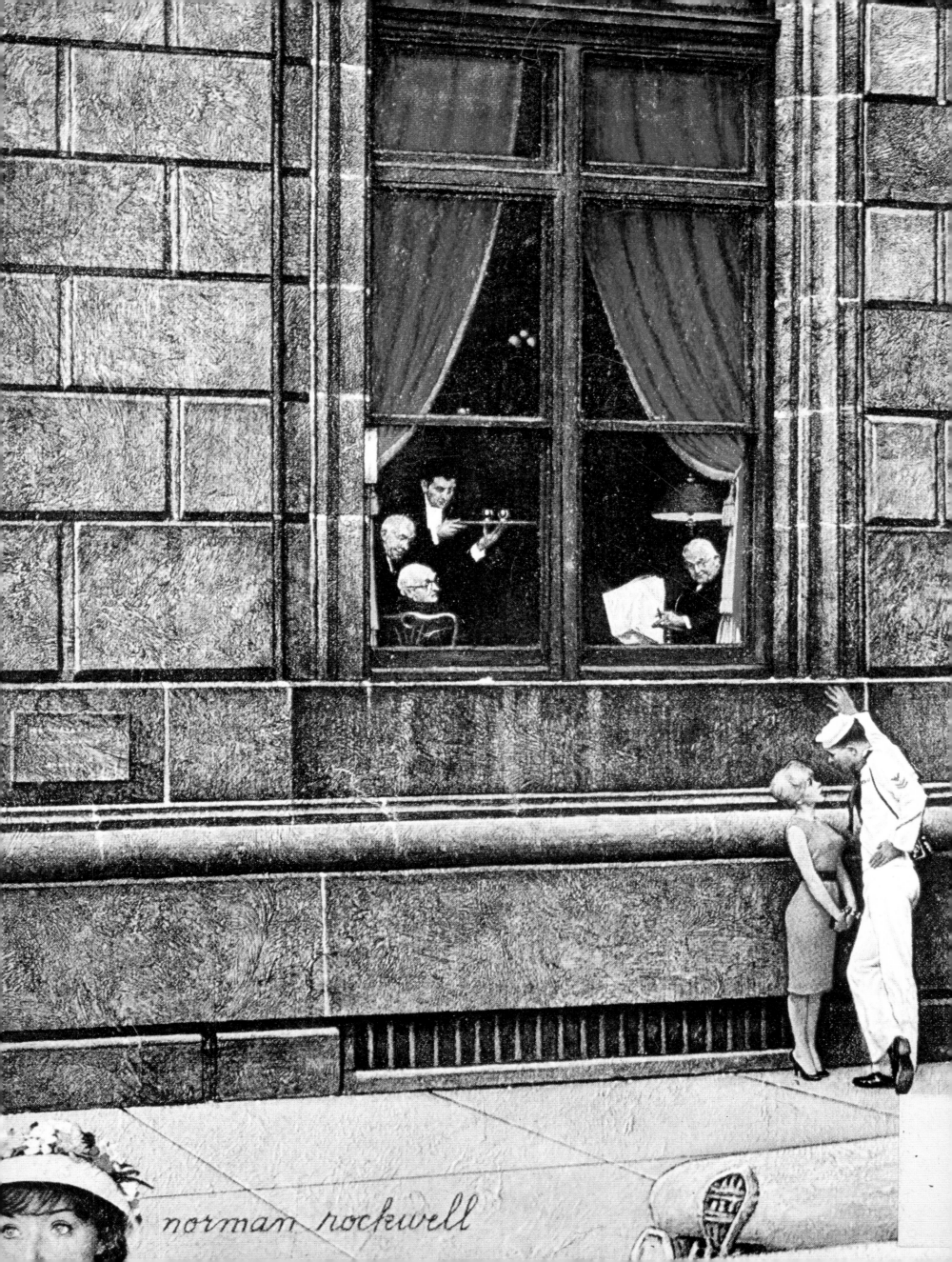

norman rockwell

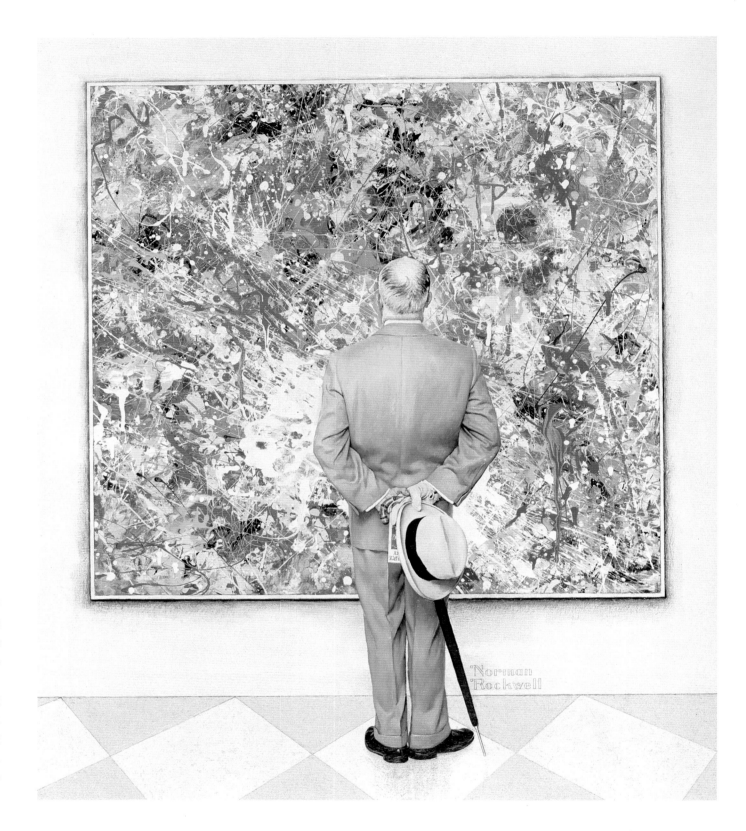

**ABSTRACT
AND CONCRETE**

*Oil on canvas, first printed
on the cover of* The Saturday
Evening Post, *January 13, 1962.*
The artist mimics a painting
by abstract expressionist
Jackson Pollack, juxtaposing
his realistically rendered
critic against the incompre-
hensible action painting.

The same theme of old versus new is presented in a very obvious way in a January 13, 1962, cover called *Abstract and Concrete*. In the painting, a gray-haired, balding man is standing with his back to us, studying a Jackson Pollock canvas on the wall of a museum. The man's suit is a mass of grayish color, set off by the conservative touches of his respectfully removed hat, white gloves, and umbrella. The reproduction of the dripped and poured paint of the abstract expressionist piece is subsumed by Rockwell's world because he has rendered it so faithfully, using his considerable mimicking skills.

From the *Post* to *Look*

In 1963, after painting 317 covers, Rockwell finally left the *Saturday Evening Post*, which was trying to lose its old-fashioned image and embark on a program that Rockwell referred to as "sophisticated muckraking." He began to receive regular commissions from *Look* magazine, and he adapted quickly to his new employer's interests. He was, above all, an illustrator, trained to do a job as it was presented to him. Unlike the *Post*, the editors of *Look* were more interested in newsworthy subjects than they were in reaffirmations of traditional American life.

Thus Rockwell painted a Russian classroom, Peace Corps volunteers in Africa, and even an evocation of man's first step on the moon. Rockwell carried out his commissions for *Look* and other publications like a professional, trying his best to give the magazine what it was asking for. Rarely did he complain or try to impose his values or point of view upon his clients. However, when he was hired to do a portrait of Spiro Agnew for the cover of *TV Guide*, he could not help remarking afterward that the ex-vice-president was not his type.

In one of his most accomplished works for *Look*, Rockwell depicted the grim walk of a solitary black girl escorted to school by U.S. marshals in Little Rock, Arkansas, shortly after integration. The suits of the marshals tend to blend into the wall in the background, which is interrupted by the violent sunburst of a red tomato, which has smashed against the wall after being thrown at the child. The undeniable focus of the picture is the little girl, in starched white, with a white ribbon in her hair, carrying her notebooks, ruler, and pencils. Her eyes have blanked to screen out the turmoil around her, but her step is resolute and her head balanced firmly on her shoulders. On the wall in the upper left-hand corner of the picture someone has scratched the initials "K.K.K."

More and more Rockwell was being asked to think globally or at least multiculturally. In 1964 he portrayed a member of the Peace Corps working in Ethiopia, again relying upon the contrast between old and new ways. This time, the representative of contemporaneity is a white American, while traditionally dressed Ethiopians, still using oxen in their work, stand by.

THE PROBLEM WE ALL LIVE WITH

Oil on canvas, first printed in Look, *January 14, 1964.*

Inspired by real scenes from the integration of southern schools, Rockwell focuses on the bravery of the young girl, the only character whose face is visible. The body language of the marshals conveys a sense of their being disconnected and unfeeling, while the writing and garbage that cover the wall convey the hatred and inhumanity of the crowd.

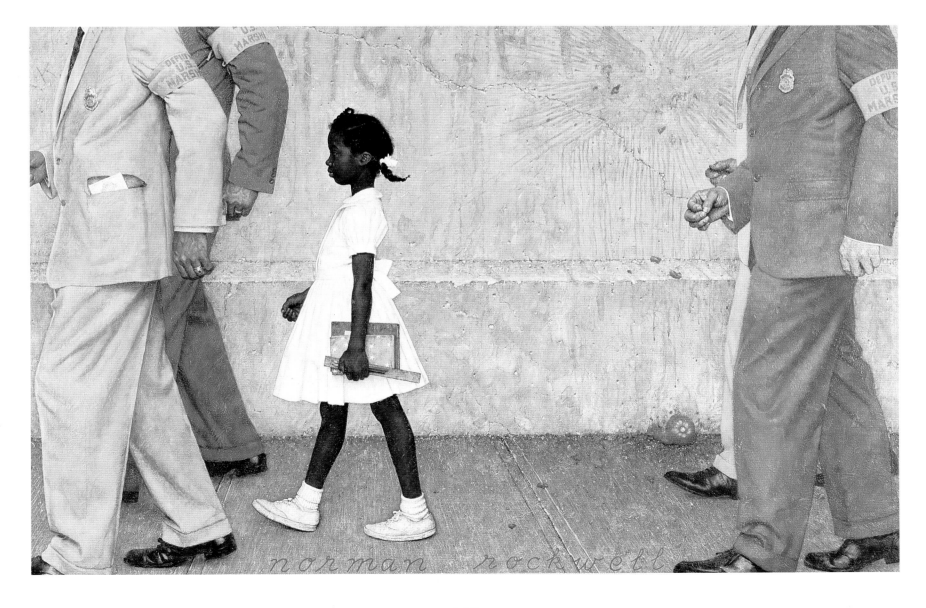

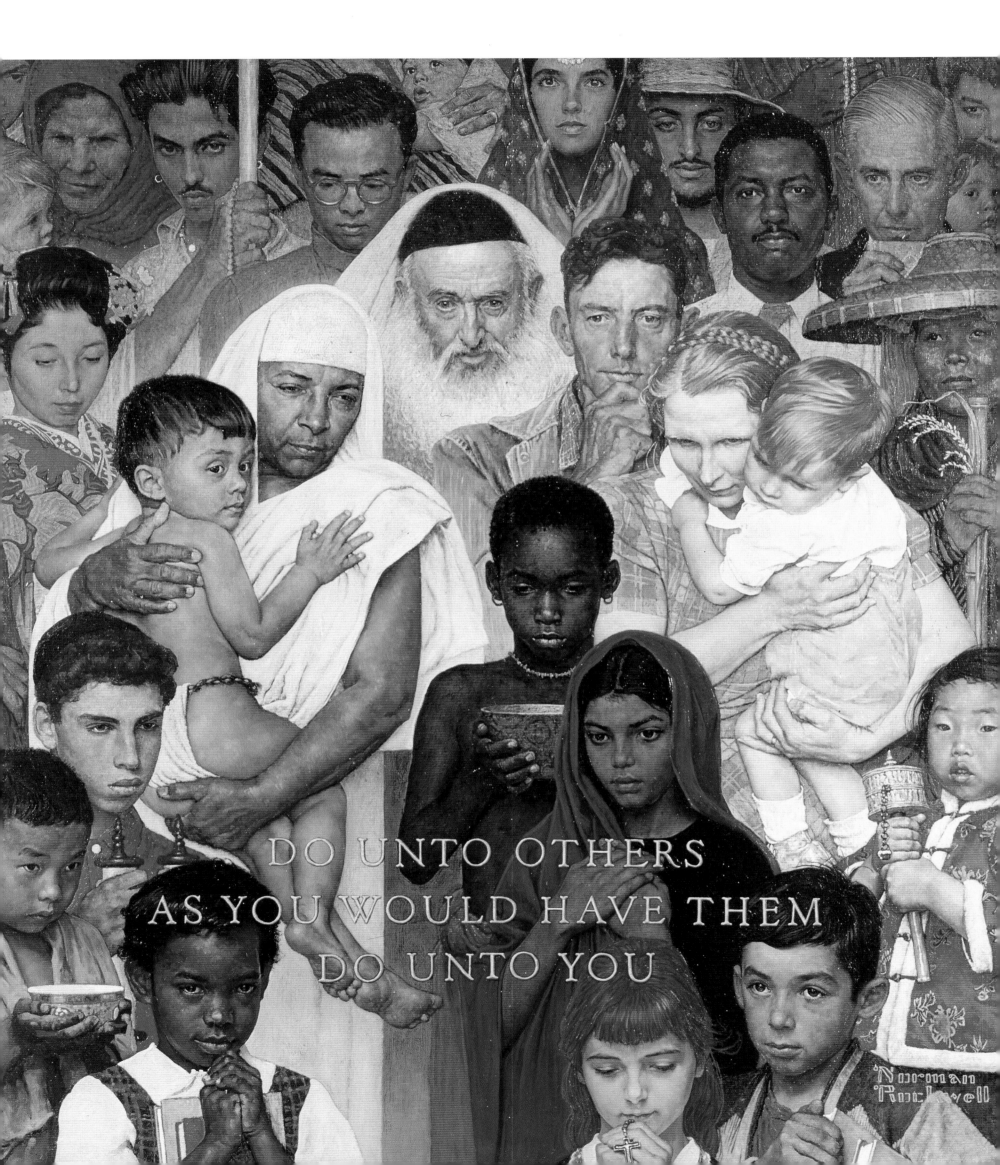

DO UNTO OTHERS
AS YOU WOULD HAVE THEM
DO UNTO YOU

A *Look* illustration for May 16, 1967, is one of only a few of the painter's other successful multicultural paintings. It depicts black children moving into a new neighborhood, to the curious and perhaps wary stares of three white children. Rockwell cleverly sustains both tension and balance in the painting by giving the little black girl a white cat to hold, which is focused on the alert black puppy perched between the feet of one of the white children.

When Rockwell was confronted by such subject matter, he often found himself at a loss for finding a way to depict it as narrative. Certainly if there is blame for such a failing, it must be laid not upon Rockwell per se but upon America's history of segregation and racial separation. There were at that time a limited number of situations in which people of different ethnicities intimately related. For an artist used to anecdotes that centered around family life, it was difficult to dream up scenarios in which members of different races could purposefully interact.

The *Look* illustration just described is a significant exception to this problem. However, in confronting multicultural subjects, Rockwell often had to rely upon a technique that Buechner refers to as "the massing of people." He had already used the technique

in *Freedom of Worship* in 1942, which presents a close-up of many faces in different kinds of prayer, representing a variety of religions. It's doubtful that all of these people would be praying their separate ways in the same space, but the "massing" of figures eliminates the need for a setting and gives the images an iconic quality, just as Rockwell's use of geometric backgrounds had accomplished in the 1920s. Buechner informs us that these paintings were based upon a studio-arranged composition pasted together from photographs and that the unifying element was often a single source of strong light.

In 1961 Rockwell applied this massing of people in a painting called *The Golden Rule,* for the April 1 *Post* cover. This time the figures are drawn from head on, and their presence together is allegorical rather than realistic. There is an enormous variety of ethnic features in this painting, yet all faces seem infused by an identical pensive, almost abstract or spiritual expression. Another picture that utilizes this technique is a portrait of the Apollo 11 Space Team for the July 15, 1969, issue of *Look.* To gather every member of the team together in the same space, Rockwell had once more to forego a realistic narrative. Thus he painted them all in profile, faces upturned toward the heavens.

**APOLLO 11
SPACE TEAM**

*Oil on canvas, first printed
in* Look, *July 15, 1969.*
Rockwell celebrates the
Apollo 11 moon landing
with a tribute to not
only the three astronauts
who flew the mission,
but also the countless
NASA technicians who
made the landing possible.

THE GOLDEN RULE

Oil on canvas, first printed on the cover of
The Saturday Evening Post, *April 1, 1961.*
Rockwell uses a Christian
proverb to convey a message
of religious tolerance, with a
composition reminiscent of
his 1943 *Freedom of Worship*
painting. Rockwell did several
paintings in which he massed
together the faces of a large
and diverse group of people,
focusing on both the differ-
ences and commonalities
between all the characters.

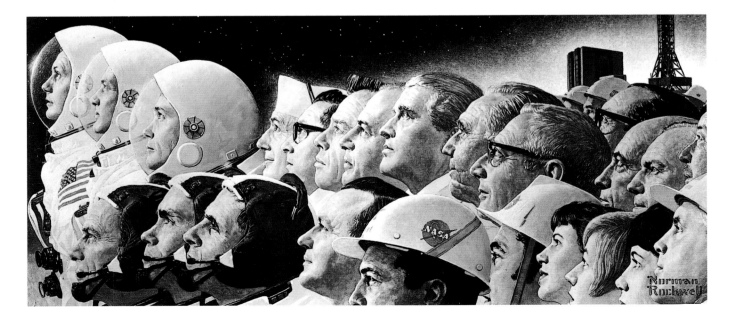

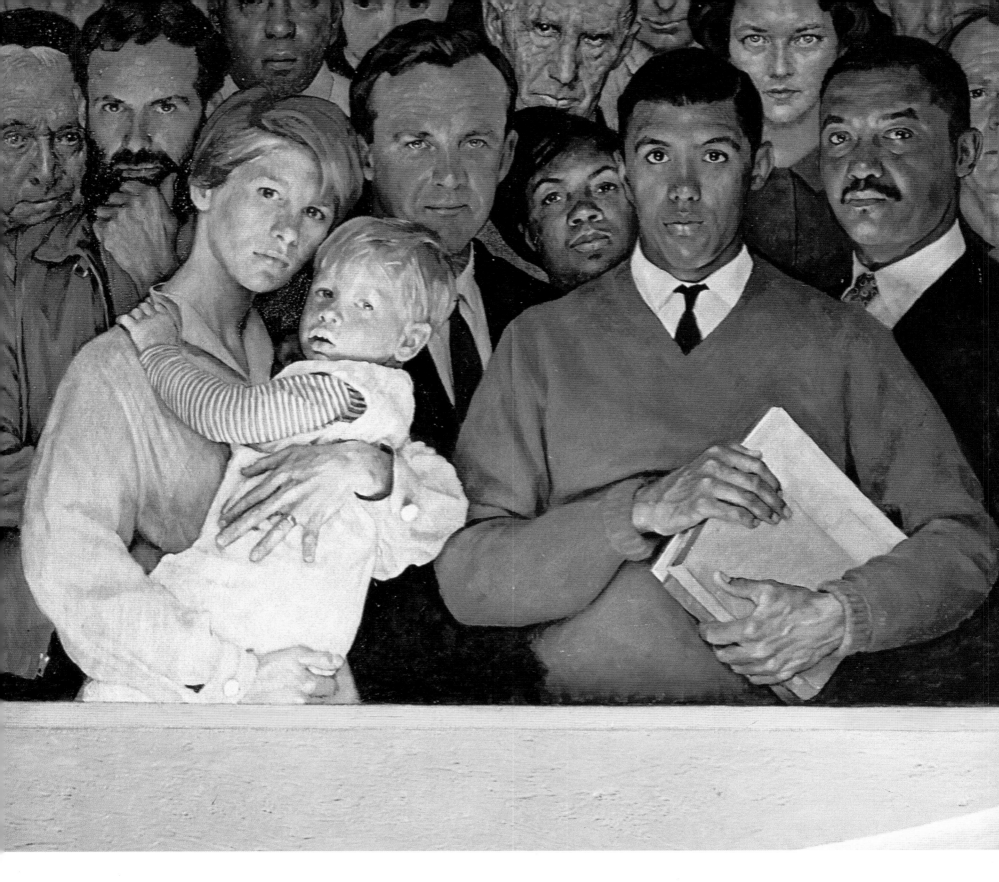

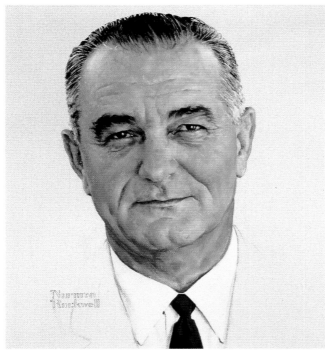

Celebrating Norman Rockwell

During the sixties and seventies, approval of Rockwell
was sometimes used as an inverse measure of one's
adaptation to the changing times. Political conserva-
tives like Ronald Reagan, whom Rockwell had
painted, praised him, calling him their favorite artist.
Members of the counterculture made reference to
him as a catchword for conformity. However, even
those who were critical of Rockwell seemed ambiva-
lent. The left-wing magazine *Ramparts* published a
snide profile of him even though they had commis-
sioned him to do a portrait of Bertrand Russell
several years before.

A remark by the portrait artist Peter Hurd became
public after President Johnson rejected Hurd's por-
trait of him and pulled out a likeness by Rockwell,
asking him why he couldn't do as good a job. Hurd
dryly replied that although Mr. Rockwell was a good

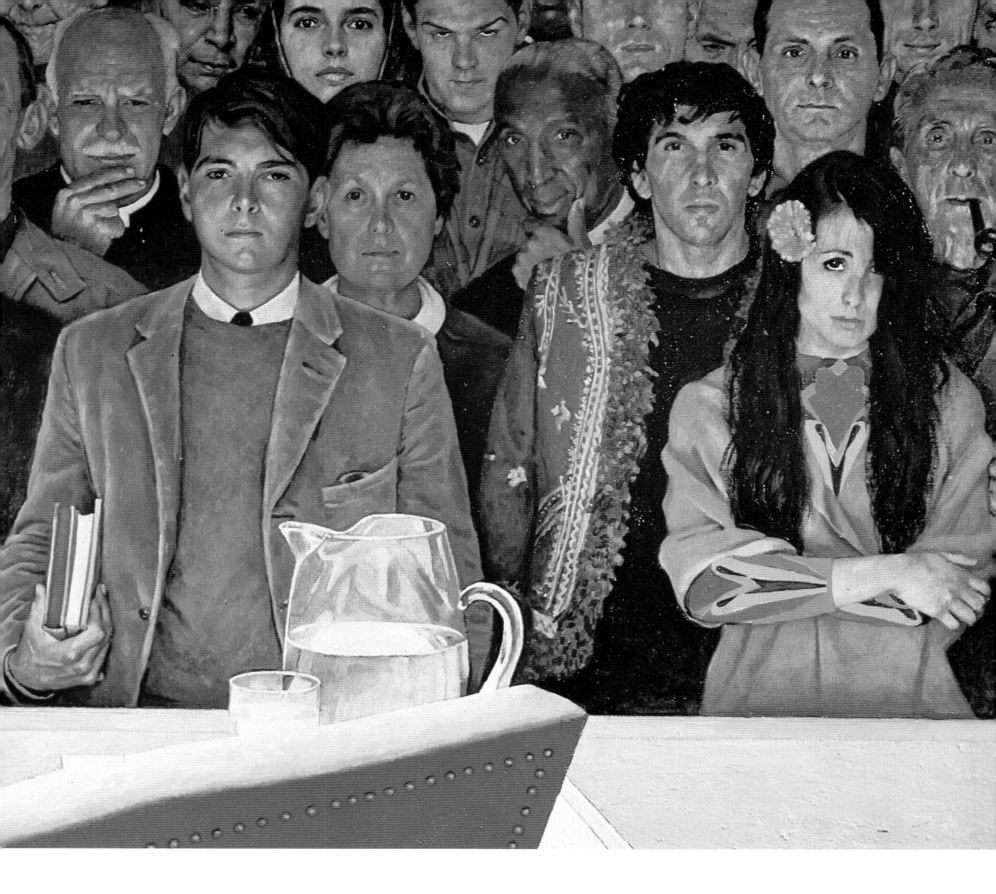

commercial artist, he was the kind of artist who re-lied upon copying from photographs. It was a remark that must have stung Rockwell, who never quite shook his chagrin over his decision to stop using only live models.

Despite other scathing criticisms, Rockwell's works achieved serious recognition in 1968, when an exhibition of fifty of his oil paintings was organized at the Bernard Dannenberg Gallery on Madison Avenue in New York. They were accompanied by the catalogue *Norman Rockwell: A Sixty Year Retrospective,* with its comprehensive text by Thomas S. Buechner. The gallery was continually mobbed, and the show was a great success. This was a year prior to Woodstock, when the counterculture would reach its apogee.

That same year, and perhaps as a result of the increasing tensions between the government and the people caused by the Vietnam War, as well as the

rising tide of liberalism in the country, Rockwell painted an illustration for *Look* entitled *The Right to Know.* It is another allegorical work, in which a mass of people are directing piercing gazes at an empty chair behind a desk. The painting is breathtaking and somewhat un-Rockwellian because of its candid and confrontational approach, which forces the viewer to stare into the intense, almost accusatory eyes of a few dozen people. At the right are two representatives of the counterculture, a young man wearing an afghan-embroidered jacket and a young woman with a flower in her hair, wearing a pink jacket over an op-art–patterned top. Next to these two figures is Rockwell himself, pipe in mouth, his tired but alert eyes staring at us as if in anticipation.

In 1970 Buechner, who was to become a principal in-fluence in the Rockwell revival of the 1970s, published a huge coffee-table book on Rockwell and his works

THE RIGHT TO KNOW

Oil on canvas, first printed in Look, *August 20, 1968.*
Like most of America, Rockwell was not as opti-mistic in the 1960s as he had been in the 1940s. Here, he groups himself (at the extreme right) with a large mass of questioning, almost accusing Americans.

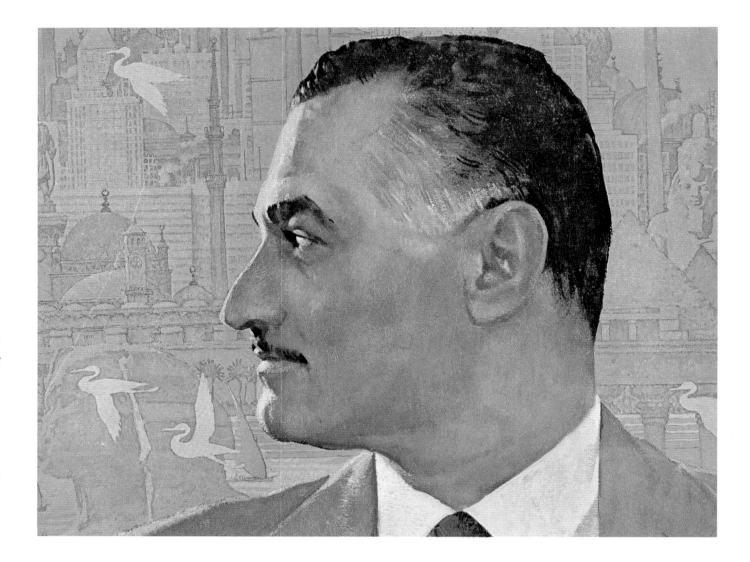

**PORTRAIT OF GAMAL
ABDAL NASSER**

Oil on canvas, first printed on the cover of
The Saturday Evening Post, May 25, 1963.
After World War II, the United
States began to established it-
self as a major world power.
Rockwell's subject matter dur-
ing the '50s and '60s began to
reflect this shift, as with this
portrait of Egyptian President
Gamal Abdal Nasser.

with publisher Harry Abrams. It offers overwhelming evidence of Rockwell's craft and creative output and has become a classic reference for Rockwell collectors and admirers.

Over 10,000 spectators and 2,000 participants came to a lavish Rockwell Parade in 1976 that had been organized to celebrate the American bicentennial in Stockbridge. The crowd cheered at the floats that passed by, each representing in tableau a well-known Rockwell illustration. They included, among others, the Four Freedoms, images from the Boy Scouts series, the returning G.I., and a well-loved Rockwell painting of a rosy-cheeked doctor examining a girl's broken doll.

Despite all of this public adulation and some critical approval, Rockwell had himself changed with the times. "I really believed," he told a reporter, "that the war against Hitler would bring the Four Freedoms to everyone. But I couldn't paint that today. I just don't believe it. I was doing this best-possible-world, Santa-down-the-chimney, lovely-kids-adoring-their-kindly-grandpa sort of thing. And I liked it, but now I'm sick of it."

Meanwhile, in 1969, the *Saturday Evening Post*, which had been established in 1821, had finally stopped publishing. Their attempt at revamping their image without Rockwell seemed to have failed. Two years later the *Post* was revived as a quarterly, and Rockwell was asked to do the commemorative cover. The seventy-seven-year-old artist chose to portray a gap-toothed nineteenth-century street-corner urchin in knickers and high stockings, with a news bag slung over his shoulder, hawking an antique version of the periodical.

In 1976 Rockwell's health began to fail and he grew increasingly frail. He received the Presidential Medal of Freedom from President Ford in 1978 and, that same year, left most of his well-known works to the Norman Rockwell Museum, which had been established in Stockbridge. Rockwell died in November of 1978, at the age of eighty-four. Perhaps revealing a true New England sensibility, his wife Mary simply told reporters, "He didn't die of anything except being 84 years old." He was buried at St. Paul's Episcopal Church in Stockbridge.

JACK BENNY

Oil on canvas, first printed on the cover of The Saturday Evening Post, *March 2, 1963.*

Throughout his career, Rockwell remained the chronicler of American entertainment,
from his early homages to movie stars to his later portraits of television icons.

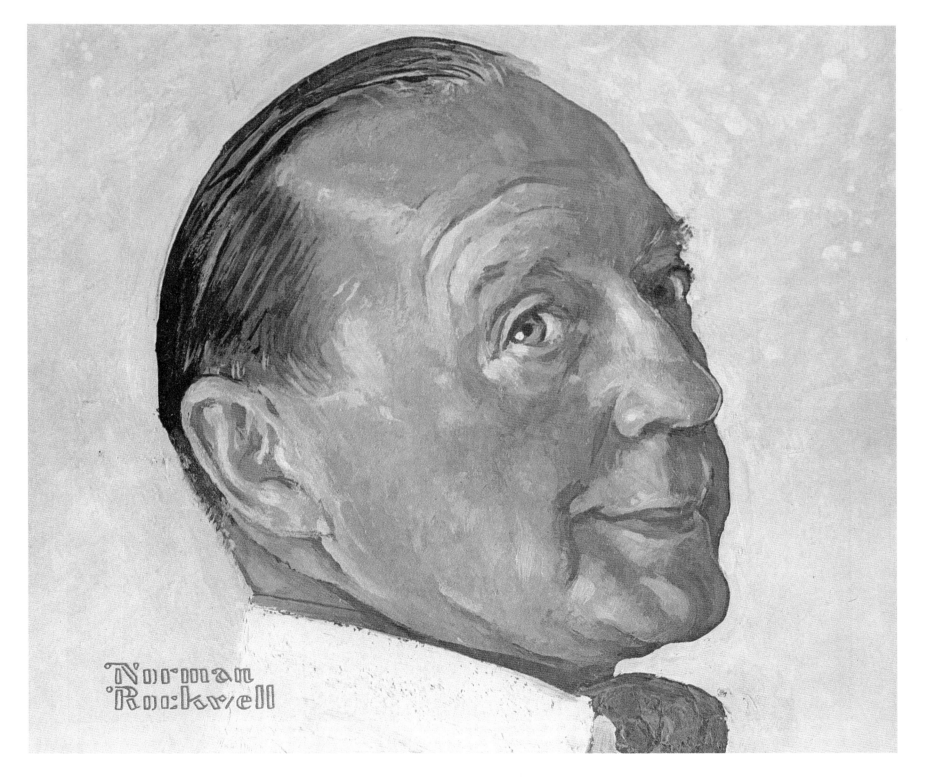

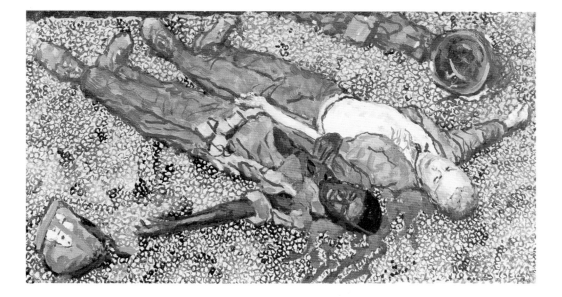

BLOOD BROTHERS

Preliminary sketch for oil painting, c. 1968.

One of two studies for a painting commissioned by the Congress of Racial Equality. This one is closest in composition and detail to the finished work, and conveys much of the power of the actual painting. The blood of the two soldiers—one black, one white—flows together on the ground, demonstrating that while treated unequally in life, all Americans are indeed equal in death.

NORMAN ROCKWELL IN HIS STUDIO

Photograph, c. 1968.

During the 1960s, Rockwell, like much of the rest of the country, became concerned with social ills and injustices, and found himself unable to paint with the same optimistic cheer with which he had made his name.

**PORTRAIT OF
ROBERT F. KENNEDY**

Oil on canvas, 1968.

Rockwell's portrait of Robert
F. Kennedy reminds viewers
of the young politician's po-
litical promise, as well as the
tragedy of this assassination.

PORTRAIT OF RICHARD M. NIXON

Oil on canvas, first printed in Look, *March 5, 1968.*

Rockwell's portrait of Richard Nixon captures the sense of sheer determination that
seemed quite gentle at the time, but which would be recast as much darker later on.

Norman Rockwell

JFK'S BOLD LEGACY—
PEACE CORPS

Oil on canvas, first printed on the
cover of Look *magazine, June 14, 1966.*
Rockwell and the *Post* parted
ways in the mid-1960s, and
the artist began to do more
illustrations for *Look* maga-
zine. The magazine was more
concerned with the social
and political issues that
marked the decade, and Rock-
well produced some of his
most moving paintings for it.

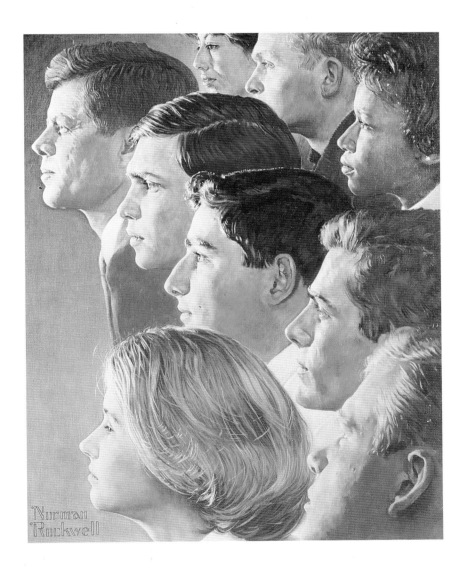

FOLLOWING PAGE:

MOVING IN

Oil on canvas, illustration
for *Look* magazine, May 16, 1967.
At a time when adults through-
out the nation were embroiled
in battles over the desegrega-
tion of schools, Rockwell
captured the curiousity and
innocence with which chil-
dren approach such events.
While the children size one
another up, Rockwell uses
common props—baseball
gloves and pets—to accentu-
ate the similarities, rather than
the differences, between them.

A TIME FOR GREATNESS

Oil on canvas, first printed in Look, *July 14, 1964.*

A Time For Greatness appeared on the cover of *Look* in July 1964, six months after
the assassination of President Kennedy and just prior to the Democratic National
Convention which nominated Lyndon Johnson. It is a poignant reminder of what might
have been. Ambassador Averell Harriman can be seen to the right of the President.

**CHRISTMAS
IN BETHLEHEM**

*Oil on canvas, first printed
in* Look, *December 29, 1970.*
In a serious departure
from the Christmas covers
of the old *Post*, Rockwell
paints a contemporary
scene in the Holy Land, as
a Christmas procession
is viewed by tourists
alongside armed soldiers.

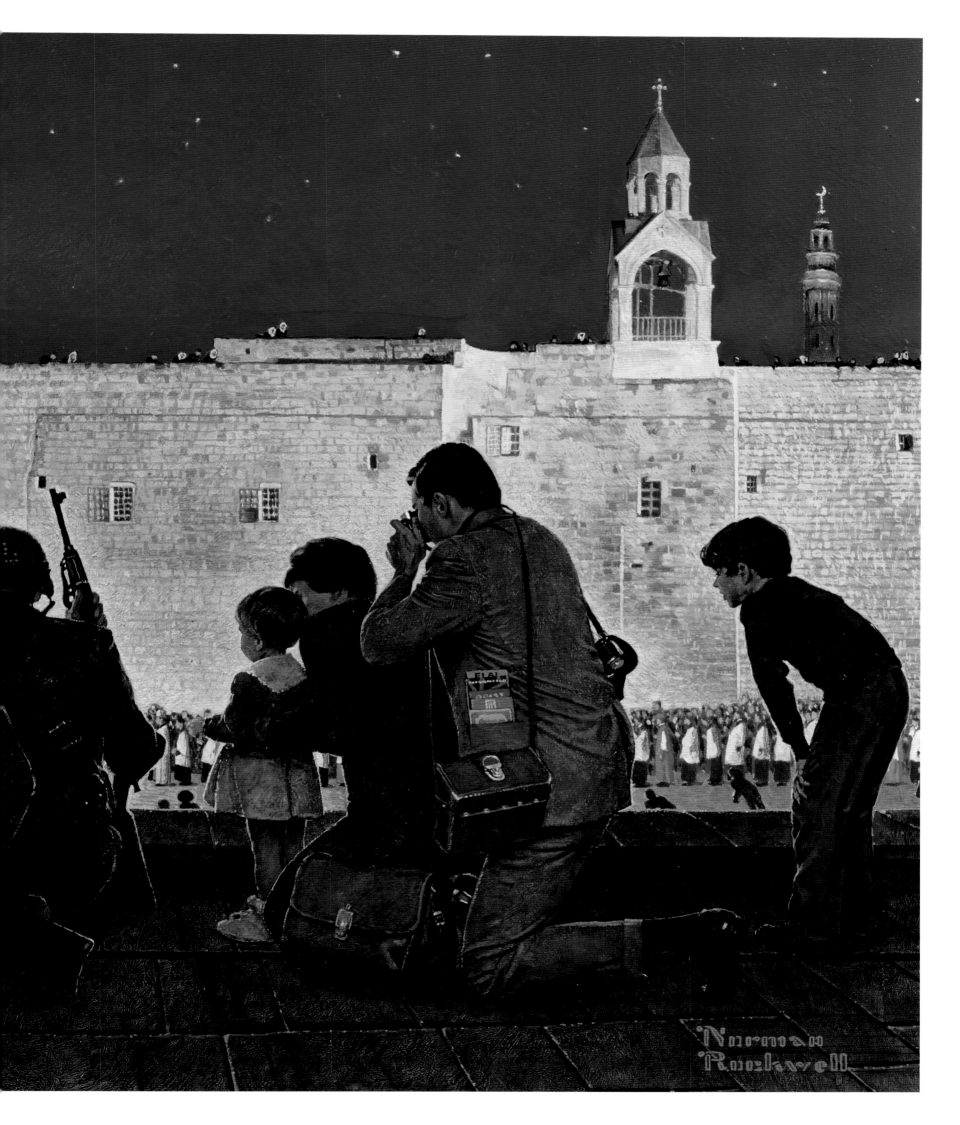

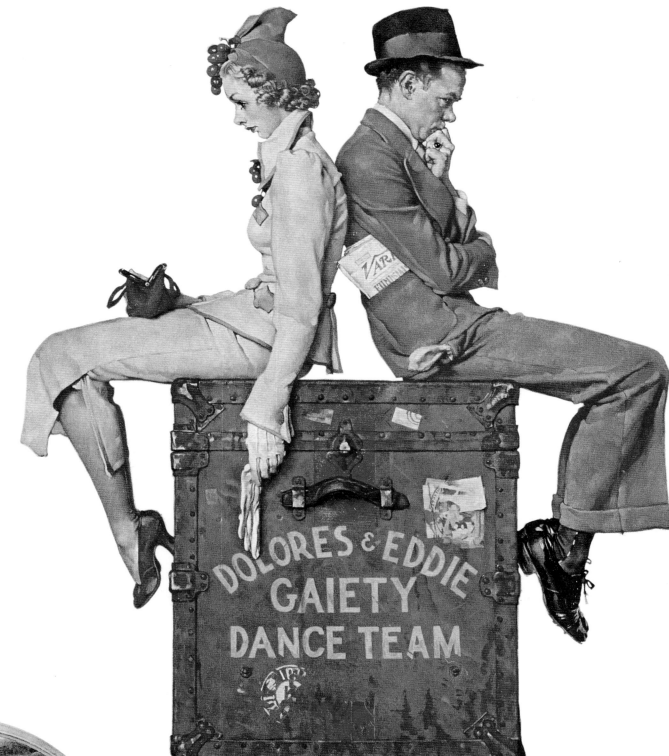

DELORES & EDDIE
GAIETY DANCE TEAM

Oil on canvas, first printed on the cover of
The Saturday Evening Post, June 12, 1937.

As a chronicler of American popular
culture, Rockwell is unsurpassed.

THE OLD COUPLE

Oil on canvas, first printed on the cover of
The Literary Digest, April 15, 1922.

Rockwell painted active older people throughout
his career, and when he himself was in his
seventies, he fit the mold he had idealized, if
not created. He remained an active illustrator, and
always believed himself to be growing as an artist.

ROCKWELL'S LEGACY

Today the Norman Rockwell Museum in Stockbridge, Massachusetts, is housed in a sprawling white colonial-looking building, designed by architect Robert A. M. Stern. Rockwell's studio was moved to the site of the museum in 1986 and is open to the public, who can examine the easel, palette, paints, and brushes that were used to create his beloved paintings.

In an obituary in *Time*, Robert Hughes wrote, "Norman Rockwell shared with Walt Disney the extraordinary distinction of being one of the two artists familiar to nearly everyone in the U.S., rich or poor, black or white, museum goer or not, illiterate or Ph.D." Perhaps to the surprise of some critics, such populist notoriety has barely diminished over the years. In circles frequented by collectors of American illustration, Rockwell's paintings get the highest prices. In 1994, a study for *Freedom of Speech* netted $407,000 at an auction.

Writing of Rockwell when he was seventy-six, Thomas Buechner said, "He has been America's most popular artist for half a century. In fact, his work has been reproduced more often than all of Michelangelo's, Rembrandt's, and Picasso's put together." Buechner pointed out rather ironically that "no civilization has ever had its unimportance so richly, accurately and lovingly recorded," and took issue with those critics so focused on the necessity of change in art that they had lost their ability to evaluate its quality.

In Buechner's remarks were inklings of the postmodern revolution in art criticism that was to come. In some ways the postmodern viewpoint justifies the production of Rockwell and offers an answer to his lifelong conflict between high art and commercial concerns. Such a perspective stresses the impossibility of cultural production outside received historical imperatives. It looks askance at the Modernist emphasis on an avant-garde, and portrays Modernist ambitions of progress and originality as a cultural illusion.

Today many artists have become less intimidated by the artistic ideals that so burdened Rockwell's creative spirit. They feel perfectly at ease borrowing the techniques, structures, images, and narratives from the entire historical canon, appropriating these elements into their own very referential vision. Their sensibility has given Rockwell credibility in the sense that few now find it necessary to judge his work upon the sole qualification of innovation. Instead, they see it much as he did, as an extended document of a specific time in America, a highly elaborated record of our values and our dreams.

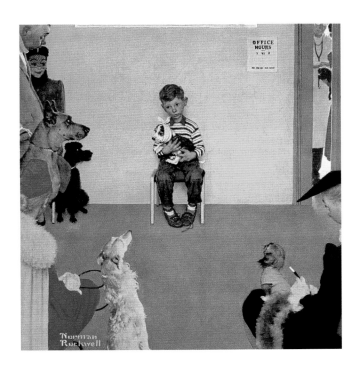

WAITING FOR THE VET

Oil on canvas, first printed on the cover of The Saturday Evening Post, *March 29, 1952.*
Rockwell's unblinking eye found beauty in the most mundane moments, and his phenomenal talent allowed him to record those moments perfectly. While overlooked as an artist for much of his life, his work has been reproduced more often than any other artist.

TWO PLUMBERS AND A DOG

Oil on canvas, first printed on the cover of The Saturday Evening Post, *June 2, 1951.*

Two plumbers enjoy the feminine luxuries of the boudoir. Rockwell's attention to detail and talent for faces and figures made his images appear as realistic as photographs.

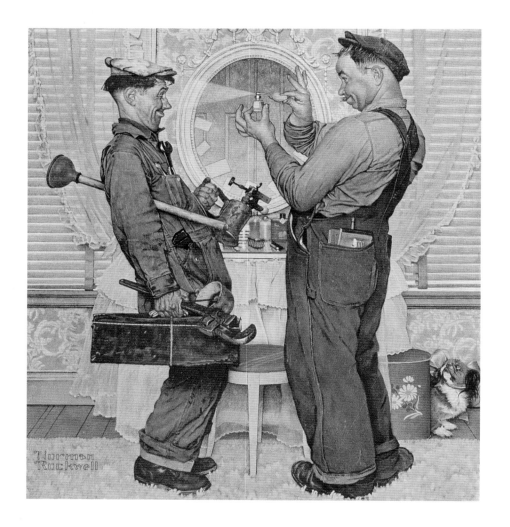

THE CHARS

Oil on canvas, first printed on the cover of The Saturday Evening Post, *April 6, 1946.*

Rockwell's talent for figures was the cornerstone of his art; his feel for scenery came later. As an artist, he continually honed his craft.

THE SATURDAY EVENING
POST
APRIL 6, 1946 10¢

THE PLAYBILL
FOR THE MAJESTIC THEATRE

Banquet

IE PLAYBILL

Norman
Rockwell

A Complete Novelette
BY AUDREY DE GRAFF

G. I. Deviltry Costs
Us Plenty
BY NATHANIEL GORDON

INDEX